C000142699

Revolution in Hungary

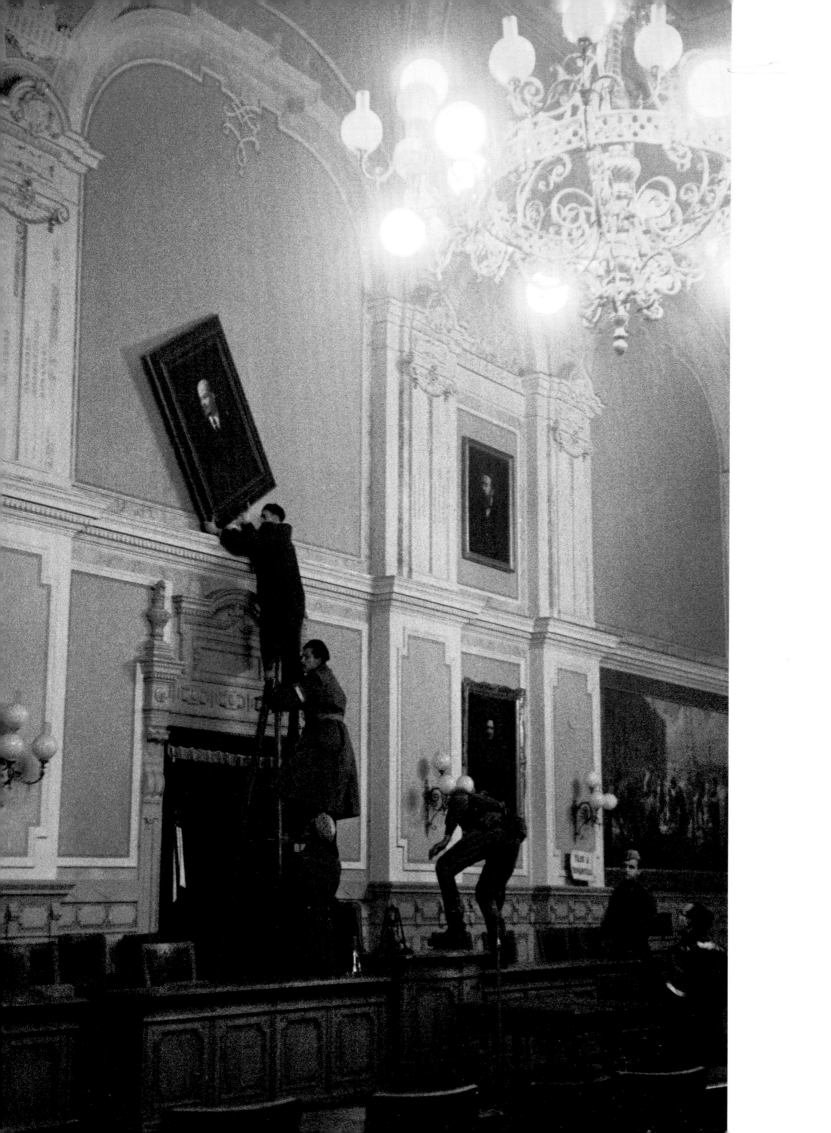

ERICH LESSING

Revolution in Hungary
THE 1956 BUDAPEST UPRISING

Texts by George Konrad, François Fejtö, Erich Lessing and Nicolas Bauquet

Thames & Hudson

Previous page
The portrait of Lenin in the council room of
the city hall in Györ is taken down by insurgent soldiers,
at the end of October 1956.

We thank Professor A. Schmidl for having given us the military information essential
to our book.

First published in the United Kingdom in 2006 by
Thames & Hudson Ltd, 181A High Holborn,
London WC1V 7QX
www.thamesandhudson.com

First published in hardcover in the United States of America in 2006 by
Thames & Hudson Inc., 500 Fifth Avenue, New York, New York 10110
thamesandhudsonusa.com

Design: Eva Vincze
Captions: Traudl Lessing
Translation from Hungarian: Michael Blumenthal
Translation from German: Jeanette Demesteere
Translation from French: Philippa Richmond

First published in 2006 by Biro éditeur
11 rue des Arquebusiers
75003 Paris, France

British Library Cataloguing-in-Publication Data
A catalogue record for this book is available from the British Library

Library of Congress Catalog Card Number 2006923082

ISBN-13: 978-0-500- 51326-2
ISBN-10: 0-500-51326-0

Printed and bound in Austria

Contents

Chronology

1948

March 25
Nationalization of large businesses.

June 12
Incorporation of the Hungarian Social Democratic Party into the Communist Party. Founding of the unified MDP Party (Hungarian Workers' Party).

August 20
Beginning of forced collectivization.

1949

May 15
Parliamentary elections with a unified list.

September 24
Verdict in the Rajk trial. László Rajk, a leading functionary of the MKP (Hungarian Communist Party), Interior Minister, then Foreign Minister, is sentenced to death in a show trial and executed. Rehabilitated in 1956, his reburial on 6 October 1956 was attended by a large crowd of mourners.

1952

August 14
Mátyás Rákosi is appointed Prime Minister.

1953

July 4
Policy speech by Imre Nagy in Parliament.

1954

October 1–3
A Central Committee decision endorses Nagy's reform plans.

December 1
Rákosi attacks Nagy in the Politburo.

1955

March 2–4
The Central Committee condemns Nagy's reform policies.

April 14
Imre Nagy is stripped of all his offices.

May 14
Signing of the Warsaw Pact.

May 15
Signing of the Austrian State Treaty.

May 26
Khrushchev in Belgrad, reconciliation with Tito.

July 18–23
Geneva Summit Conference.

1956

October 6

The funeral of Rajk attracts over 300,000 people.

October 23

3.00 pm: Students march to Bem Square.

Evening: Demonstrators demand the reading-out of sixteen points, among them: departure of the Soviets, Nagy as Prime Minister, condemnation of Gerö and Rákosi, free elections, right to strike, revision of the political process, liberation of all political prisoners and dissolution of the secret police. The radio, however, broadcasts a speech by Gerö, in which he turns against the demonstrators.

9.00 pm: Address by Imre Nagy in Parliament; shortly after this, a riot at the radio building breaks out and spreads through the city.

9.37 pm: The statue of Stalin is overturned. Around midnight, Soviet troops march into Budapest and attack the rebels.

October 24

8.13 am: The appointment of Nagy as Prime Minister is announced.

12.10 pm: Nagy calls for an end to the violence. Mikhail Suslov and Anastase Mikoyan arrive in Budapest.

October 25

12.32 pm: The deposition of Gerö and the appointment of Kádár as First Secretary of the MDP is announced on the radio.

October 26

Battles throughout the entire country. In Mosonmagyaróvár and Miskolc, members of the State Security Service (AVO) fire on demonstrators. There are instances of justice by lynching on the part of the demonstrators.

October 27

Imre Nagy makes public the names of his governing team, consisting of less encumbered and persecuted Communists.

October 28

1.20 pm: Nagy announces a cease-fire on the radio. The Soviets begin their withdrawal. The AVO is immediately dissolved, and an amnesty for all fighters agreed upon.

October 29

The Hungarian Defence Minister announces the departure of the Soviets; they are to have abandoned Budapest by 31 October. The American ambassador Bohlen lets the Soviet government know that the United States of America does not consider the new Hungary as its ally.

János Kádár declares himself to be in accord with the re-establishment of the multi-party system.

October 30

Final battle: In the morning, the AVO is driven out of the party building on Köztársaság Square (Republic Square). Many dead on the rebel side. Twenty-four defenders of the building are lynched.

Imre Nagy announces the restructuring of the goverment along the lines of the 1945 coalition.

In the evening, the West Hungarian Revolutionary Committee comes into being in Györ, presided over by Attila Szigethy.

10.00 pm: Release of Cardinal Mindszenty.

October 31

Imre Nagy announces that negotiations on Hungary's withdrawal from the Warsaw Pact have begun. Soviet troops from Romania and the Ukraine begin to move against Hungary.

November 1

Nagy summons Soviet ambassador Andropov and informs him that Hungary will withdraw from the Warsaw Pact in protest against the new troop movements. Nagy asks the UN for an acknowledgment of Hungarian neutrality.

November 2

The Hungarian government protests in three notes against the renewed invasion of the Soviet troops. The UN Security Council decides to submit the Hungarian question for debate on 4 November.

Evening: Discussion in Brioni between Khrushchev and Tito. Tito supports the intervention.

November 3

Negotiations with Soviet generals over the beginning of the withdrawal of Soviet troops. A further round is planned for 10.00 pm at Tököl, where General Maléter and the Hungarian delegation are arrested.

November 4

The flight into Austria begins. By 31 December, 176,422 Hungarians have taken refuge in Austria.

4.00 am: Beginning of the general invasion of Budapest by Soviet troops.

5.20 am: Nagy announces the Soviet invasion.

The armed groups in the capital renew the battle. Nagy and his companions take up asylum in the Yugoslavian Embassy.

November 22

Abduction of the Nagy group to Romania.

1958

June 16

Execution of Imre Nagy, Pál Maléter and Miklós Gimes.

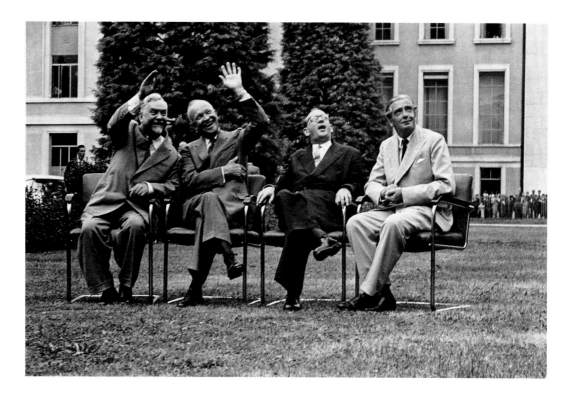

Nikolai Bulganin, Dwight D. Eisenhower, Edgar Faure and Anthony Eden posing for the press in the courtyard of the Palace of Nations during the Geneva summit conference, Switzerland, 1955.

First session of the Geneva summit conference. Among the participants: Dwight D. Eisenhower and John Foster Dulles for the United States; Nikolai Bulganin and Nikita Khrushchev for the Soviet Union; Edgar Faure and Antoine Pinay for France, and Anthony Eden and Harold Macmillan for Great Britain. 1955.

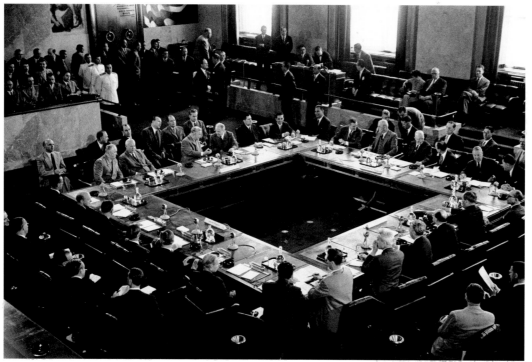

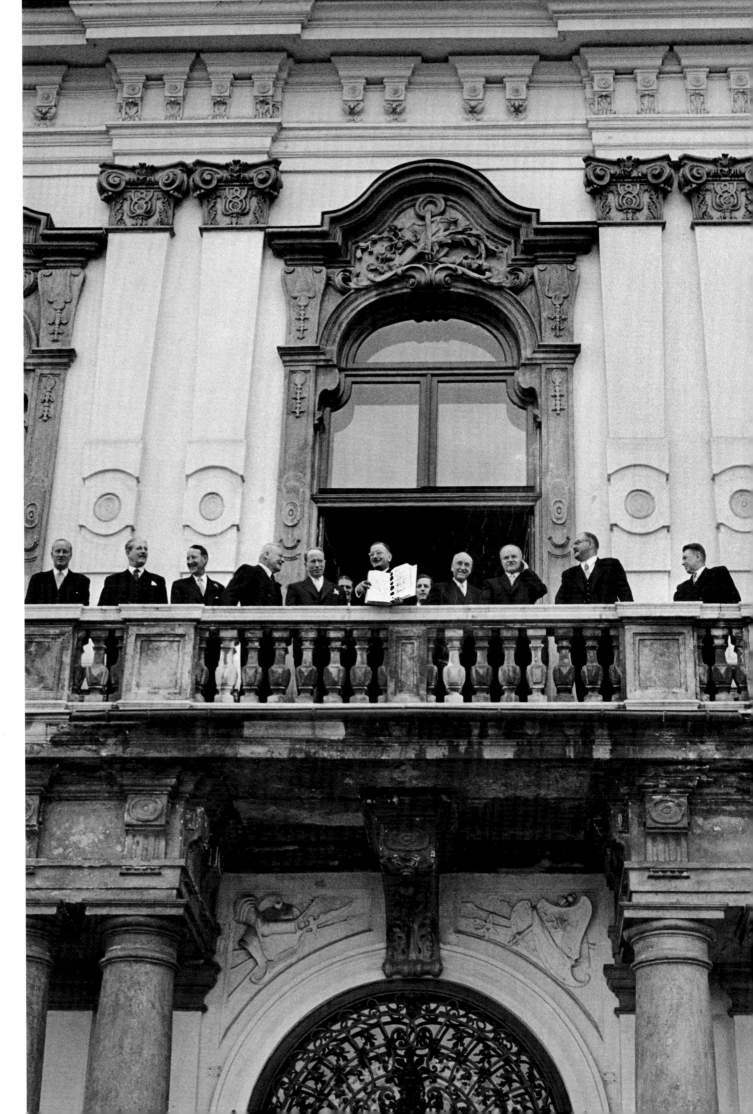

The Austrian State Treaty, which brought an end to the Allied occupation of Austria, is signed on 15 May 1955, in the presence of five foreign ministers: Dulles for the United States, Macmillan for Great Britain, Pinay for France, Molotov for the Soviet Union, and Figl for Austria. Leopold Figl showing the signed treaty to an ecstatic crowd, Vienna, Austria, 1955.

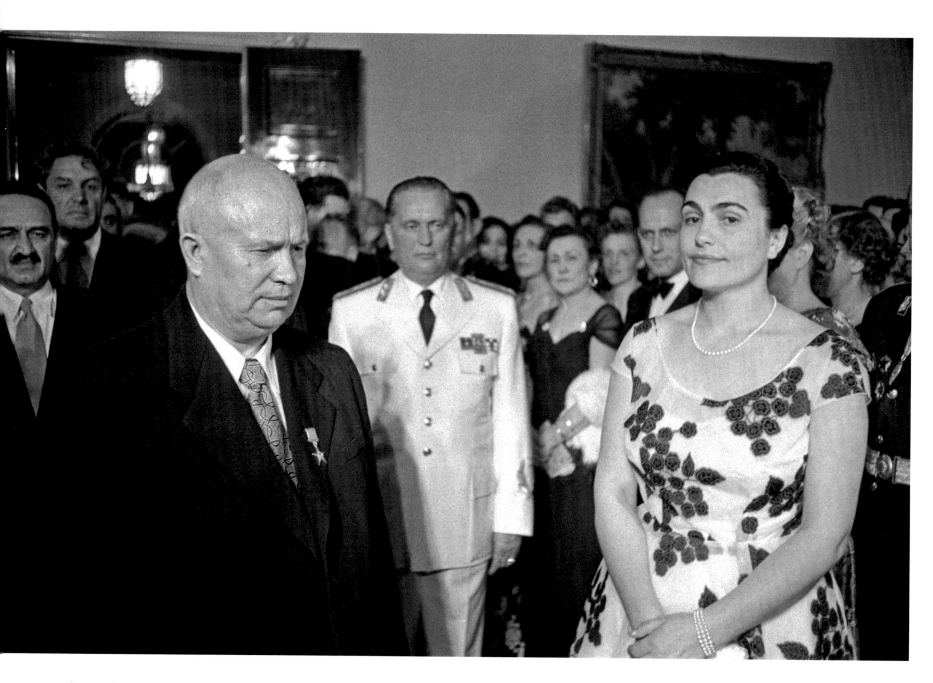

Reconciliation between the Soviet Union and
Yugoslavia: the hosts are Tito and his wife
Jovanka; the guests, Nikita Khrushchev and
Anastas Mikoyan, a member of the Central
Committee of the Soviet Communist Party.
Belgrade, Yugoslavia, March 1955.

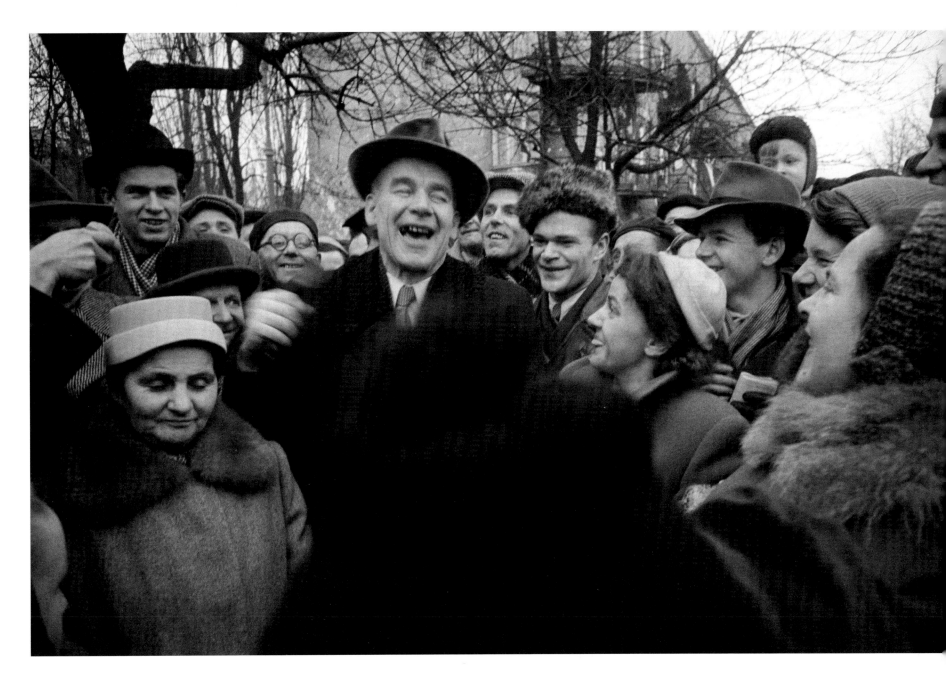

Having successfully rallied most of Poland's Communist officials to his movement for democratization, Wladyslaw Gomulka was elected First Secretary of the Central Committee in October 1956. His victory was openly welcomed in Hungary, and, on 23 October 1956, all of Budapest was preparing to express its solidarity with Poland. A year later, Gomulka was re-elected First Secretary of the Polish United Workers' Party. He is seen here surrounded by sympathisers on leaving the polling station in 1957.

Erich Lessing

Memories of the year 1956

I am known as a photojournalist but in reality I'm a *zoon politikon*, a political animal. I've always been interested in politics, especially the relationship between the individual and politics – 'power' and how it plays out between them. To what extent does power affect people? Can a population, if only in rare moments of world history, influence the powers that be to the point of bringing about their downfall? The time after the Cold War, immediately after Stalin's death, was one of these moments of intense political and diplomatic activity. After Stalin's death, the 20th Congress and the elimination of Malenkov and Bulganin, there was an easing of international tension. It lasted from Khrushchev's takeover to Khrushchev's demise.

Since my latest exhibit in France, I've been referred to as the Cold War photographer. In some respects this is true, though my personal political interest has always been in the countries of Communist Europe.

Because I sensed that something important was about to happen in 1956, I had proposed a series of articles to *Life* magazine on the four most important Communist countries: the GDR, Poland, Czechoslovakia and Hungary. The latter three were at that time much simpler to cover than the GDR, which was the most complex. I spent an entire year (1954–55) driving around these three countries, with stop-overs in Belgrade, where it was always easier for us journalists to learn what was going on in other Communist countries. Every day, I listened to the 6.00 am news; the worker's unrest in Poznan, the worker's uprising in Berlin were already old stories, but at the end of the 20th Congress things began to crack and eventually crumble.

I had always had a very good relationship in Hungary with Péter Várkonyi, press secretary to the Foreign Ministry. Later on, he became Imre Nagy's press secretary; however, when Nagy wanted to pull out of the Warsaw Pact, Várkonyi distanced himself, realizing that no good could come of it.
One weekend in May or June 1956, I had no projects or meetings. Budapest was empty, the weather was fine, so I took Friday off and drove to the Mátra mountains, where I found a small hotel for the night. Early Saturday morning, the phone rang. As nobody knew where I was, it had to be a mistake. On the other end was Péter Várkonyi's deputy, who said: 'Archbishop József Grösz of Kalocsa, has just been released from prison and is holding a press conference. I simply wanted to inform you. Could you please drive to Kalocsa immediately?'
The Hungarian authorities knew exactly where I was, even though I was unaware of being kept under house surveillance.

At this time, a certain liberalization was emerging in Poland, a growing agitation among the so-called intellectuals. In Hungary, things were moving even faster. In June of that year I was in Budapest and had an interview with Ernö Gerö, who was then second to Mátyás Rákosi. It was one of the strangest interviews I've ever had. I asked a question, the

*As the books and records burned out front,
with people throwing ever more books on the pile,
the man continued to stand there reciting Petöfi.*

translator translated, Gerö answered, but while the translator was translating, he simultaneously raised one of his eyebrows, signaling to me that Gerö's responses had absolutely nothing to do with the truth. After this totally uninteresting interview, I said to the translator, 'You don't have a tic, so you must have been trying to say something with this eyebrow stuff?' He answered, 'Yes, and moreover you probably want to see Imre Nagy? Journalists are not allowed but if you want to take photos I can accompany you.' The translator was a young university professor called András Hegedüs — exactly the same name as the future Communist Prime Minister. Because he didn't want there to be any confusion, he added a middle initial 'B': András B. Hegedüs. A few days later, he picked me up at my hotel and drove me to see Nagy who was still, at that time, in voluntary exile. We had an hour-long, very interesting conversation about art, photography, landscapes and Paris. Not even one word about Communism, agrarian policy or politics. It was the first and last time I saw Nagy.

There was an event at that time which made it very obvious to me that something in the East had to give. It was the famous evening of 27 June 1956 at the Petöfi Circle, where András B. had taken me. The Petöfi Circle was nothing more than an ad hoc gathering of liberal Communists recruited by word of mouth. That evening there was supposed to be a discussion about the government's press and information policy, a perfectly inoffensive subject. The editor-in-chief of *Szabad Nép* (Free People), the Party newspaper, sat at the podium, and it was soon evident that the room could not hold all the people. A loudspeaker had been set up that could carry the discussion into the courtyard where hundreds were already waiting. I had just arrived with my camera, the lone photographer, when from the crowd loud voices shouted, 'No photos, no photographers'. Then Hegedüs stood up on the rostrum and said, 'We want to talk about freedom, what a free press stands for, and you don't want any photographers to bear witness — shame on you!' They quietened down, and I began to shoot.

Suddenly I noticed a very important person in the audience: it was the great philosopher of liberal Communism, György Lukács. I took his photo, together with the leader of the Social Democrats, Árpád Szakasits, who had recently been released from prison.

Then I returned to Poland where, after Nikita Khrushchev's visit to Warsaw, Wladyslaw Gomulka once again became the leader of the Polish Workers' Party and most people believed in the approaching liberalisation.

On 24 October 1956, I heard on the radio that a demonstration was going to take place at the memorial of the Polish general Bem, who in 1848 had helped the Hungarians confronted with the Habsburg monarchy. On the following morning, I heard that things had gone badly during the demonstration, so I took the next plane to Vienna, where I met up with a colleague and drove to Györ. The border was wide open, and we were able to drive into Hungary. We spent the night in Györ, where the revolutionary council was meeting at City Hall and soldiers ripped Lenin's portrait off the conference room wall. Early the next day, we headed in the direction of Budapest, and suddenly there were many cars following us. About forty kilometers from Budapest, in Tatabánya, there was a roadblock controlled by Soviet soldiers. A Soviet major who spoke German came out and said: 'It's too dangerous, we don't know what's happening in Budapest.

You can't go any farther.' I went into his office and asked if I could phone Budapest. I got Péter Várkonyi and said, 'I'm sitting here, and behind me there are forty cars full of journalists. We can't continue to Budapest, can you do something?' He wasn't sure but promised to try. After about twenty minutes, the same Soviet major reappeared, had the barrier lifted and wished us a good trip and good luck. So we all went to Budapest. The first shots had already been fired; we drove to the Duna hotel, parked the car and the porter said: 'Mr Lessing, there's fire in Váci Street!' We rushed over there, and in front of the Soviet bookstore there were piles of books being set alight, bringing back memories of Nazi times. But then Hungarian reality set in, because there was a man standing in the shattered store window reciting Petöfi's *National Song*. As the books and records burned out front, with people throwing ever more books onto the pile, the man continued to stand there reciting Petöfi.

We were sort of clueless about where to go next. Since it was mostly spontaneous, we headed towards places in Budapest where people were likely to gather. We reached the huge demonstration at the end of Váci Street, and suddenly there was a tank in front of me shooting at random. I got out of the firing line by driving the wrong way down a one-way street. In the meantime, the revolt had taken over. I found a Hungarian colleague, who said, 'Go over to Party headquarters and take a look, they're taking down the giant emblem of the Communist Hungary.'

I said to myself, if that's all they have to do, things can't be going so well! A rumour started that Imre Nagy was back, Kádár had disappeared, Rákosi hadn't been seen for awhile, nor had Gerö, but Andropov and Mikoyan had just arrived — a lot was going on in the Budapest Communist Party headquarters.

We arrived at the moment of a terrible shoot-out in which the loyal AVO people (in fact the AVH or secret police) who had just surrendered were shot down by a machine-gun. This was photographed by John Sadovy, who later remarked, 'I was able to hang on to my life by hiding behind the view-finder of my camera.' And he gave up photojournalism afterwards. The young Jean-Pierre Pedrazzini from *Paris Match* fastened his camera to a machine-gun mount, with a large, conspicuous telephoto lens. He received an abdominal gunshot wound, was taken to the hospital and then flown back to Paris, where he died a few days later.

And then there was this very bizarre time of street fighting during a civil war, with people quietly doing their shopping, stepping around the chalk-covered corpses of fallen Russian soldiers, while someone else charged their rifle or shot into the air and onlookers contemplated the spectacle of war. A few AVO corpses were lying around in front of the Budapest Communist Party headquarters, and some people placed Rákosi's photo under their heads, while others watched, shrugged their shoulders or went on their way. A few AVO people that someone found alive were lynched and hung upside down. Many years later, in 1996, I had an exhibit about the revolution in Budapest, and the curator at the Hungarian National Museum, Emil Horn, who had himself been imprisoned for seven years, begged me not to use those lynching photos. 'We don't want this to be the image of our revolution.'

The Hungarians picked up their own dead in trucks draped with black flags. They left the Soviet soldiers lying there covered in chalk, a precaution in case of an epidemic.

A painter drove around the city on a bicycle — a painter with his paint boxes — and whenever he found an enemy tank or a heavy gun he painted over the communist symbol with that of the 1848 revolution. With shooting on the left, shooting on the right, the artist painted his symbol.

Where the weapons came from was quite unclear, just like the emergence of this famous one-legged revolutionary. Today, a memorial stands in the place where he was shot. Neither was it clear where the orders were coming from; there was a leftist revolt, but also a right-wing one, whose headquarters were on the square opposite Corvin Cinema, led by Gergely Pongrátz. In less than a week, political life had totally changed: new groups were formed, and after Cardinal Mindszenty's liberation, a new Catholic party emerged, greeted by an enthusiastic crowd.

And then there was this bizarre time of street fighting during a civil war: where people quietly did their shopping, stepping around corpses covered with chalk.

The Austrian Socialist, Peter Strasser, arrived with a printing-press from Vienna, since the Hungarian Social Democratic Party didn't yet have one.

It was a situation that had never happened before and would probably never occur again. But it can, I think, be described as the beginning of the end of Soviet domination, even if it took another thirty years. Unlike Poznan, which no longer had any real influence, or Prague '68, which was a short-lived, almost insignificant interlude because the population was not deeply affected, Budapest was, and still is, the symbol of a national uprising.

There were smaller battles in the city between the Soviet tanks and the Hungarian tanks. Some of the Hungarians had changed camp and took part in the battle, even using captured Soviet tanks. Most of these tank battles took place in the centre of the city, Üllöi Street, the wide boulevards, near the Kilián barracks where General Maléter held out until the end. One of the revolutionary tanks blocked the door to the Kilián barracks so that nobody could get through. General Maléter, who negotiated with the Soviets under the Nagy regime, was arrested during the negotiations and hanged along with Imre Nagy. There were hordes of young people around the Hungarian tanks; young boys climbed up and chatted with the soldiers. It was hard to tell in the beginning which part of the Hungarian army really deserted, or whether they simply took off the Communist Party cockade. One could usually recognize the tanks by their flags, because during the revolution the hammer and sickle had been cut out. Another week passed, and the wildest rumours began to circulate: the Russians are leaving; the Russians are going to leave. Nagy formed a new government, there was shooting, then silence again, stores were looted or set on fire. Suddenly new newspapers appeared, *Népszabadság* (Freedom of the People), *Függetlenség* (Independence), while the Party organ *Szabad Nép* (Free People) disappeared. And I discovered what it means when people finally demand 'real' facts instead of propaganda: out

of the press-building windows the printers tossed the first issues of *Függetlenség*. The crowd stood below, catching the pages as they fell, such was their thirst for the truth!

The really extraordinary thing about being in a city in the throes of revolution was that at lunchtime one could be in the middle of a shoot-out, then dart back to the hotel to see if there was anything to eat. Indeed, the dining-room was packed, and the waiters wore their usual dinner-jackets. As I was being seated, one of them said, 'Mr Lessing, our goulash is quite delicious today!' I ate my goulash with gusto, then got into my car and drove back to the revolution.

Nagy decided to pull out of the Warsaw Pact, which for some of us was indeed a bad sign. Moreover, we heard that something was brewing at the Suez Canal. Then we got news from Munich that the American soldiers stationed in Germany had been sent on leave. It became clear that the Americans, or those in the fledgling NATO, were not going to intervene in Hungary. It was a distinct signal to the Soviets – Yalta still holds, this is your territory, whatever you do there will be found out later – but we won't budge. Soldiers are on leave. There is no crisis.

And then the Russians pulled out but Andropov remained in Budapest, and rumour had it that Khrushchev and Mikoyan were there as well. We also heard that Yugoslavia was sending troops.

So I got in my car and drove to the Ukrainian border to watch the Russians retreat. I turned down an empty road, and suddenly, out of nowhere, there were Soviet tanks. They were not going east, but in my direction, towards Budapest. I doubled back, returned to the Duna Hotel and told my colleagues, 'Friends go home, it's going from bad to worse, the Russians are coming back!' Most of them thought I was nuts and stayed. I piled in two Hungarian friends, the border was open, and we sped off.

The Russians returned and the revolt was crushed. Imre Nagy found asylum in the Yugoslav embassy; some of my colleagues were there too. The Austrian ambassador Peinsipp drove to town with a huge red-white-red flag, handing out provisions. From November to the beginning of December, the border was mainly open, bringing a big flood of refugees into Austria who crossed over the famous Andau bridge.

Before Christmas, I drove to Budapest in a delivery van loaded with medicine and fruit. I photographed the ravaged city in the winter snow. Since most of the big stores had been plundered and burned to the ground, people had set up their tables amidst the ruins. They sold Christmas trees and candles in front of the Erzsébet bridge.

And then came the day of reckoning: a large gathering of writers, all those in the Petöfi Circle who had formerly quarrelled and remonstrated,

were back. The writer Tibor Déry gave an incendiary speech against the 'old new' Communist regime under János Kádár, and everything he predicted turned out to be true.

I had to get my films out of Hungary. In the meantime, my wife arrived with medicine from Geneva and Vienna. We found ourselves in a no-man's land near Hegyeshalom; I waited in the deep snow near the barrier, saw my wife standing at another barrier; she trudged 300 metres through the snow until she got to the Hungarian side, and we drove on to Budapest. At the Duna Hotel we were welcomed by a former chess champion who had been demoted to porter. He told us he had reserved the bridal suite, complete with machine-gun holes in the wall above the bed; and, in effect, above the big white fake Biedermeier bed the pockmarks of bullet holes were clearly visible. That was the atmosphere in Budapest shortly before and after Christmas.

A little later, I went back to Hungary, by which time they had started to clean things up. Traffic police regulated the traffic in front of the ruins as normal life took over again. It was the time of so-called Goulash Communism; it seemed as though the revolution had never happened. I revisited the Sztálinváros steelworks, which had already taken back its old name Dunapentele. There, too, they were winding up the accounts, just like in the communes and the collective farms. What would emerge under Kádár? Could we even begin to imagine what this new Communism without Gerö and Rákosi, and (we hoped) without the AVO, would look like? That hope turned out to be in vain because the secret police outlasted every regime.

Translated from German by Jeanette Demesteere

François Fejtö

Budapest 1956:
an anti-totalitarian revolution

For some it was a revolution, for others a counter-revolution; but for everybody it was a complete surprise, both compelling and elusive.

In order to understand the memorable events which took place in Hungary in October 1956, it is necessary to go back at least a dozen years to the moment when Hungary, like all of Eastern and then Central Europe, was liberated (some would say seized) by the Red Army. It was as a 'liberator' that the Soviet Union, at the time an ally of the Western powers, was allowed to take Hungary into its sphere of influence, along with Poland, Romania, Bulgaria and Czechoslovakia, and to retain its 'liberating army' on Hungarian soil for as long as it judged necessary. The Hungarian government, the first to be democratically elected in a long while, was asked to extend a warm and friendly welcome to the occupying army, not exactly an easy task.

It did not help that, in order to try to recover the areas which it had lost at the Treaty of Trianon in 1920 (two-thirds of its territory), Hungary had allowed herself to become an amenable ally of Nazi Germany for the whole of the Second World War. When German troops occupied the country in the early part of 1944, Hungary actively helped the Nazis in their pursuit of the 'final solution' by sending 450,000 Hungarian Jews, until then spared, to Auschwitz, and by inflicting heavy losses on the Soviet army. Under such circumstances, the Soviet Union, as both liberator and occupier, would not have found it easy to view Hungarians as anything other than enemies. Moreover, while it was supposed to be participating in the reconstruction of a devastated country, it was actually busy pillaging it in the name of war reparations. It is hardly surprising, therefore, that relations between the two countries were ambiguous.

The new occupier made use of several hundred Communist Party members back from exile in the USSR, and their resistance comrades, to bring the country under control. Their first objective was to start resupplying the towns. Taking advantage of the flight of the aristocracy, who under Admiral Horthy's government had owned nearly half the nation's arable land, the Communists launched an agrarian reform programme which would change the country profoundly. Entrusted to Professor Imre Nagy, the only Hungarian agricultural specialist among the exiles in Moscow, this reform could be said to be one of the more positive political actions of the new regime. Markets overflowed with

For some it was a revolution, for others a counter-revolution, but for everybody, it was a complete surprise, both compelling and elusive.

fruit and vegetables, numerous cafes opened and restaurants stopped bothering to ask their customers for their ration tickets. All of which nurtured the illusion, shared by certain Communists, that Hungary was being rebuilt in the 'Finland way'.

However, by the autumn of 1947, relations between Moscow and its former Western allies had deteriorated. The Cold War was underway and the Soviet bloc hardened. In 1948, Yugoslavia quit the Soviet bloc and Marshall Tito became an enemy, the 'chained-up dog of the American imperialists'. Deprived of the democratic rights it had gained in 1945, in particular the right to opposition, Hungary became a mere satellite state of the Soviet Union, and a period of police terror began, headed by

another former exile back from Russia, Mátyás Rákosi. The Rákosi reign of terror may have been relatively short-lived, but it was ferocious in the extreme, with internment camps, the forced expulsion of the bourgeoisie to controlled areas in the countryside, the severe purging of Tito's so-called sympathizers (including the trial of László Rajk, the Minister of the Interior, ordered by Stalin in 1949), the Russification of education and culture, the forced collectivization of agriculture and disproportionate over-industrialization in favour of heavy industry, especially the armaments industry. This mass terror, the domination of the Soviet model and the cult of Stalin all added to the Hungarians' lasting hatred of Communism and explain the violence of the 1956 Hungarian uprising.

In the space of just a few years, the standard of living of the entire population, both in the towns and in the countryside, dropped considerably. As early as 1953, the country was on the point of exploding. Stalin's death went some way to defusing the Hungarian 'time-bomb'. Rákosi was replaced as head of government by the highly popular Imre Nagy, who restored some semblance of legitimacy, in particular by putting an end to the internment camps. He also improved the balance between heavy and light industry, abandoned the collectivization of agriculture and encouraged intellectuals to speak out about the true state of the nation. The Stalinists, however, still a majority within the Kremlin, took care to retain Rákosi as leader of the Hungarian Communist Party. In March 1955, Rákosi managed to oust Nagy, accusing him of 'revisionism', the pejorative euphemism for Democratic Socialism.

In 1956, a year after his reconciliation with Tito, Nikita Khrushchev, the Soviet Communist Party Secretary, shifted the balance of power by denouncing Stalin's crimes at the Twentieth Party Congress and by ordering the rehabilitation of the Communist victims of the show trials of the period of terror, notably that of László Rajk in Hungary.

Rajk's funeral, on 6 October 1956, attracted vast crowds. In dignified silence, over 300,000 people paid a collective final homage to all the innocent victims of the Rákosi reign of terror and decisively condemned those Communist leaders who, like Rákosi himself, continued, despite their crimes, to occupy strategic positions. In the middle of this mass of people was Imre Nagy.

For numerous writers, 1955 and 1956 were years of questioning and deep moral crisis. Until then, they had been producing edifying literature idealizing the government's actions and the Party leadership, but some of them began to meet to speak out against this political appropriation of literary and artistic output. The circulation of *Irodalmi Újság*, the review of the Writers' Union, increased tenfold. The Petöfi Circle which, since 1955, had been the forum for numerous intellectuals to debate philosophical, scientific and literary issues, extended its repertoire to include public life and political events. The meetings on censorship, on the rehabilitation of the victims of the Rákosi reign of terror or on the freedom of the press, attracted thousands of people from June 1956 onwards. In September, the Writers' Congress expelled all

the Stalinists from its leadership. The students, even though mainly of peasant or working-class origin, followed this protest movement and began to mobilize, both in Budapest and in the provinces.

The impetus came from Poland where Wladyslaw Gomulka successfully rallied the majority of the Communist Party members to his movement for democracy, a victory greeted in Hungary with great outbursts of joy and enthusiasm.

All of Budapest prepared to express its solidarity with Poland on 23 October 1956. The authorities hesitated about allowing such a large demonstration, fearing it would get out of hand, but in the end they gave their permission. The crowd gathered in front of the statue of the Polish general József Bem.

The students, who were the main driving force behind the movement, had summarized the nation's aspirations in a sixteen-point manifesto which included the withdrawal of Soviet troops, the re-establishment of opposition parties, the guarantee of a minimum wage, the return of Imre Nagy as the head of government, and student and worker solidarity with Poles. The crowd greeted the reading of the manifesto with wild enthusiasm.

Imre Nagy then improvized a speech. At the first mention of the word 'comrades', he was hissed and booed. Workers from the industrial suburbs joined the procession which was slowly heading towards the national museum. The building, at the heart of the city, was an important symbol: from the top of its steps, on 15 March 1848, Sándor Petöfi had recited his famous poem, signal for the patriotic revolution to begin:

Talpra Magyar! Stand up Magyars,
the nation calls you to choose
between liberty and slavery.

The demonstrators requested that their claims be broadcast on national radio, but their request was turned down. The scheduled programme about the Party Secretary, Ernö Gerö, just back from Belgrade where he had signed a statement of friendship and cooperation with Marshall Tito, was retained.

From 3 pm to 8 pm, precious time was lost in unproductive talks between the students and representatives from the radio station. The ever-larger number of demonstrators began to grow impatient, their chanting becoming outrightly hostile towards the police and the Party Secretary.

At 8 pm, Ernö Gerö appeared; his speech sounded like a deliberate provocation. Far from announcing the return to power of Nagy and the acceleration of the country's process of democratization, in a strikingly offhand way he ruled against 'counter-revolutionaries and Fascists' who had infiltrated the demonstration and warned the crowd against such agents provocateurs. He continued by singing the praises of Russia, of its generosity and friendliness, and called for a meeting of the Central Committee eight days hence, on 31 October. The disparity between this and the expectations of the crowds in the street was such that Gerö only narrowly avoided being lynched by the demonstrators as he left the radio station. An emergency meeting at Party headquarters was immediately organized.

Gun shots were fired. The police shots were blanks, but the damage was done. Despite Imre Nagy's arrival, despite the fact that he grabbed a loud-hailer and promised the people that their main demands would be met, despite the fact that he was officially nominated as Prime Minister, it was too late. Rioting broke out. The crowd overthrew the statue of Stalin and occupied the headquarters of the official newspapers. The offices of the Party were besieged. Hundreds of Russian books were burnt in the streets. Shooting went on late into the night in the vicinity of the national radio station. And by morning 350 were dead and thousands wounded.

The Party leaders panicked. The police appeared to be incapable of controlling the nascent insurrection. Gerö called on the Soviet garrison for help, a call long attributed to Imre Nagy, despite his denial and numerous witness statements to the contrary. The appearance of Soviet tanks in the middle of the night only served to stoke the anger of the demonstrators who, meanwhile, had managed to procure weapons and ammunition.

The next day, 25 October, saw Budapest sink into bloody chaos: Soviet tanks firing, demonstrators replying with Molotov cocktails, police shooting into the crowd, people falling everywhere, the dead being removed, the wounded transported to overstrained hospitals. At the end of the day, the resignation of Ernö Gerö was announced and János Kádár was nominated as leader of the Party. Once again, it was too late. The following day, in Parliament square, men, almost certainly members of the AVO, the secret police, supported by Soviet soldiers, machine-gunned the crowd from the rooftops. For an hour, the fusillade was so intense that it was impossible to reach

the wounded. Nearly a hundred people died. The unrest spread like wildfire throughout the entire country. Revolutionary committees sprung up in provincial towns and villages as well as in the capital and its suburbs. Large factories were taken over by workers' councils based on the Yugoslavian model of self-management. There seemed to be nation-wide unanimity concerning three basic demands: a revival of democracy, the running of state enterprises by workers' councils and the departure of the Soviets from the country.

On 25 October, Imre Nagy declared that he had relieved all Stalinists within the government of their posts and undertook to negotiate the withdrawal of Soviet troops. Without waiting for the armed confrontations to end, he attempted to form a new government, calling upon several independent figures such as the agrarian Béla Kovács, a member of the Hungarian Parliament deported by the Soviets in 1947. At the same time, he was negotiating with Anastase Mikoyan and Mikhail Suslov, representatives of the Central Committee's Praesidium (the new name of the Politburo since 1952), sent by the Kremlin to find a political solution to the crisis, if possible a 'Polish-style' solution. Exhausted by these negotiations, Imre

Nagy, who suffered from a weak heart, collapsed into his armchair. He was saved by Mikhail Suslov who gave him some medication which he happened to have on him in case of emergency.

For several days, Hungary was racked by total confusion. News and rumour abounded, much of it contradictory: a lasting cease-fire, the full-scale resumption of confrontations, the forthcoming intervention of American troops via Austria. Friends, enemies, advisors, members of improvised temporary governments, all deliberated within the parliament buildings. To obtain a lasting return to peace and order, wide-reaching concessions were going to be necessary.

On the morning of 28 October, the leadership, by then made up of both Party and government members, finally reached agreement on a certain number of measures aimed at satisfying the various armed factions of the uprising and at guaranteeing the process of democratisation. These included the reorganization of the army and the police force, the planned departure of Soviet troops, the indictment of Gerö and two other ministers who had taken flight, a decree about workers' councils, another about an amnesty.

The revolutionary action has triumphed, thanks to you, its heroes. The outcome of this victory underlies the democractic government which I have just founded.

Two days later, on 30 October, Yuri Andropov, the Soviet ambassador, handed an important statement to Imre Nagy which appeared to endorse the choice of a peaceful solution for resolving the Hungarian crisis, as well as to confirm the future withdrawal of Soviet troops: 'Having in mind that the further presence of Soviet military units in Hungary could serve as an excuse for further aggravation of the situation, the Soviet government has given its military command instructions to withdraw the Soviet military units from the city of Budapest as soon as this is considered necessary by the Hungarian government.'[1] This statement was warmly welcomed by the American and other Western press. The next day, Imre Nagy announced the re-establishment of a multi-party state and 'the return to a governmental system based on democratic cooperation between coalition parties, as had existed in 1945.' In an improvised speech aimed at the various delegations flooding into Parliament, he declared, deeply moved: 'The revolutionary action has triumphed, thanks to you, its heroes. The outcome of this victory underlies the democractic government which I have just founded. We will no longer tolerate any intervention in the internal affairs of our country. From now on, our relation with the Soviet Union is based on the principle of equality of rights, national sovereignty and non-intervention in our policies. Dear friends, we are living the early days of sovereignty and independence. We have banished the Rákosi-Gerö troops, together with their immeasurable crimes, which will be paid for in the eyes of the law. People have tried to sully my name, accusing me of

summoning Soviet troops onto Hungarian territory. This is totally untrue.' Shortly after this speech, he met with foreign journalists. Brimming with optimism, he stated that Hungary now had the opportunity to leave the Warsaw Pact and to become the hub of a neutral zone at the heart of Central Europe. He even went as far as to say that Hungary might recognize the German Federal Republic, a country until then boycotted by Communist states.

Within forty-eight hours, the entire country was overcome with euphoria. In Budapest, the guns were silent and the government was busy governing, supported by the workers' councils from the large factories who were preparing to go back to work. It was essential to lay the foundations of a Socialist democracy as quickly as possible.

Meanwhile, in Moscow, Khrushchev had spent a few days hesitating between 'the military path and occupation' or 'the peaceful path, with the withdrawal of troops and ensuing negotiations'.[2] By 31 October, Khrushchev chose the military path. All the members of the Praesidium strongly endorsed Khrushchev's view. Marshall Jukov was convinced that Imre Nagy was playing a double game, and Vyacheslav Molotov believed that a

counter-revolutionary transitional government had been formed in Hungary and that forceful intervention was therefore necessary, and without further delay. Khrushchev suggested they warn Gomulka and Tito. He met Gomulka in Brest-Litovsk in Poland and explained to him that: 'We have had to revise our view on withdrawing Soviet troops from Budapest and Hungary; if we evacuate Hungary, it will encourage the French, the British and the Americans. We have no other choice. We have conceded a lot, but there is no longer a government there with whom to negotiate.'

Accompanied by Georgi Malenkov, he also paid a secret visit to Tito, in Brioni in Croatia, to try to persuade him of the legitimacy of the Soviet intervention. At the beginning of the Hungarian uprising, Tito had not hidden his sympathy for Imre Nagy, but he allowed himself to be easily persuaded by Khrushchev, not least because he, like the Russians, feared a domino effect with other peoples' democracies. By this time, worrying news was reaching Imre Nagy, alerting him to the presence of new Soviet troops on Hungarian territory, information which was confirmed by frontier guards who said Soviet troops were massing in Záhony. The Soviet ambassador reassured

the Hungarian government, telling them that the soldiers were just there 'to repatriate the wounded from the previous days' confrontations'. Kádár decided to personally visit the Soviet ambassador to clarify the situation. No more was heard of him until 4 November.

He was seized at the door of the Soviet embassy by two Soviet agents in uniform and pushed into a diplomatic car where Ferenc Münnich, the sole Stalinist member left in Nagy's government, was awaiting him. They drove straight to the military airport where a Russian plane took them to Moscow. No sooner elected leader of a remodelled Communist party, than Imre Nagy's accomplice was removed.

At his first meeting with the Praesidium, Kádár stated that Rákosi and Gerö were responsible for the Hungarian uprising. He argued against its counter-revolutionary nature, saying: 'Initially, we did not see this, we classified it as a counter-revolution, and with this we turned [the people] against us – they didn't feel themselves to be counter-revolutionaries. I personally took part in one meeting, and no one wanted counter-revolution.'[3]
Münnich made a totally conflicting statement which accorded perfectly with the opinion of the majority of the Praesidium. He underlined just how serious the situation in Hungary was, saying that only military intervention would succeed in re-establishing order in the country.

On 3 November, the Praesidium met again, this time in the presence of both Kádár and Münnich. Partly because he was popular with Budapest's working class, as a result of himself being a victim of the Stalinist terror, and partly because he was first and foremost a party man, Kádár was chosen to succeed Imre Nagy at the head of the new puppet government. Kádár was back in the fold and convinced of the necessity for a massive intervention of Soviet troops. Somehow, overnight, Khrushchev had succeeded in bringing him round. There are no official records of all this, but, knowing the Soviet methods of persuasion, it is not difficult to imagine what happened. Kádár had allied himself with Imre Nagy. But it was now him or Nagy. He somehow managed to convince himself that, even though he would be betraying his friend, he would be a lesser evil for his country than a reversion to Rákosi's rule of terror.

The die was cast. All that remained was to persuade the West that the Soviet Union was acting out of legitimate defence. The best defence being attack,

The die was cast. All that remained was to persuade the West that the Soviet Union was acting out of legitimate defence. The best defence being attack, Moscow reproached the West for having encouraged the insurgents.

Moscow reproached the West for having encouraged the insurgents whose actions had imperilled the East-West balance. The Soviet delegate told the United Nations Security Council, in no uncertain terms, on the morning of 4 November, 'Hungarian workers had presented justified demands which were exploited by Western agents, notably Americans. It was in these conditions that Imre Nagy had formed his government, following the Fascist path in order to do away with popular rule. To assist him in this task, he called upon officers from Admiral Horthy's former government, who spread destruction, murder and brutality throughout the country in order to ensure the return of a Fascist and capitalist dictatorship.'

The Russians were once again in the land of myth, as in 1949 when Moscow, followed by all the international Communist press, stated that Yugoslavia was in the hands of Fascist assassins. However, unlike 1949, Stalin's successors, fully aware of the awkward position of the West, preoccupied and divided over the Suez crisis, decided to intervene militarily and destroy the Hungarian democracy, despite the

fact that it was unanimously supported by the Hungarian people. They acted with the full and cynical approval of all the leaders of the Communist satellite nations, as well as that of China.

The second Soviet intervention was prepared in minute detail and was radically more effective than the first. The sheer might of weaponry of the Soviet army was enough to discourage resistance.

At dawn on 4 November, at 4.25 am precisely, Soviet troops opened fire on some barracks to the south of Budapest. Shortly afterwards, cannon fire echoed throughout the city. The rebels put up barricades at all the major crossroads. Fighting took place in Üllöi Street, Marx Square, Kálvin Square, the Kilián barracks, in front of the Corvin Cinema, on the other side of the river, in Buda, on mount Gellért, in the southern train station. Imre Nagy gave the order to the leaders of the rebel groups to hold fire.

At 5.20 am he addressed the Hungarian people on national radio: 'This is Imre Nagy, President of the Council. This morning, at dawn, Soviet troops attacked the capital in order to overthrow the Hungarian democracy's legal government. Our troops are fighting. The government is still in its place. This is to alert the Hungarian people and the entire world.'

At 7.56 am, the Hungarian Writers' Union launched a radio appeal to the West: 'This is the Hungarian Writers' Union, speaking to writers throughout the world, to all scholarly and literary societies, to all academies and scientific societies, to intelligentsia the world over, we ask each and every one of you to help and support us. There is not a moment to lose. You know what is happening, it is pointless saying any more. Help Hungary! Save her writers, scholars, workers and peasants, save our intelligentsia! Help, help!'

Help was not forthcoming and by 8.25 am the Hungarian national radio station ceased broadcasting. Kádár, back in Budapest, announced that he was taking over as head of a workers' and peasants' revolutionary government.

The Kilián barracks resisted assaults and air raids for three days. Those besieged in the Citadel held out until 7 November. When they encountered intense resistance, the Soviets fired at houses randomly to terrorize the inhabitants and force them to

surrender. By 8 November, most of the city bore the scars of bitter fighting: hundreds of buildings in ruin, thousands of others badly damaged. Men, women, children, civilians and the military, the entire population of Budapest had resisted the Soviet intruders without success. On 10 November, there was no more gunfire in the capital. Only the intellectuals continued a rearguard action, many having managed to hide and form pockets of clandestine resistance.

According to an official Hungarian source, there were 2,740 registered deaths in Budapest between October and December 1956. Nearly half of those who died in combat were under thirty years old, and one death in six was a woman. To avoid arrest or deportation, 200,000 people fled to the West. 25,000 civilians were arrested by the Soviet police and set to work clearing the capital and its suburbs. They were subsequently deported to Russia. 35,000 Hungarian soldiers were disarmed. A number of writers, including Tibor Déry, were held in prison for many years, only finally being released thanks to relentless pressure by Western writers.
As for Imre Nagy, he was handed over to the Soviets, who kept him under house arrest in Romania until he was handed back to the Hungarian justice.

He was officially arrested on 14 April 1957 and was judged for high treason. Nagy defended himself with courage but without illusions, against accusations of felony, treason and connivance with the Fascists. Condemned to death on 15 June 1958, he was hanged the next day at dawn in the courtyard of Budapest's High Court, together with Miklós Gimes, publicist and former editor of the Party's official newspaper.

If nothing else, the rebels fighting for Hungary's freedom managed to shake up the West's conscience, showing them the true face of Soviet Communism. In order to crush a revolutionary movement whose aim was the spread of democracy, the Soviet Union, whilst priding itself on being a proletarian regime fighting for the liberation of the working class throughout the world, did not hesitate to fire on workers and destroy their factories.

Finally, the Hungarian revolution unveiled the fundamentally deceitful nature of the Communist system for all the world to see. The Kremlin attempted to justify the intervention of its tanks by insisting that it was defending democracy against Fascism, and Socialism against an attempt to restore capitalism in Hungary. It is clear, however, that none

of the claims by the youth and the workers' councils had anything to do with restoring the old regime; on the contrary, they wanted the workers' councils to take over the management of the factories.

Those peoples subdued by Soviet power have never ceased to proclaim their commitment to freedom and democracy, values dear to Western Europe which, nevertheless, has never forced the Soviet Union to pay a strong political price for its brutality. Budapest 1956 therefore poses an awkward question for Western governments, a question which Henry Kissinger formulated in the following way: 'would stronger Western diplomacy have been able to prevent, or at least lessen, the Hungarian tragedy?'

Translated from French by Philippa Richmond

1. Declaration by the Government of the USSR on the Principles of Development and Further Strenghtening of Friendship and Cooperation Between the Soviet Union and Other Socialist States 30 October 1956.

2. 'Working notes from the session of the CPSU CC Praesidium on October 30, 1956' in *Cold War International History Project Bulletin No. 8/9*, winter 1996–97.

3. 'Working notes from the CPSU CC Praesidium Session with the participation of János Kádár and Ferenc Münnich, 2 November 1956' in *Cold War International History Project Bulletin No. 8/9*, winter 1996–97.

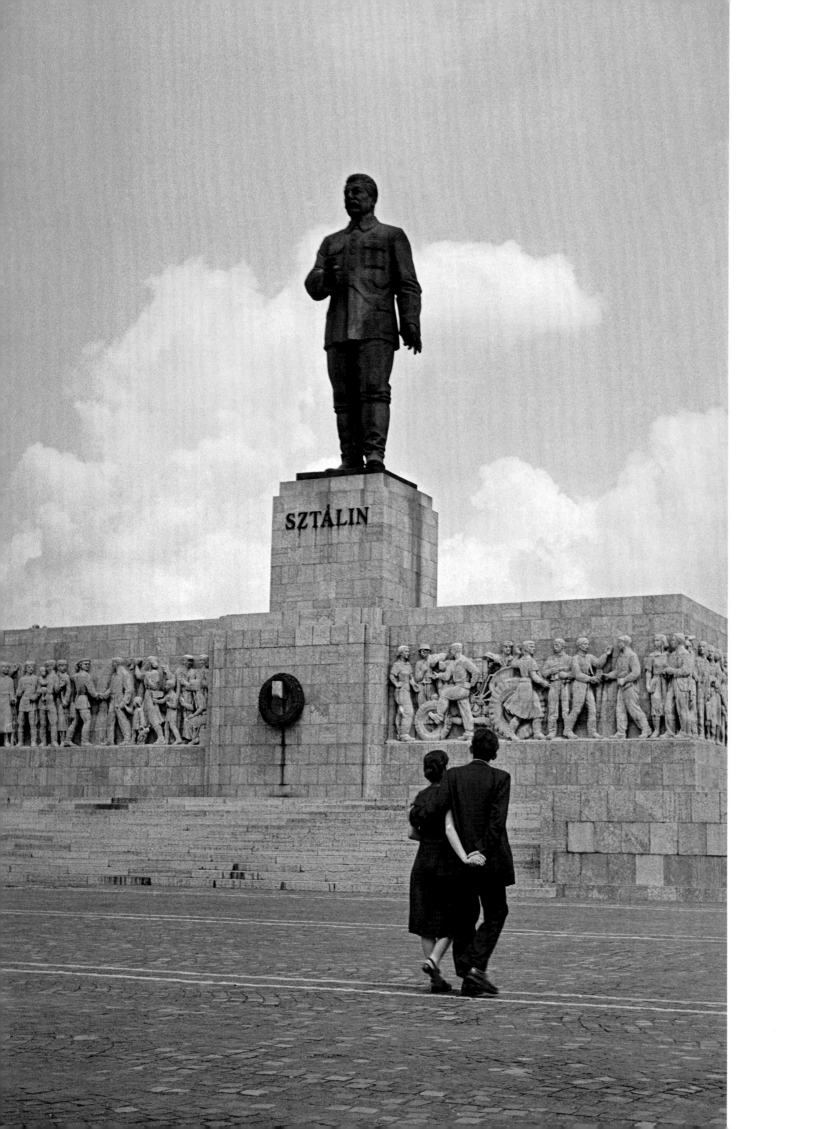

COMMUNIST HUNGARY

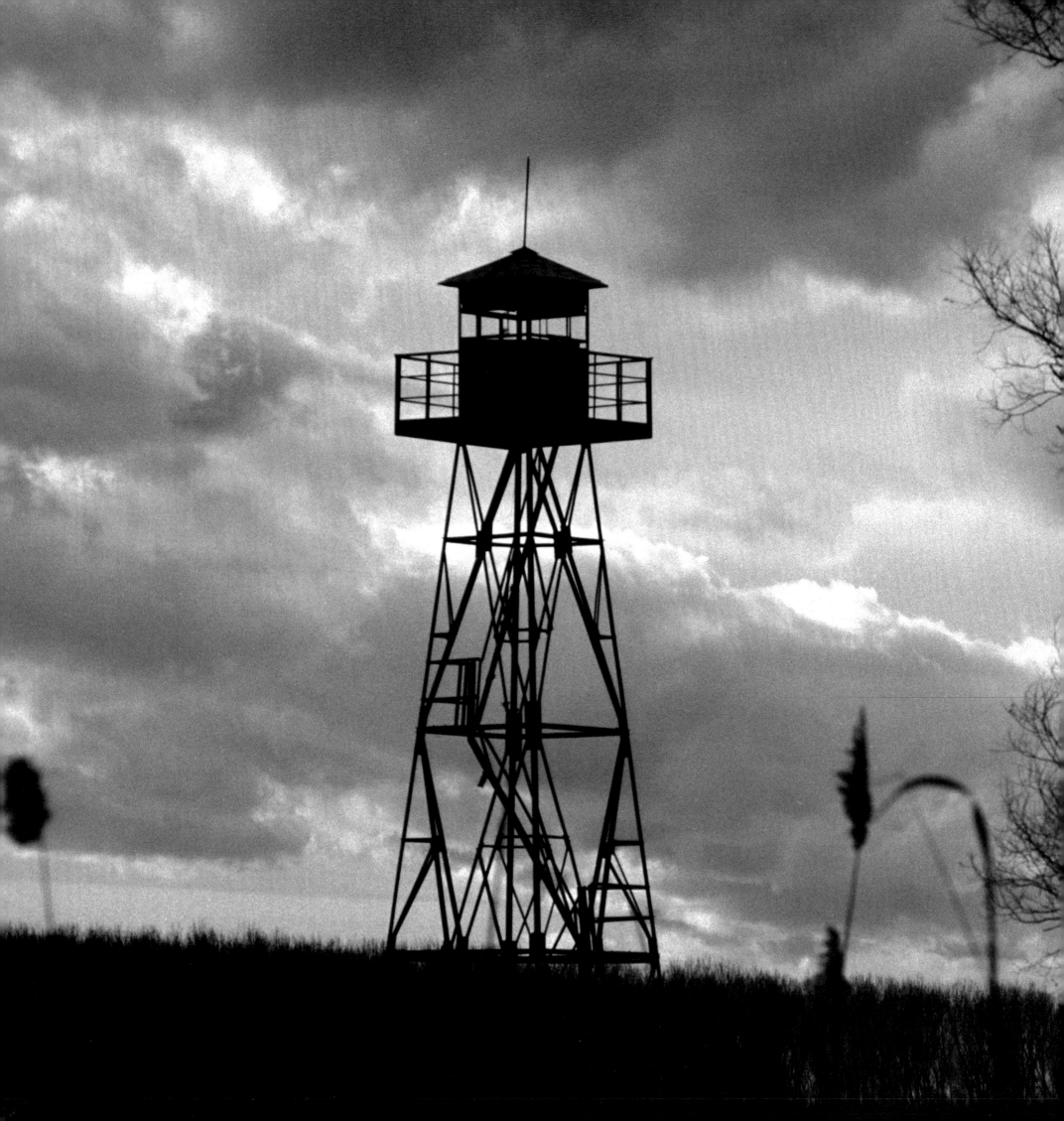

Previous page
A young couple strolling past the giant Stalin monument on Budapest's Felvonulási Square (Parade Square). The bronze statue was torn down from its base and destroyed on the first day of the revolution, 23 October 1956.

Between 4 November and 31 December 1956, 155,085 Hungarian refugees crossed into Austria. In memory of the mass exodus, the Hungarian authorities preserved two of the watch-towers which dotted the Iron Curtain near the Austrian village of Andau. 1998.

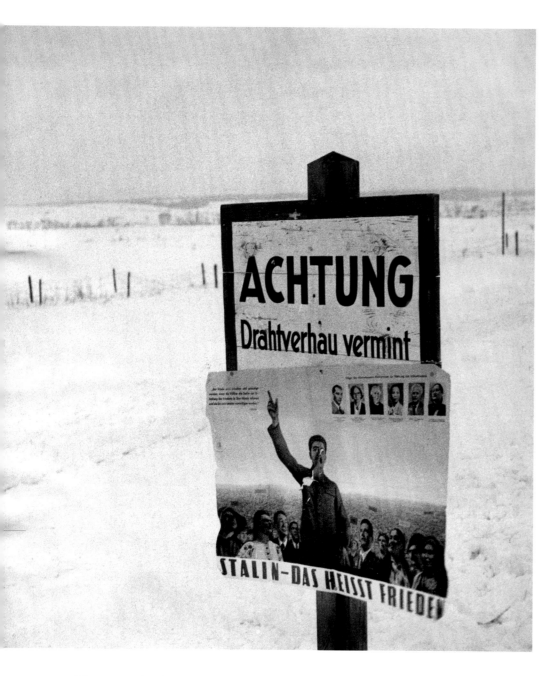

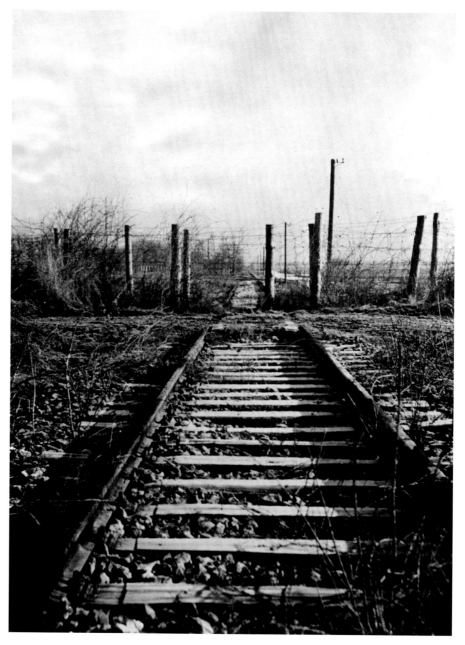

The sign at the Austro-Hungarian frontier warns: 'Attention – mines along barbed-wire fence.' Apparently ironically, residents on the Austrian side nailed a Communist poster under the warning sign which says: 'Stalin – his name means peace.' 1949.

A barbed-wire fence from the Iron Curtain cuts across a single-track railway line which connected Austria and Hungary. 1947.

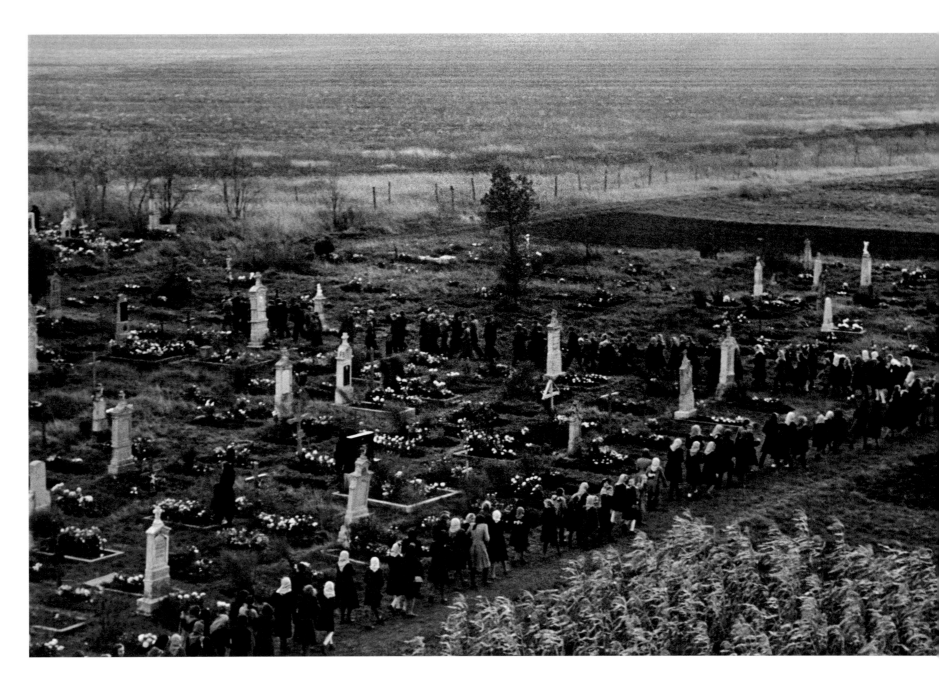

The people of Schattendorf visiting their dead
in a cemetery surrounded by minefields
on All Souls' Day in 1952. Until 1989 the Iron
Curtain between Austria and Hungary passed
through the village graveyard. 1952.

The mail coach arrives in
Karcag in the Puszta,
the vast Hungarian plain. 1956.

In the countryside

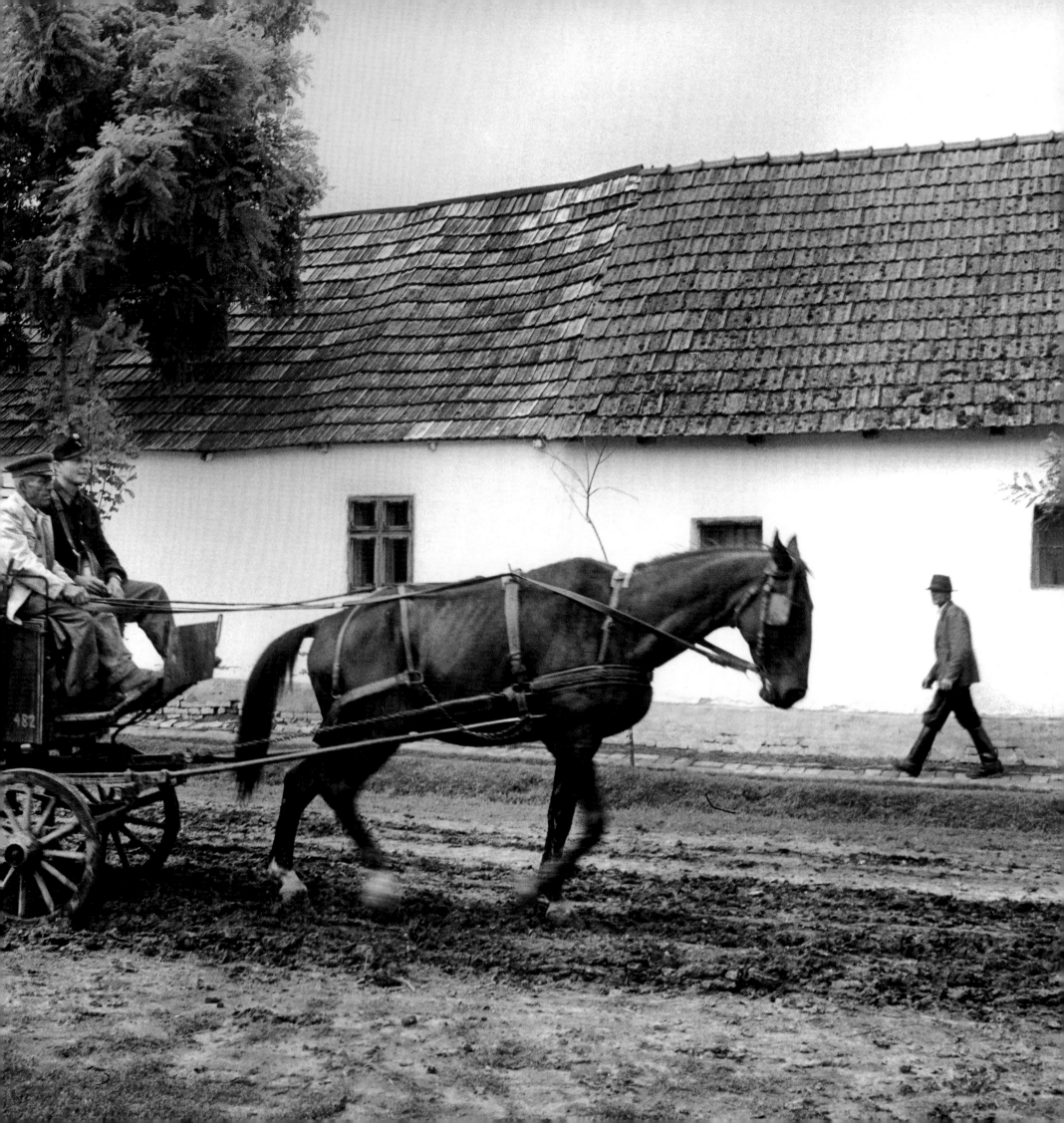

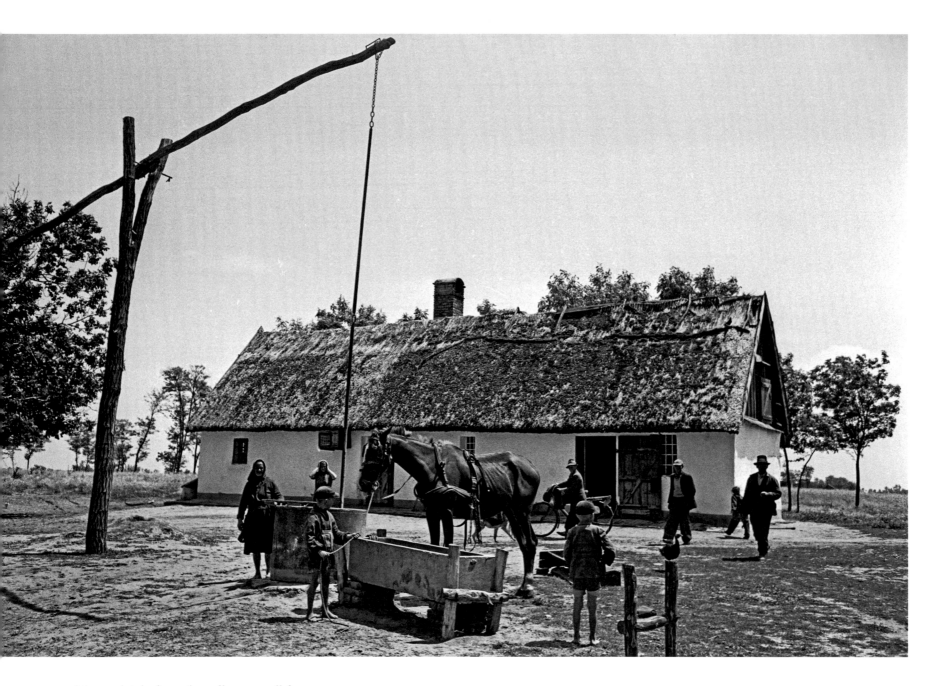

A horse drinks from the well on a small farm
in a Puszta village. 1956.

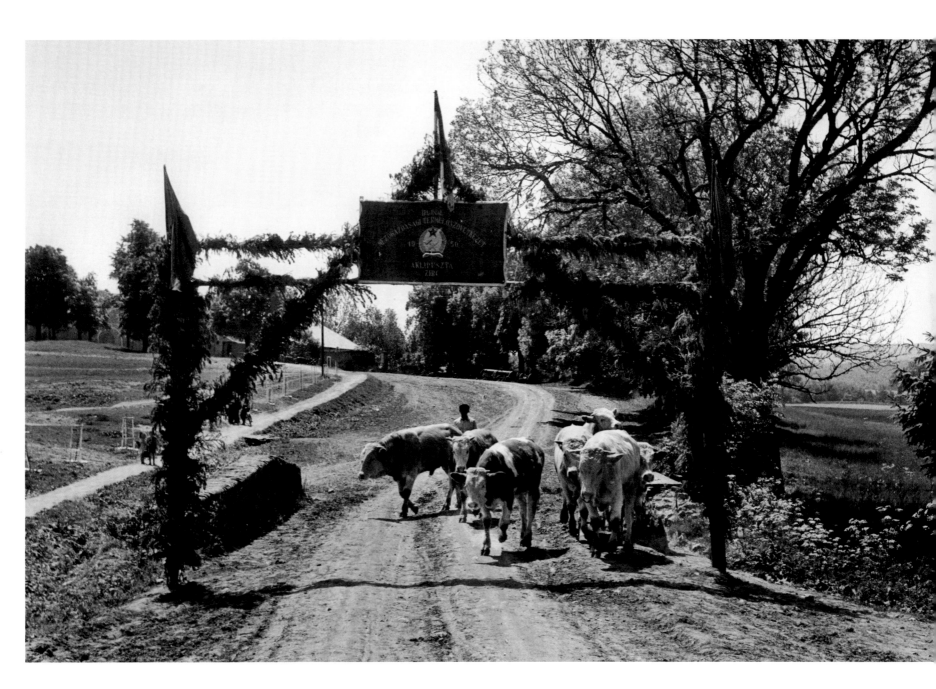

Under the decorated gate of the cooperative,
a herd of cows returns from pasture. 1956.

Members of a cooperative return home
from work in the fields. 1956.

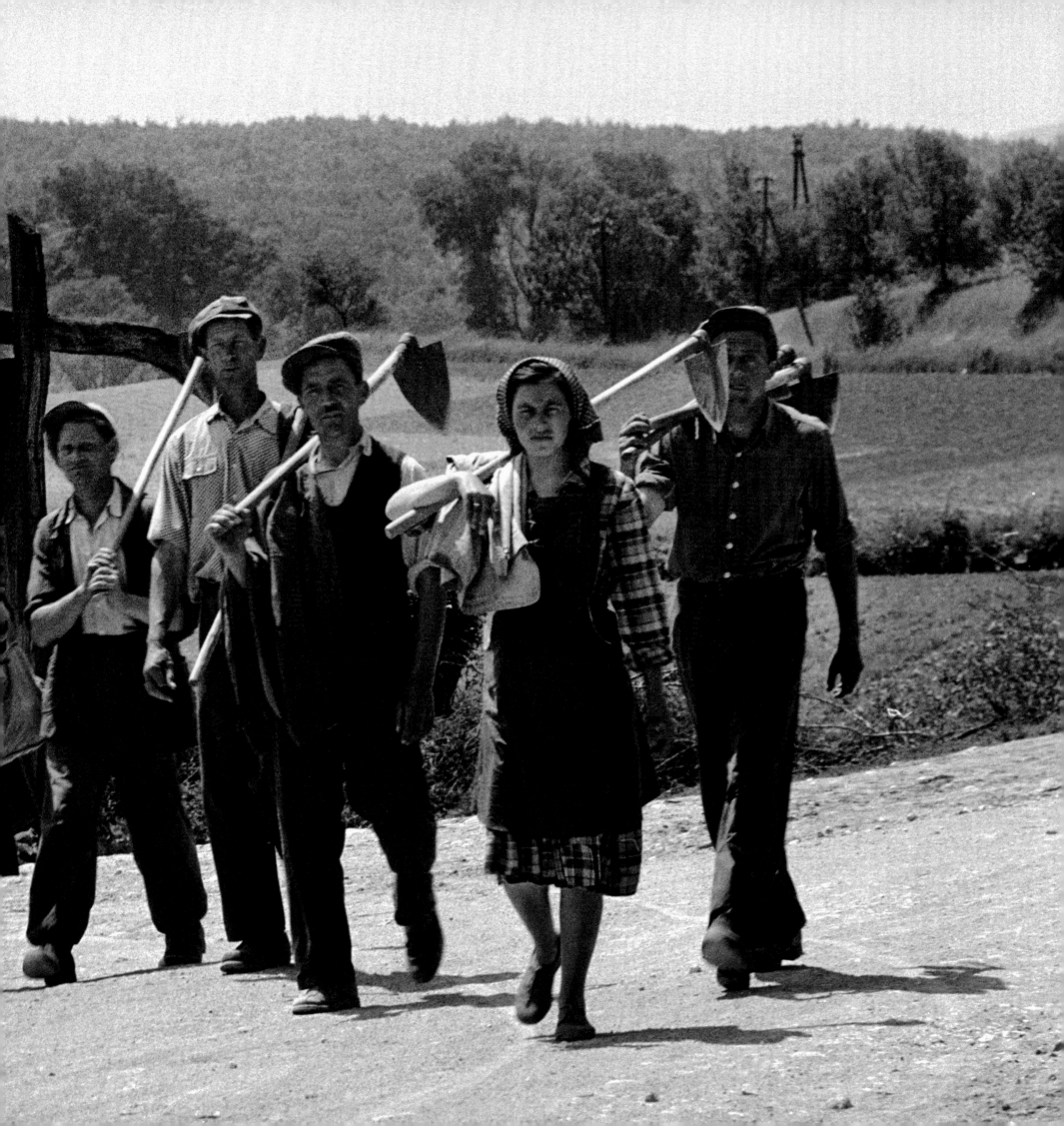

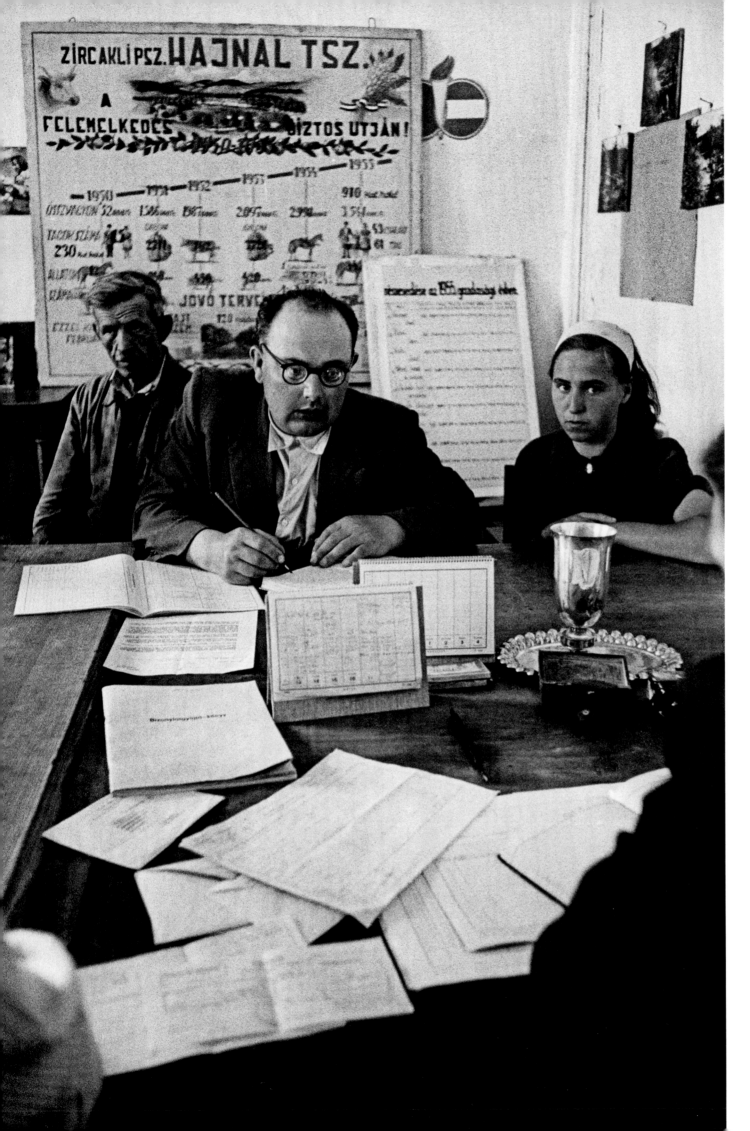

The office of the Production Cooperative
'Hajnal' (Dawn) in Zirc. In the background,
a poster with the cooperative's production
figures. 1956.

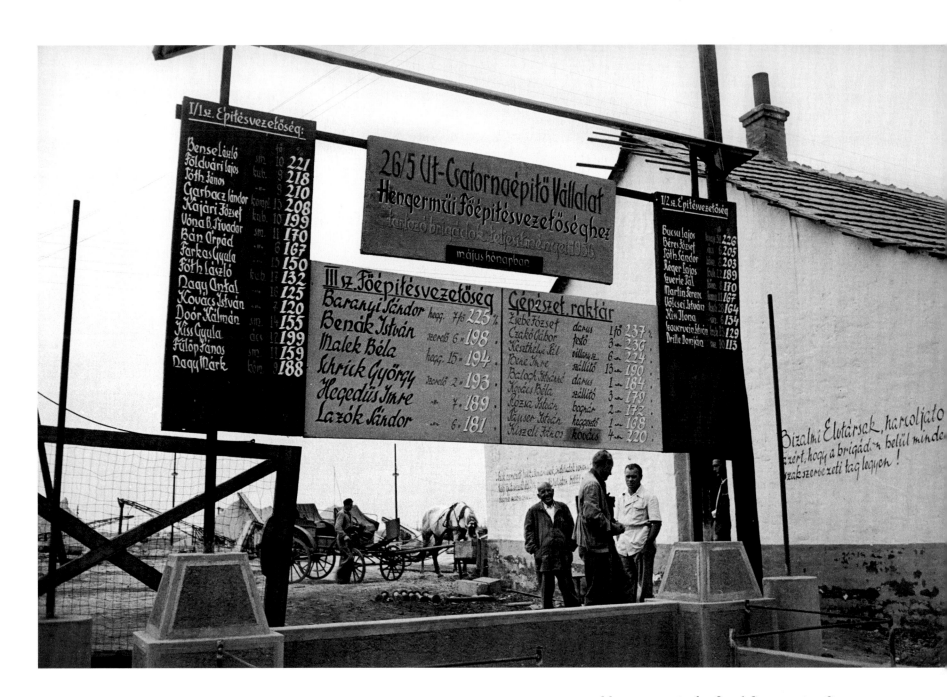

Management site for Canal Construction Company
No. 26/5. On the board are the rankings of workers
according to performance in the 'Socialist Brigades'.
On the wall to the right, the inscription reads:
'Comrades, fight for every member in your brigade to
join the Trade Union.'

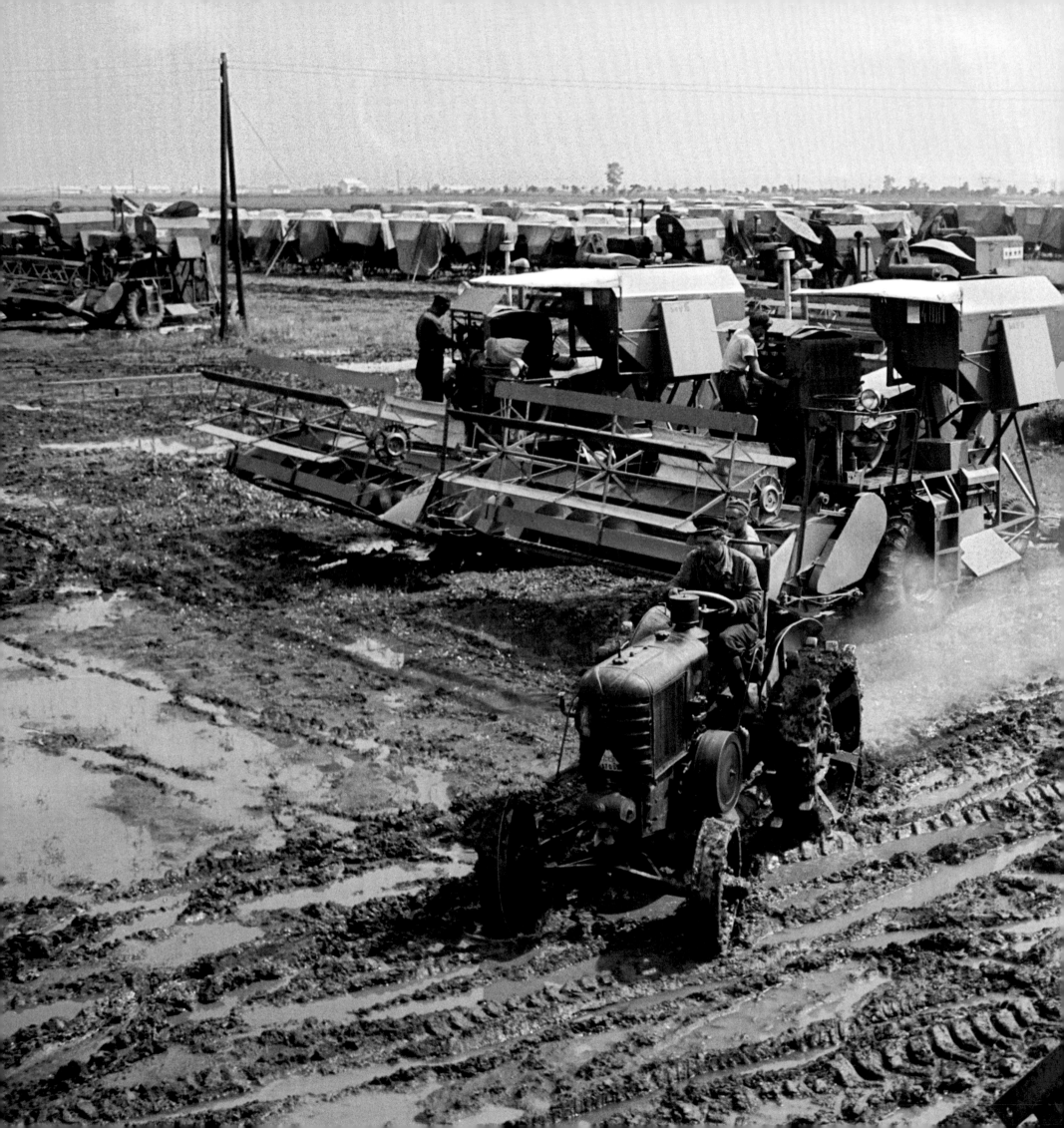

An agricultural tractor station (MTS). In the 1950s, the cooperatives did not have machinery of their own, but rented it from the state.

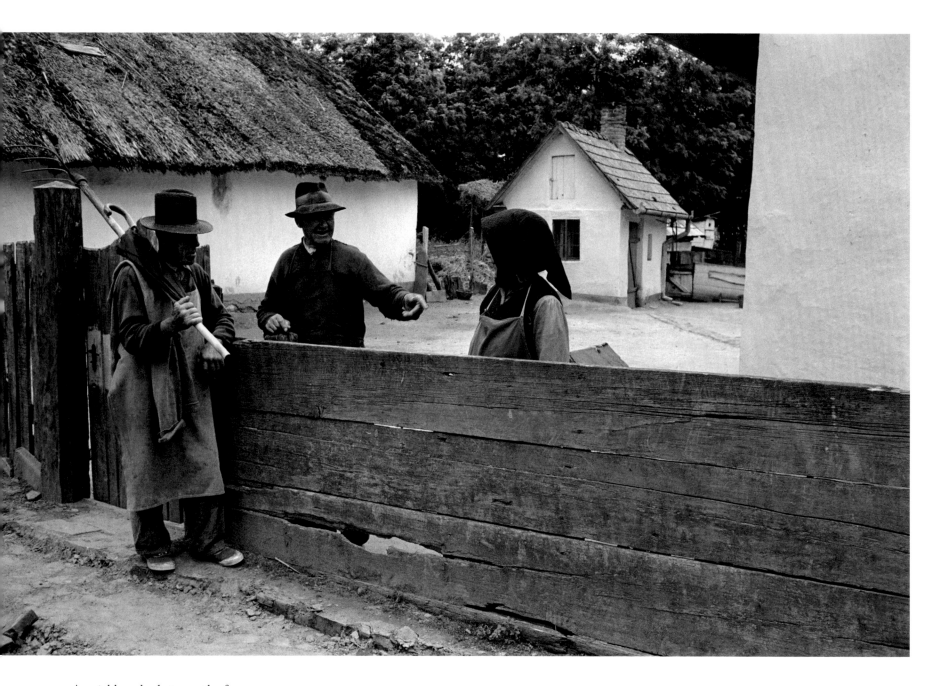

A neighbourly chat over the fence
in a Puszta village.

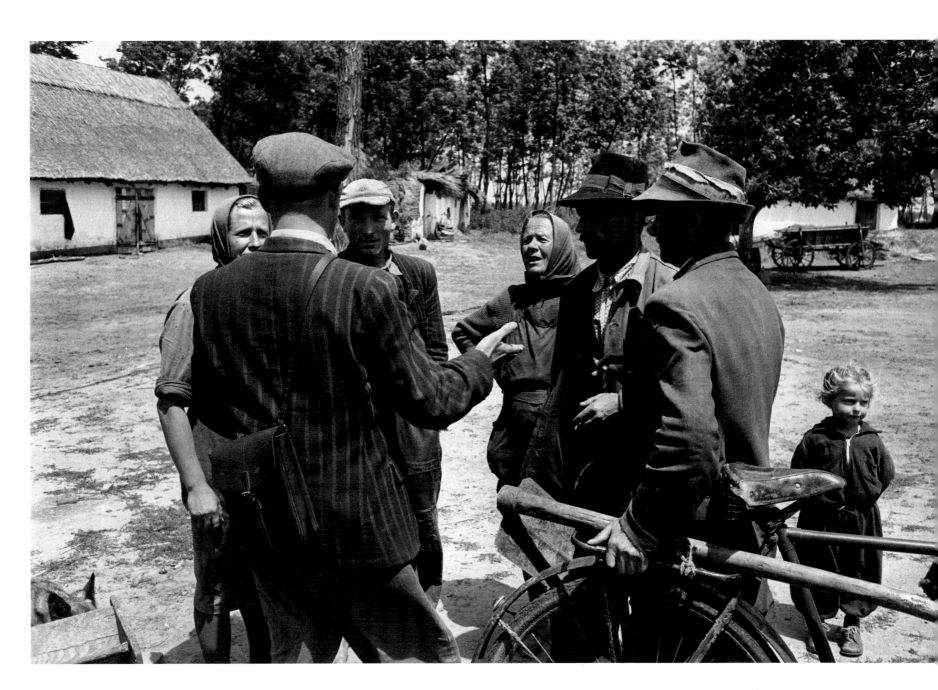

A discussion with the Communist Party
Secretary in a Puszta village.

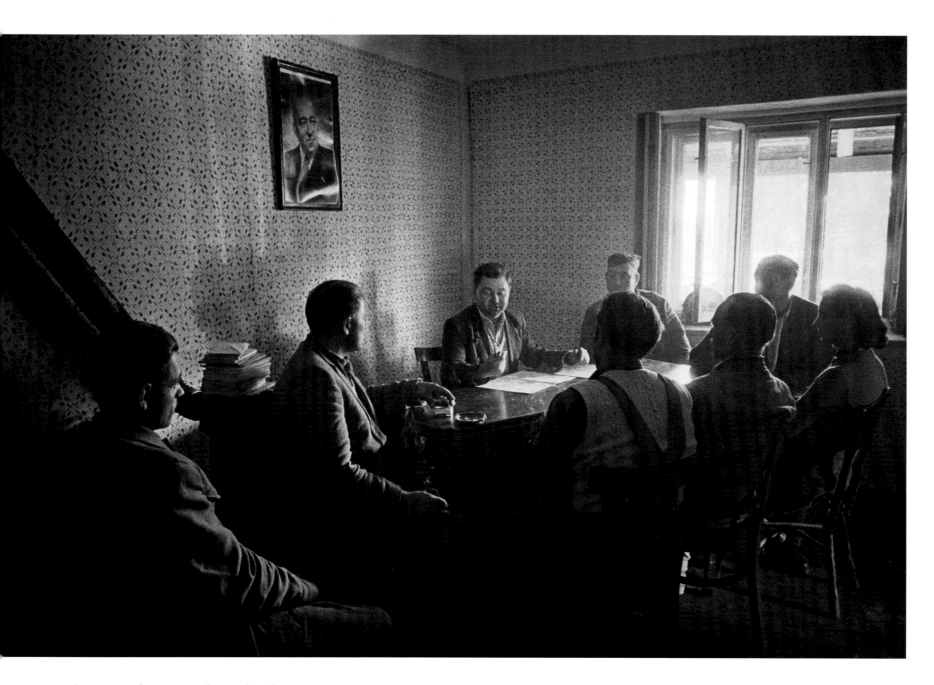

A meeting of a communal agricultural commission
under the chairmanship of the Secretary
of the Communist Party. On the wall a portrait
of First Secretary Mátyás Rákosi, later ousted,
and exiled to the Soviet Union in July 1956.

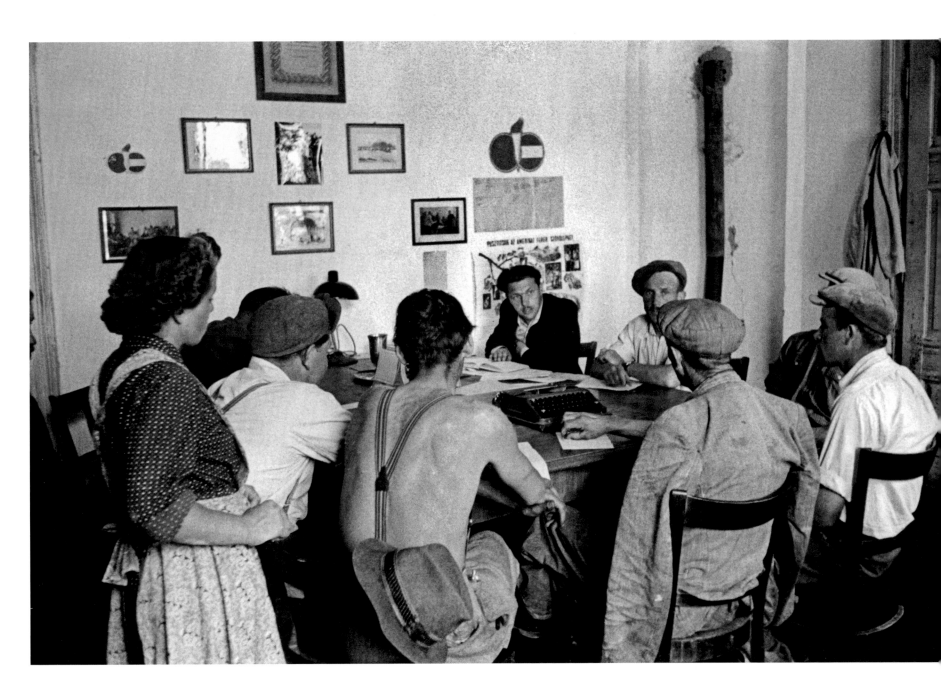

A board meeting of the agricultural cooperative
'Hajnal': during the meeting, work is divided
up between the various brigades, plans
for the harvest are made and accounts settled.

A couple selling onions on a Budapest street. In 1956, state-owned agricultural production cooperatives based on the Soviet model existed in Hungary, but the largest part of the land was small fields cultivated by private farmers for personal use and sale on the free market.

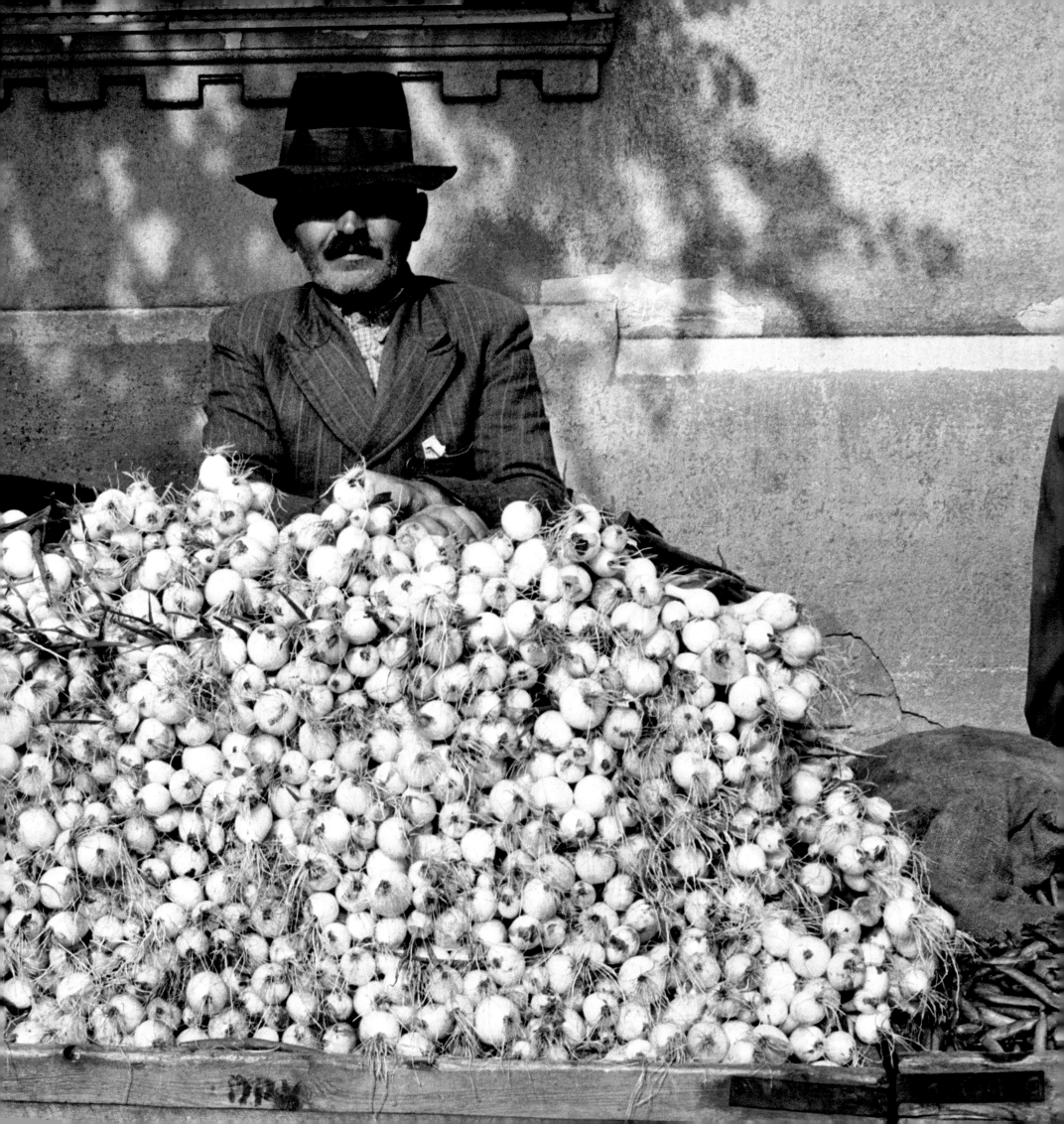

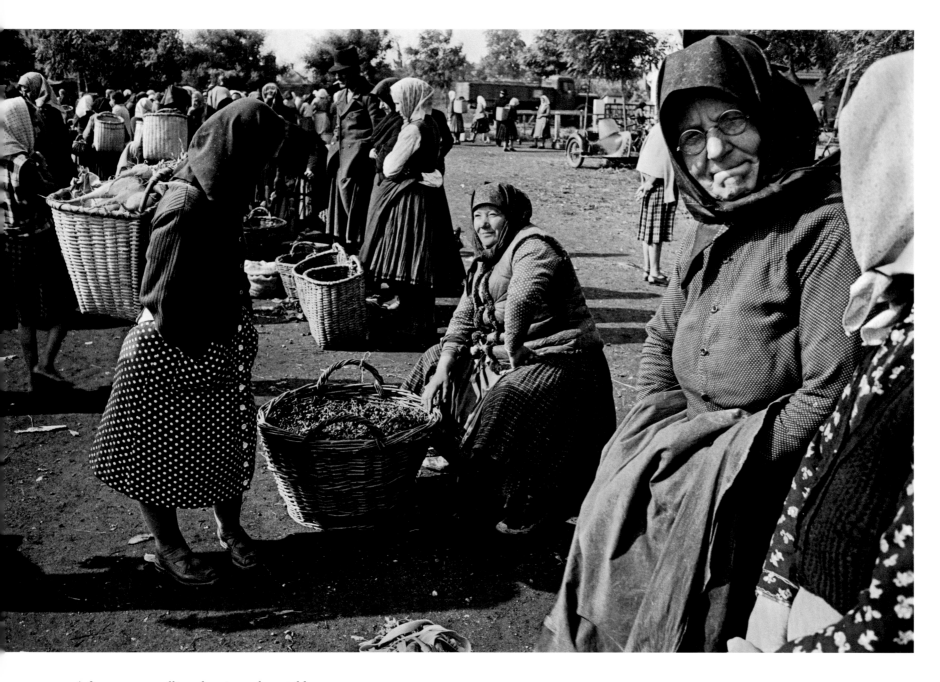

A farm women selling cherries and vegetables
from huge baskets.

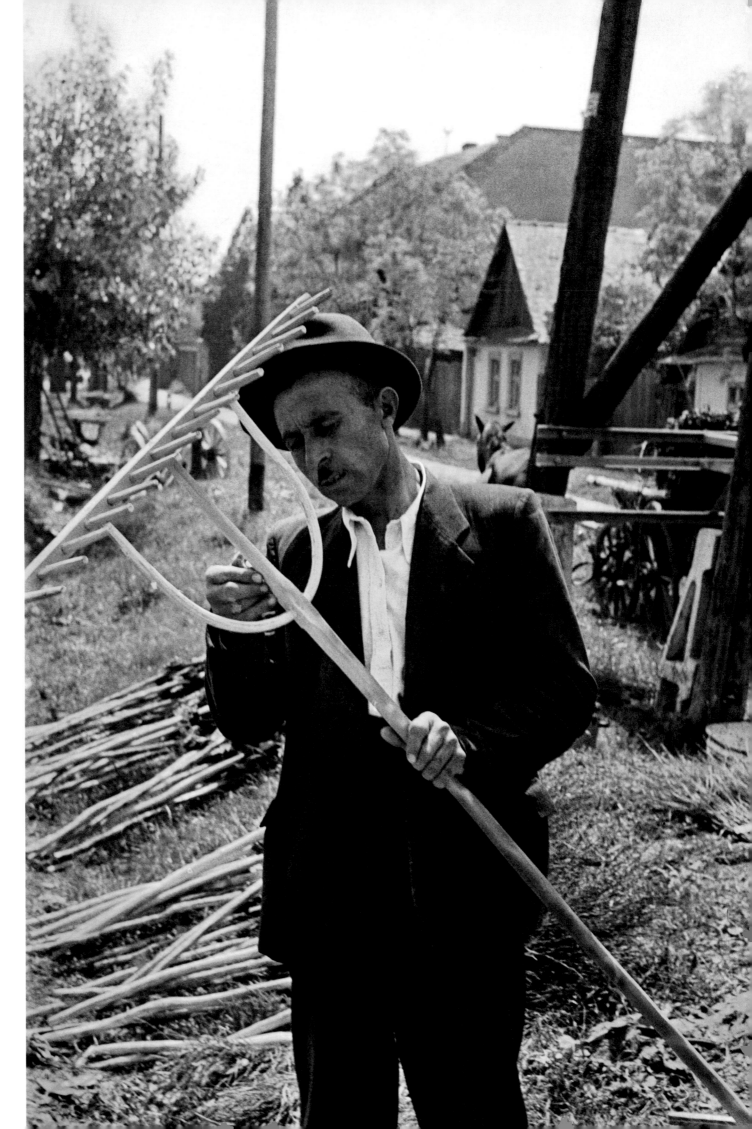

Trying out a hand-made rake
at the village market.

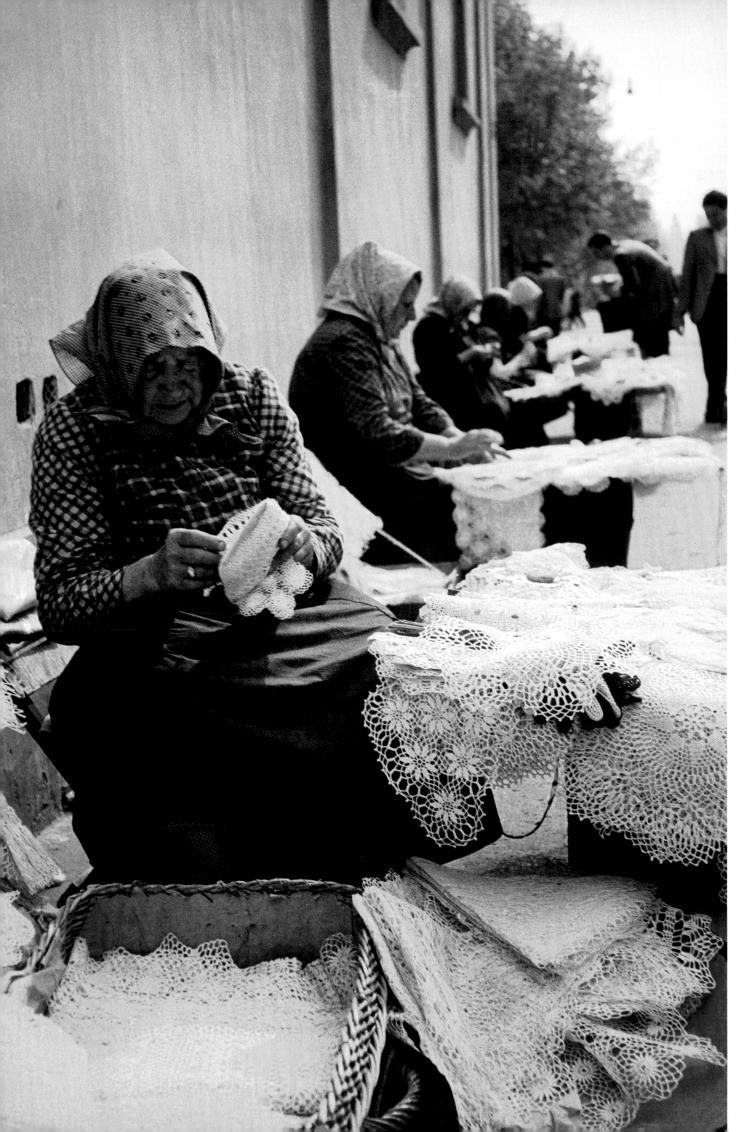

Lacemakers sell their wares to townspeople and tourists in Budapest.

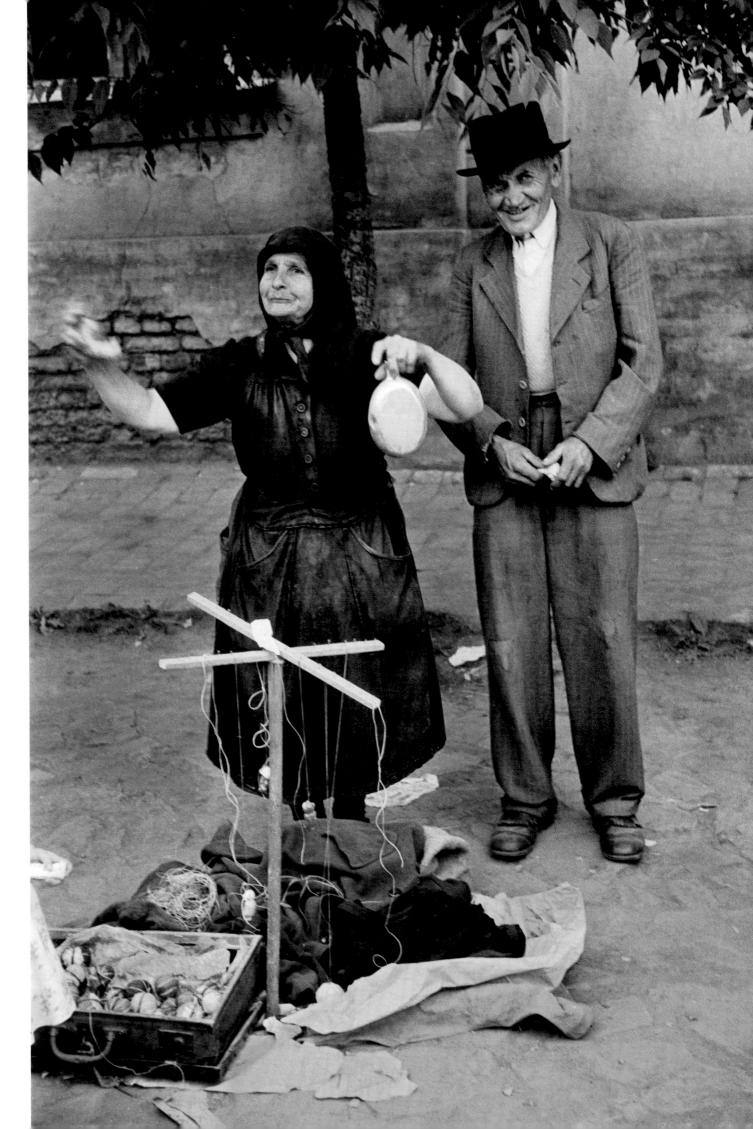

An elderly couple sells hand-made toys
on a Budapest street.

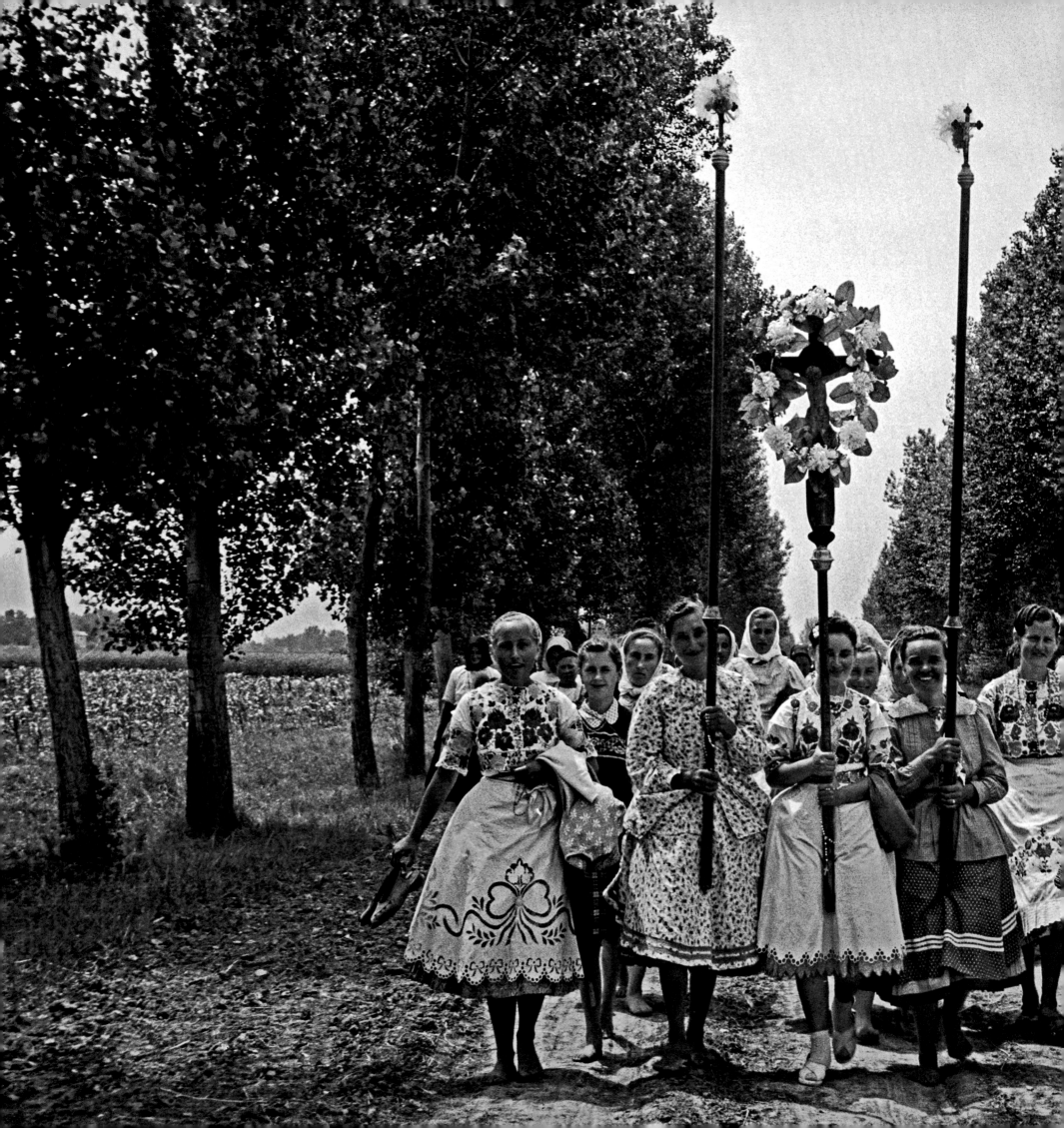

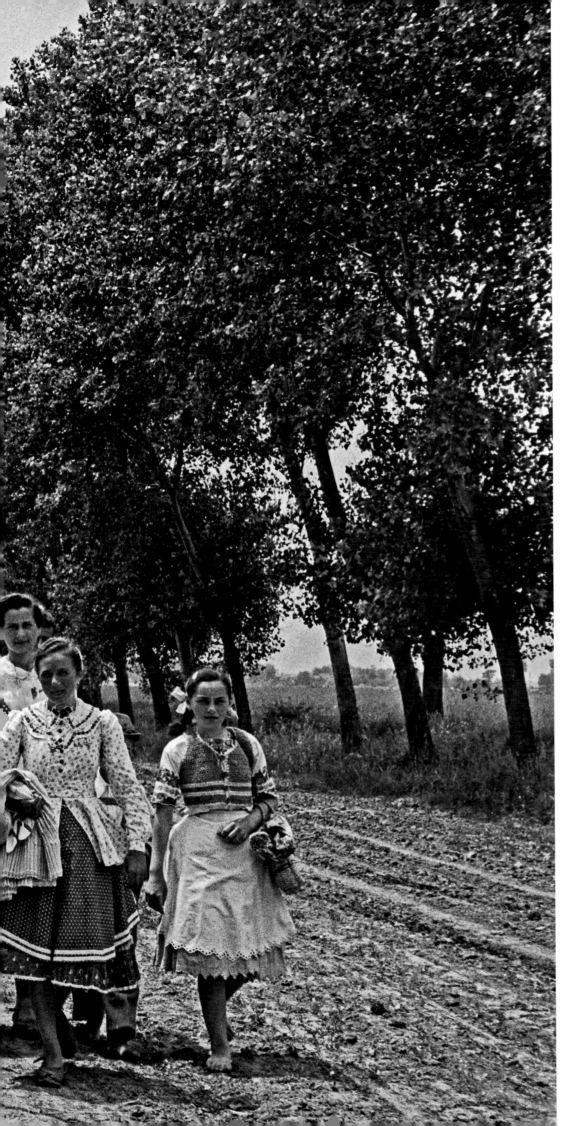

The Corpus Christi procession in Kalocsa
is led by girls and young women in embroidered
local costume.

Religion

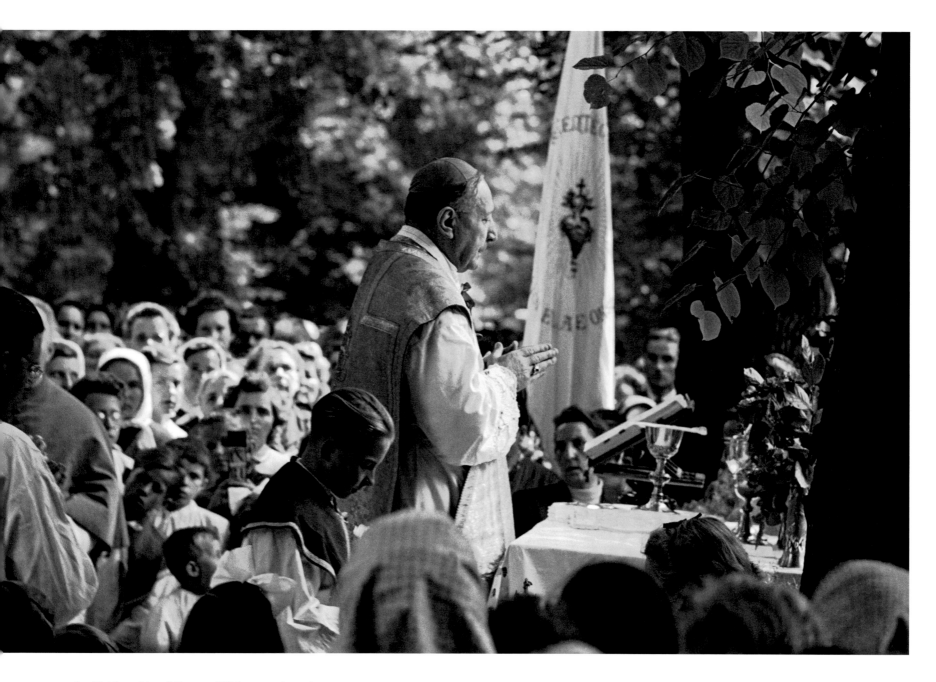

Archbishop József Grösz of Kalocsa, released
from prison on 12 May celebrates an open-air
mass on Corpus Christi day, 31 May 1956.

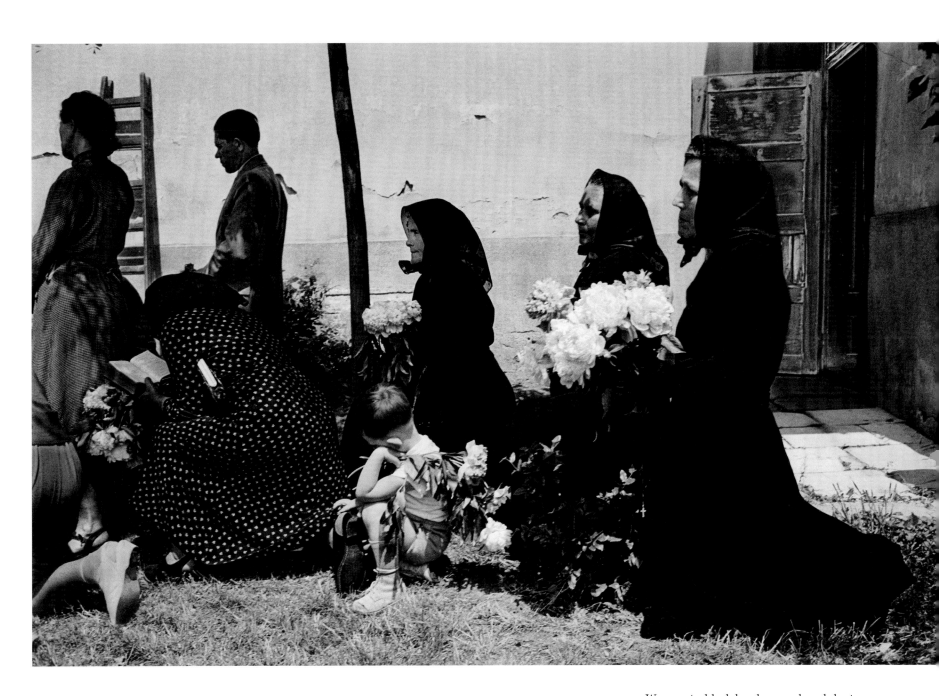

Women in black headscarves kneel during
the Corpus Christi procession in Kalocsa.

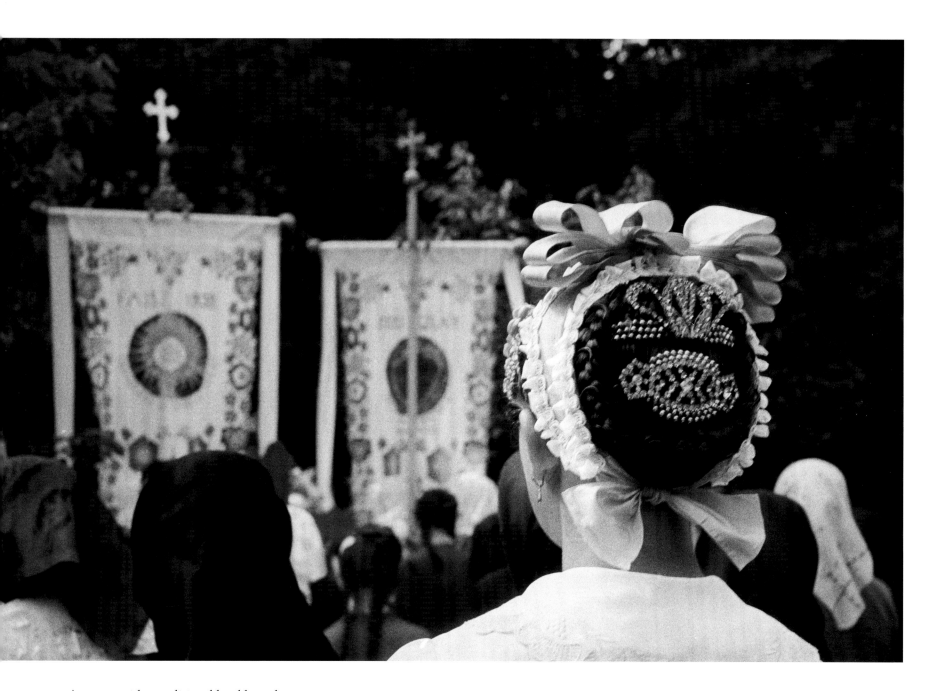

A woman with a traditional beribboned cap
and paste-studded combs during the
Corpus Christi procession.

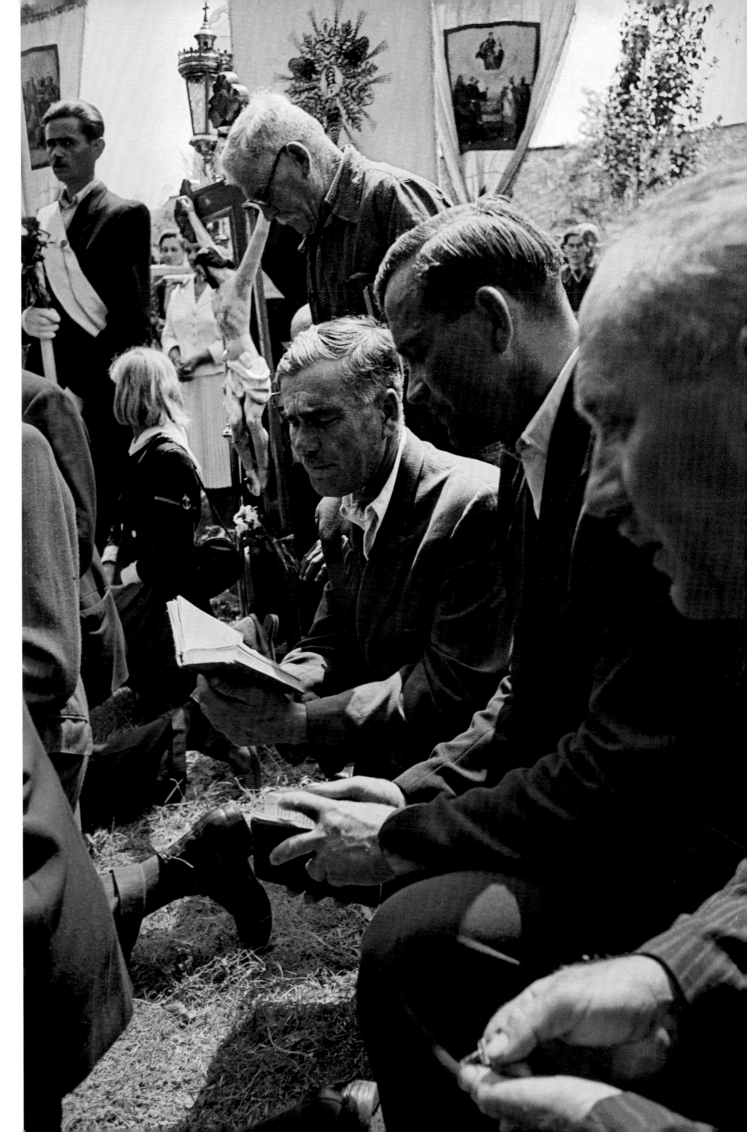

Farmers kneel under their church flags
in the Corpus Christi procession.

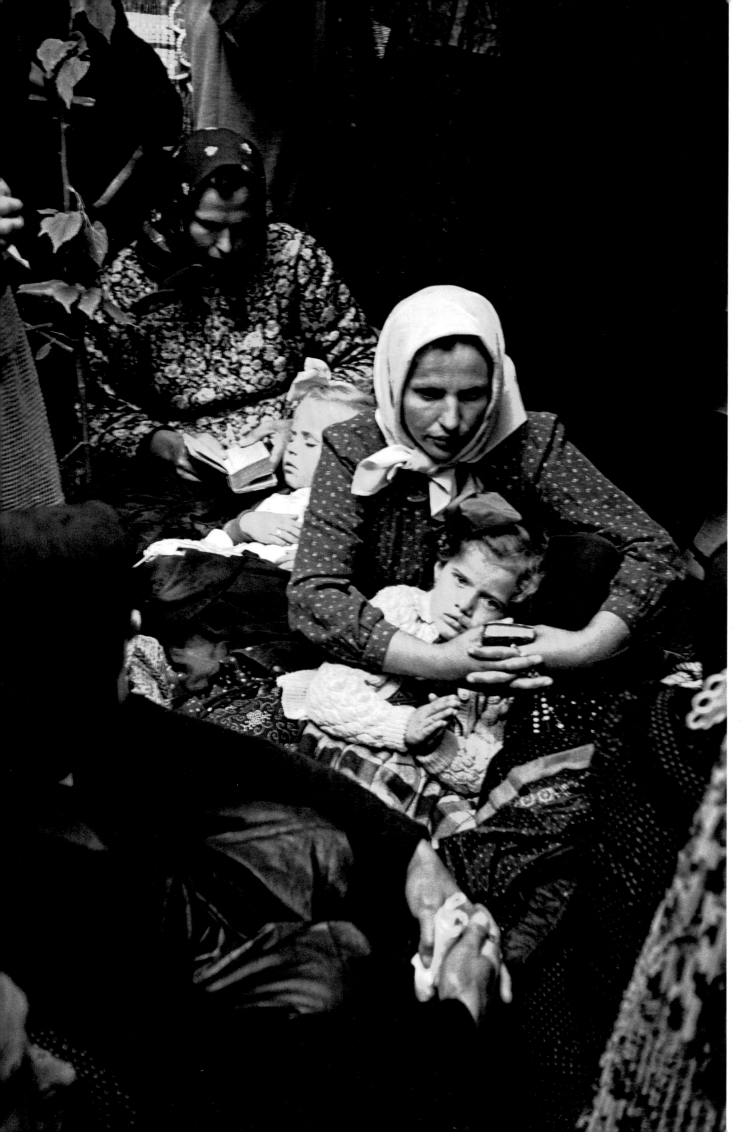

Mother and child during the open-air
mass on Corpus Christi day in Kalocsa.
The mass was celebrated by Archbishop
József Grösz.

After Sunday mass, farmers meet
in front of the church.

In town

A policeman and a street sweeper at the Pest end
of Budapest's Petőfi Bridge.

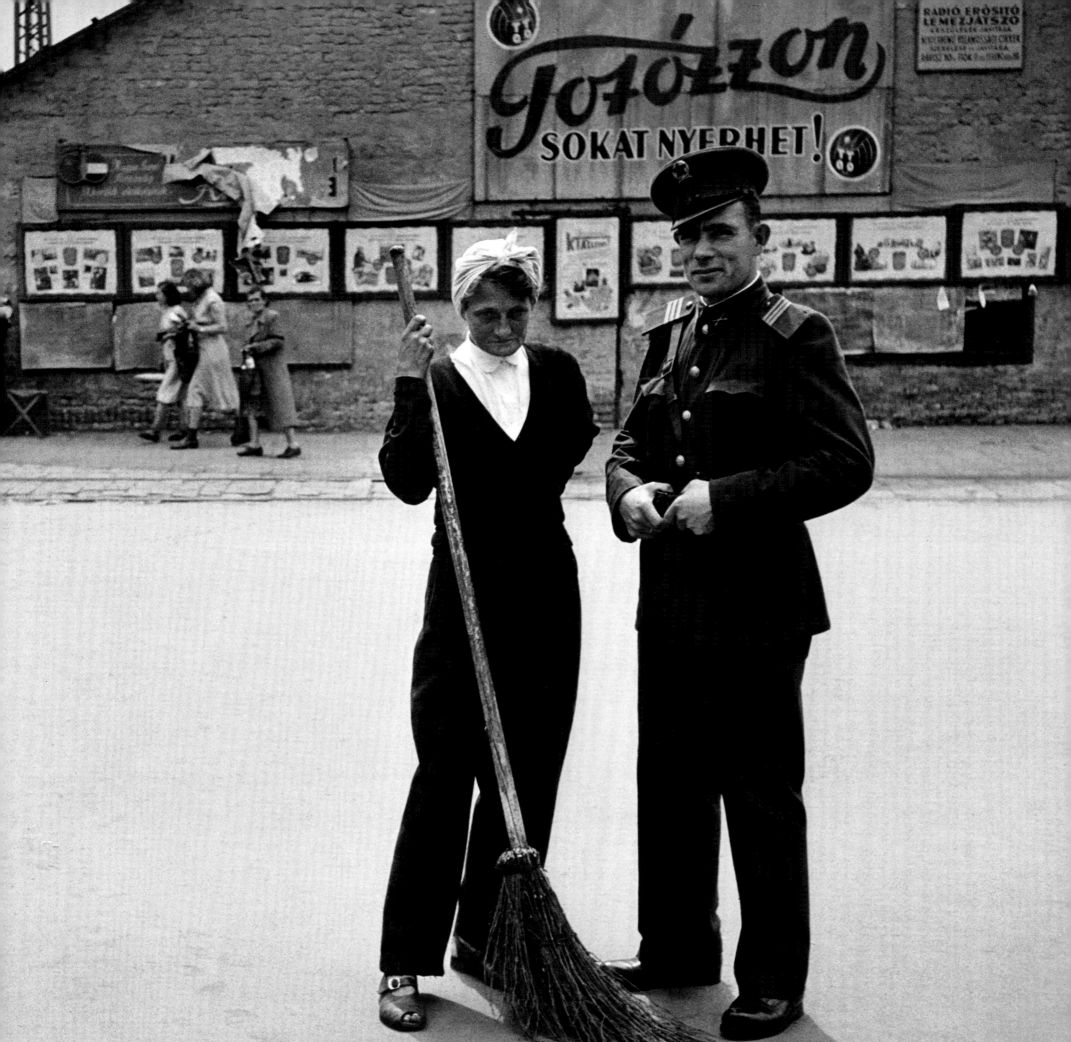

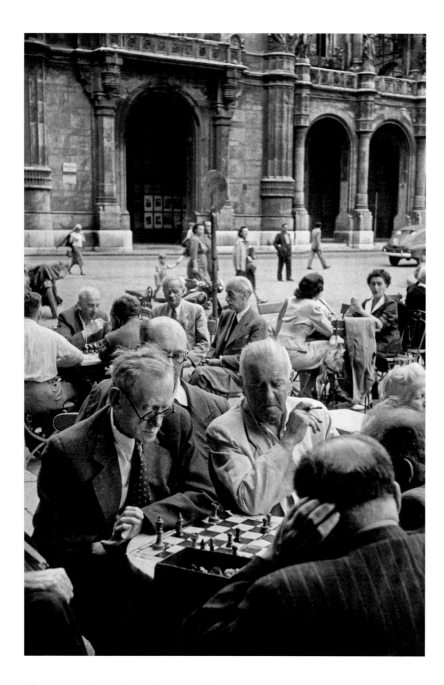

Hungarians have always been excellent
and passionate chess players. Open-air chess
at Vigadó Square.

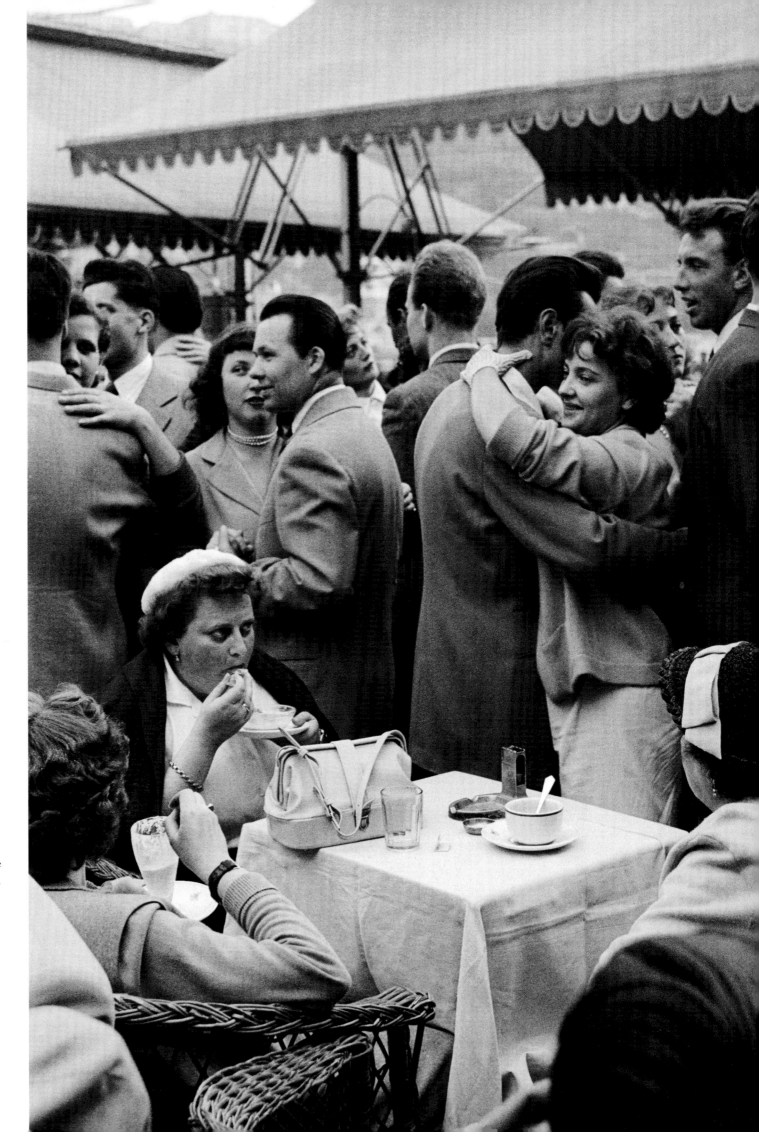

Five o'clock dance in a coffee-house
on the Danube promenade.

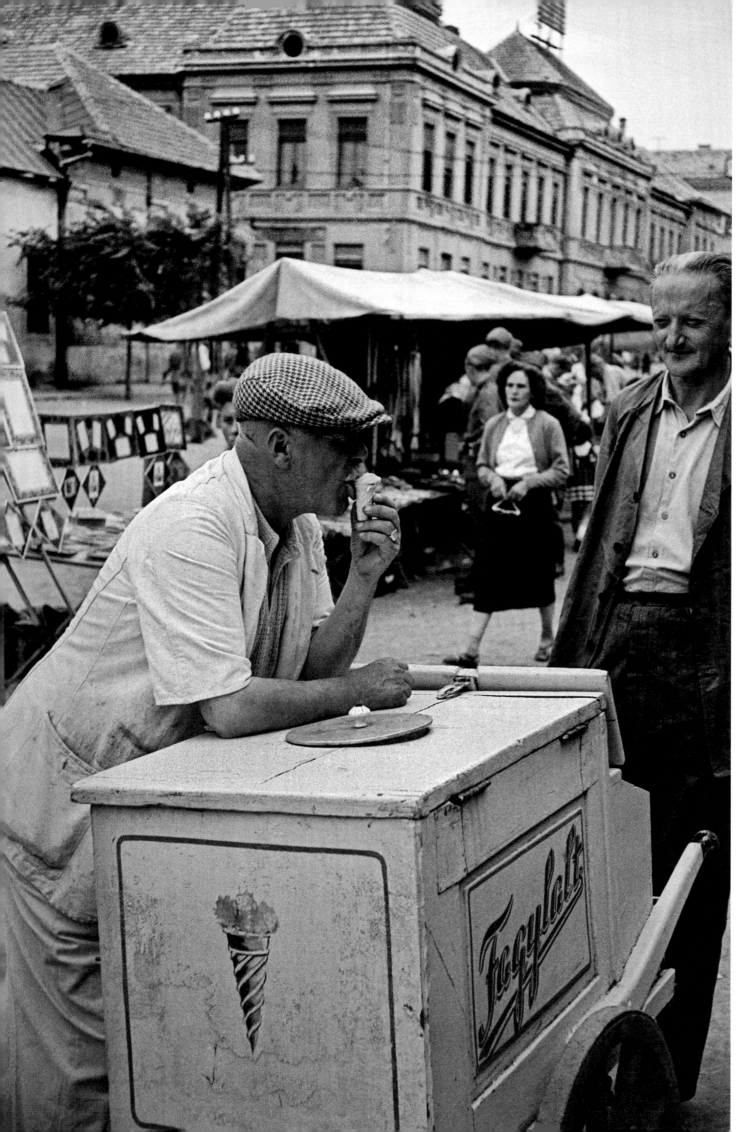

A 'private entrepreneur' tastes his
own ice-cream.

Two girls at a stall in a Budapest market.

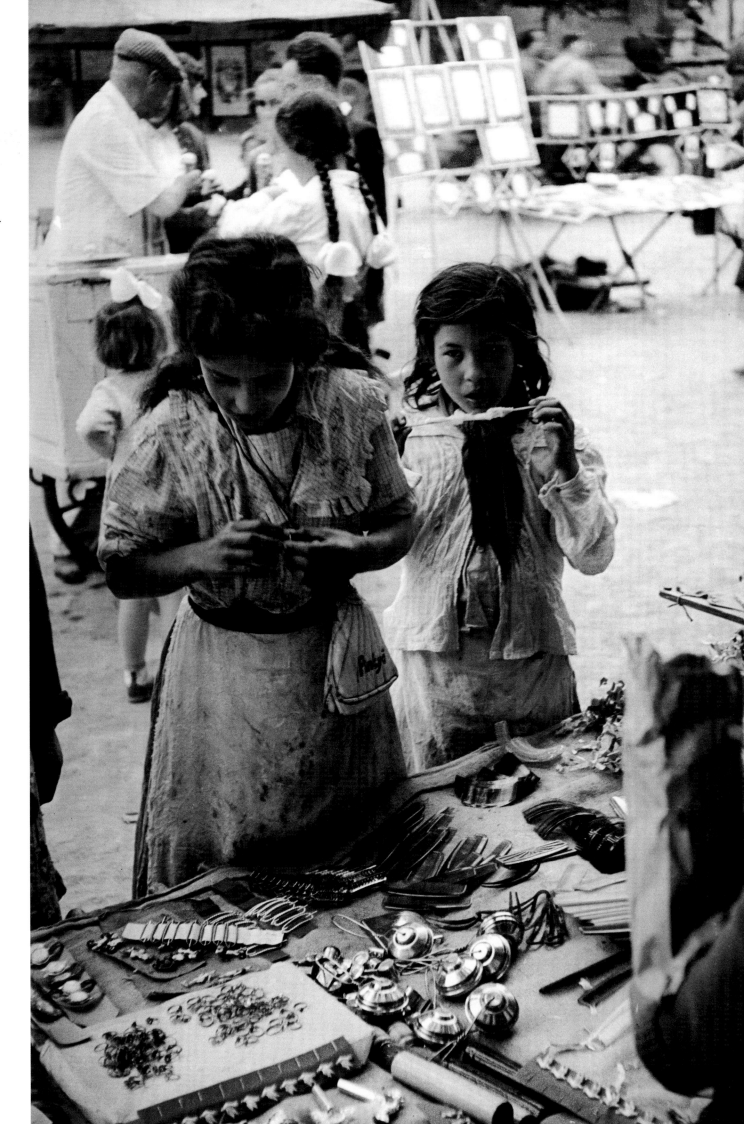

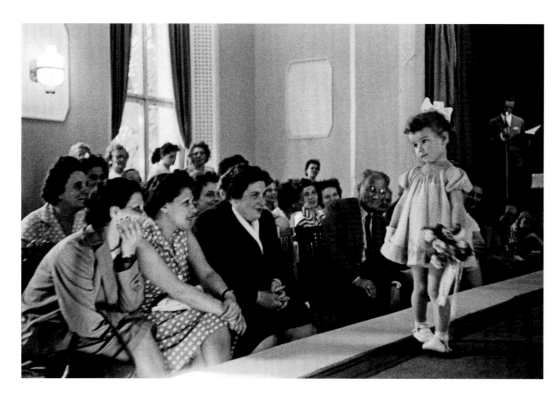

A childrens' fashion show in Budapest.

A fashion show.

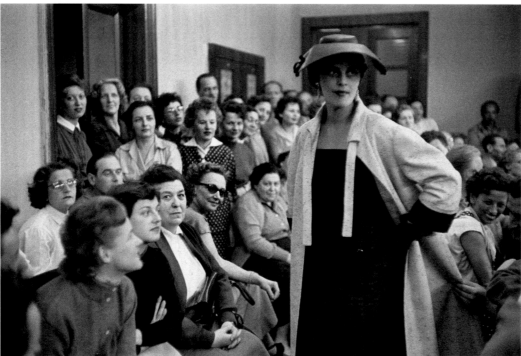

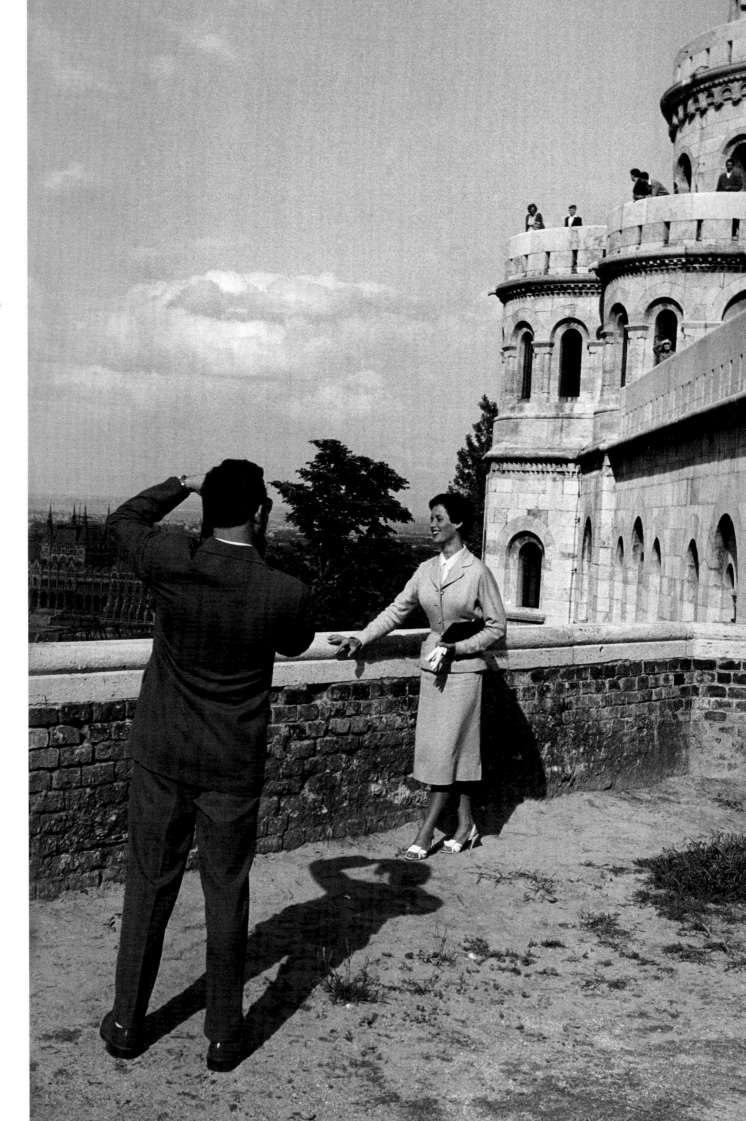

An elegant couple on the Fisherman's
Bastion in Budapest Castle.

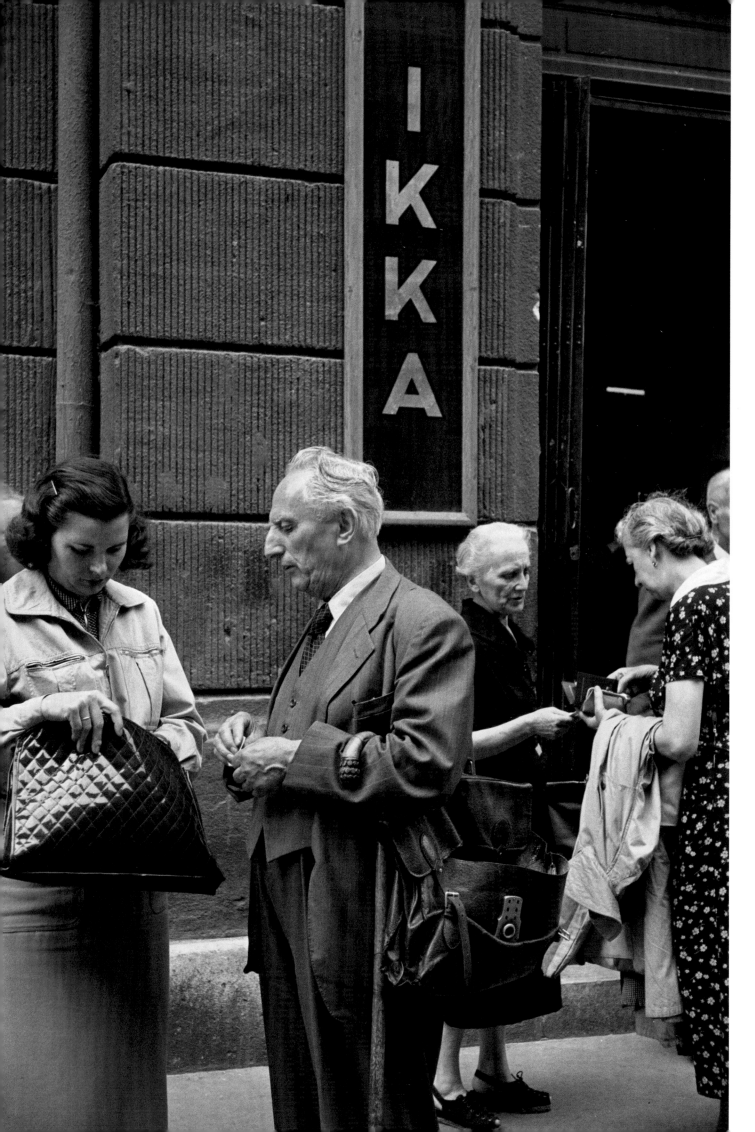

In the 1950s, Hungarian citizens were not allowed to own Western currencies. Money received from abroad had to be exchanged for coupons, which were often immediately sold to others, to be used in IKKA shops.

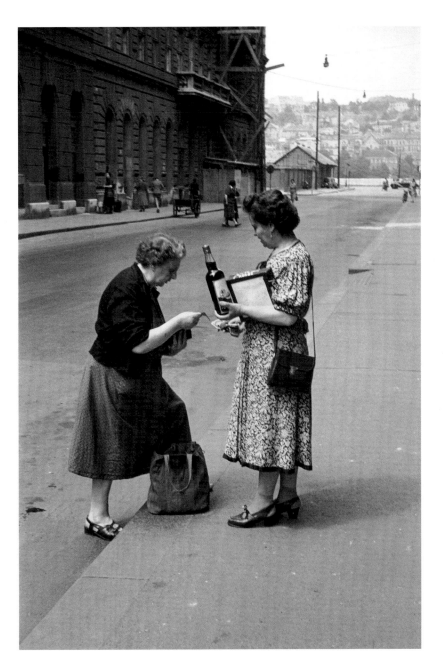

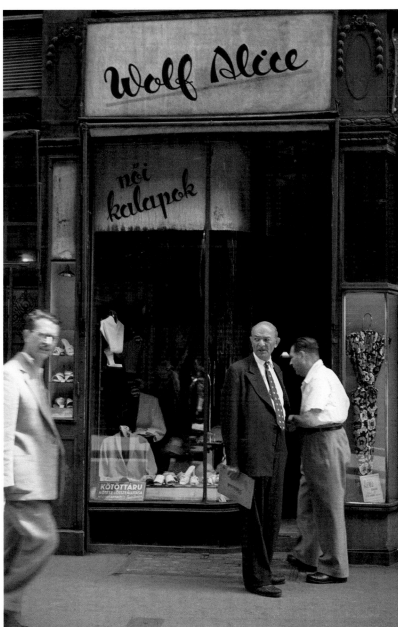

A quick business deal on a Budapest street, in front of an IKKA shop.

A fashion shop in downtown Budapest, then the most elegant city in the Communist world. In 1949, an attempt was made to close down the private retail trade, but in 1953, private shops were permitted to open again.

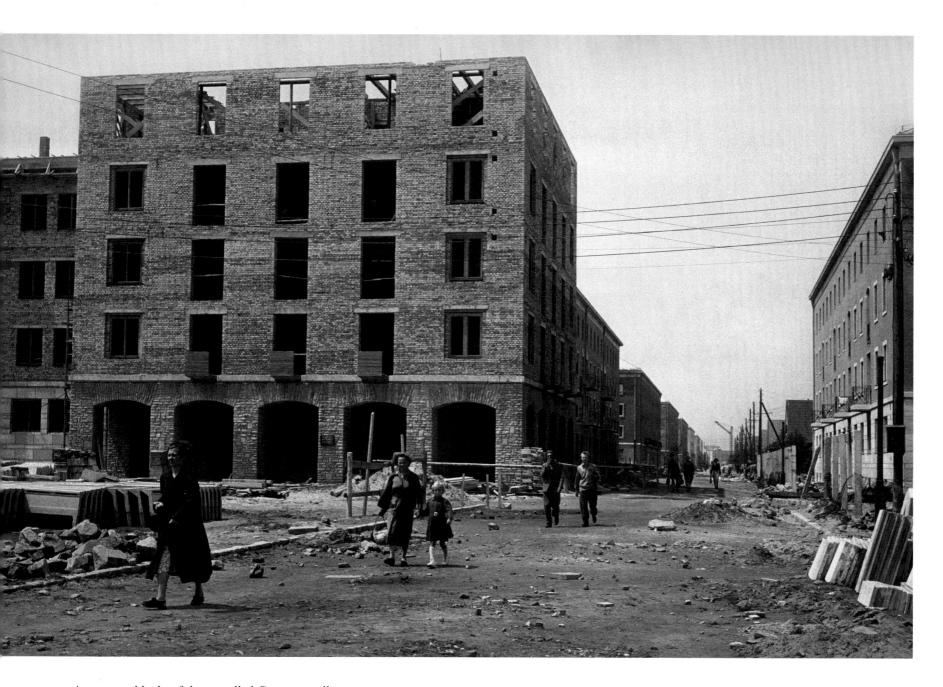

Apartment blocks of the so-called C-type, small
flats of forty-five to fifty square metres with
no bathroom, under construction in Budapest.

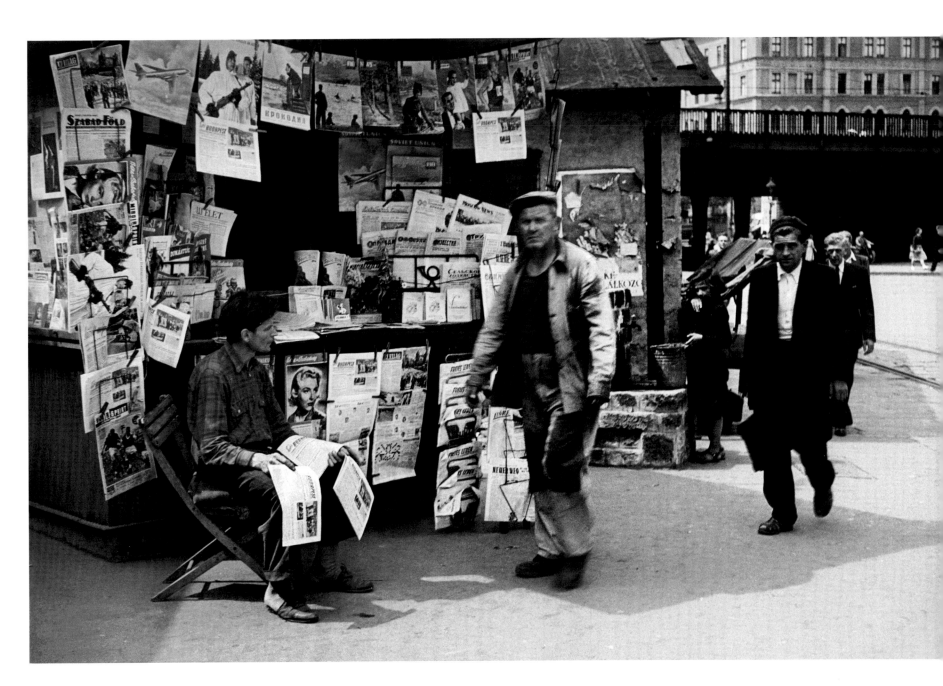

A newspaper stall in Budapest. In the 1950s,
the press was under the tight control
of the Communist Party. Nonetheless, critical
articles appeared in some papers during
the summer of 1956.

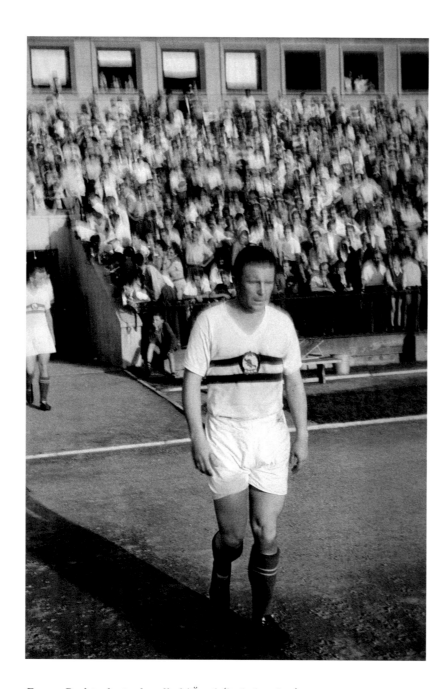

Ferenc Puskás, lovingly called 'Öcsi' (little brother),
captain of the famous Hungarian national team,
at Népstadion (The People's Stadium).

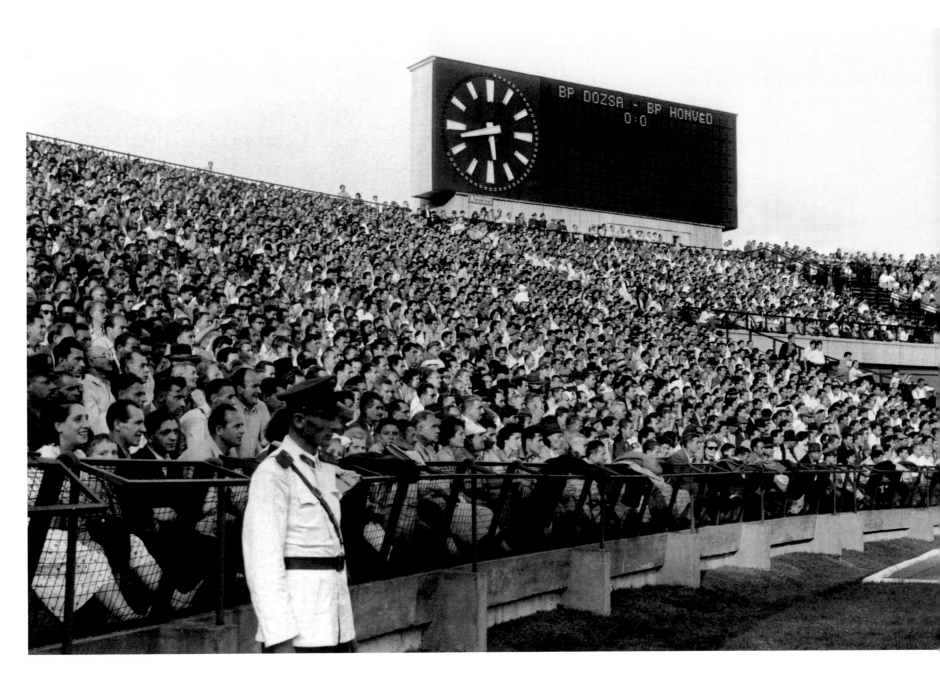

BP DOZSA - BP HONVÉD
0:0

This was the era of Ferenc Puskás, who scored eighty-three international goals during his career with the Kispest-Honvéd team.

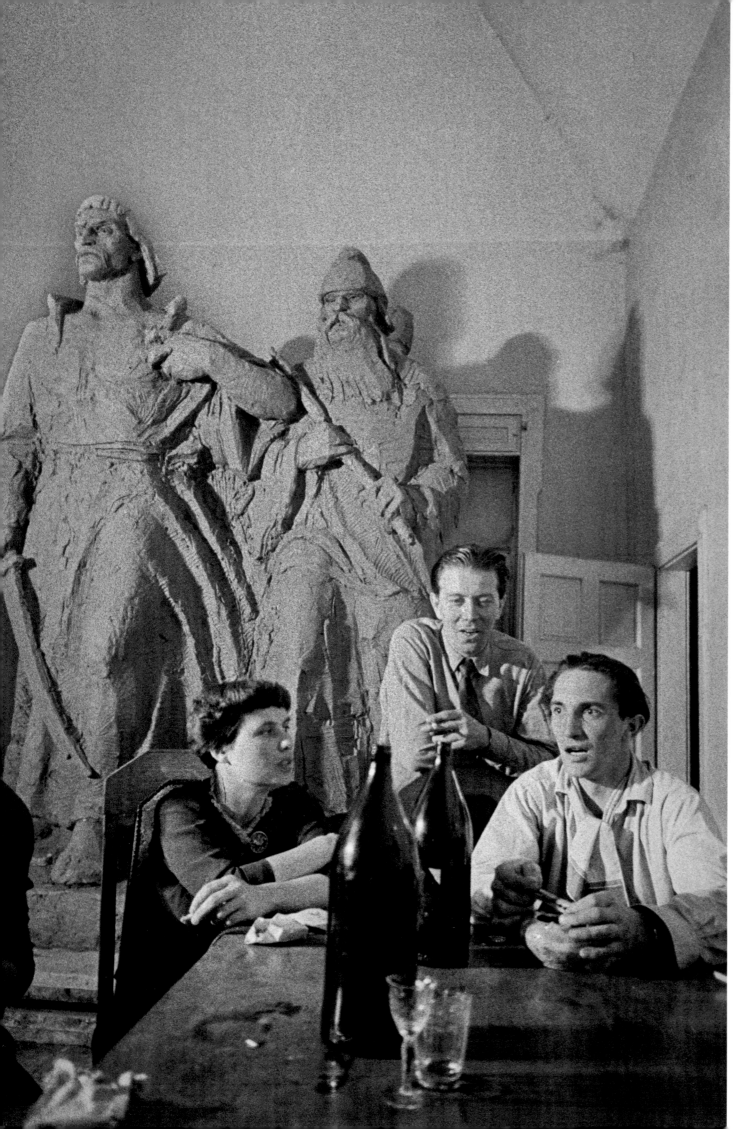

Sculptor István Kiss with friends, in front of his group of statues 'György Dózsa'. Dózsa was the leader of the Hungarian peasant revolt of 1514 and was executed the same year.

The Dózsa monument now stands on the slope of Budapest's Castle Hill.

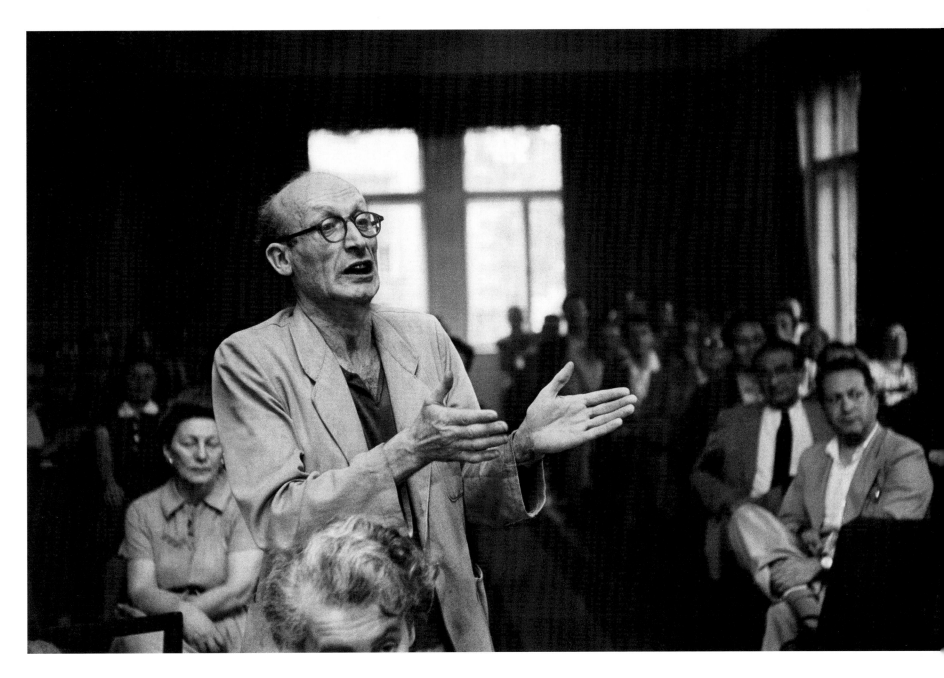

In a stormy meeting of the Hungarian Writers'
Union, György Szüdi called the planned rise of
agricultural production by twenty-seven per
cent 'simply idiotic'. The Writers' Union was
dissolved in January 1957 but permitted to be
re-established in 1959.

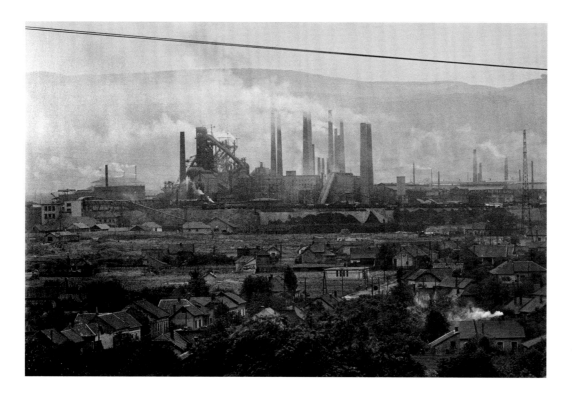

View of the Lenin ironworks in Diósgyör.

Workers at the Martin furnace
in Sztálinváros (Stalin City).

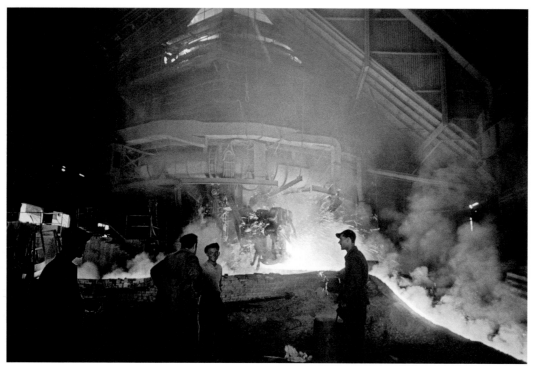

At the factory

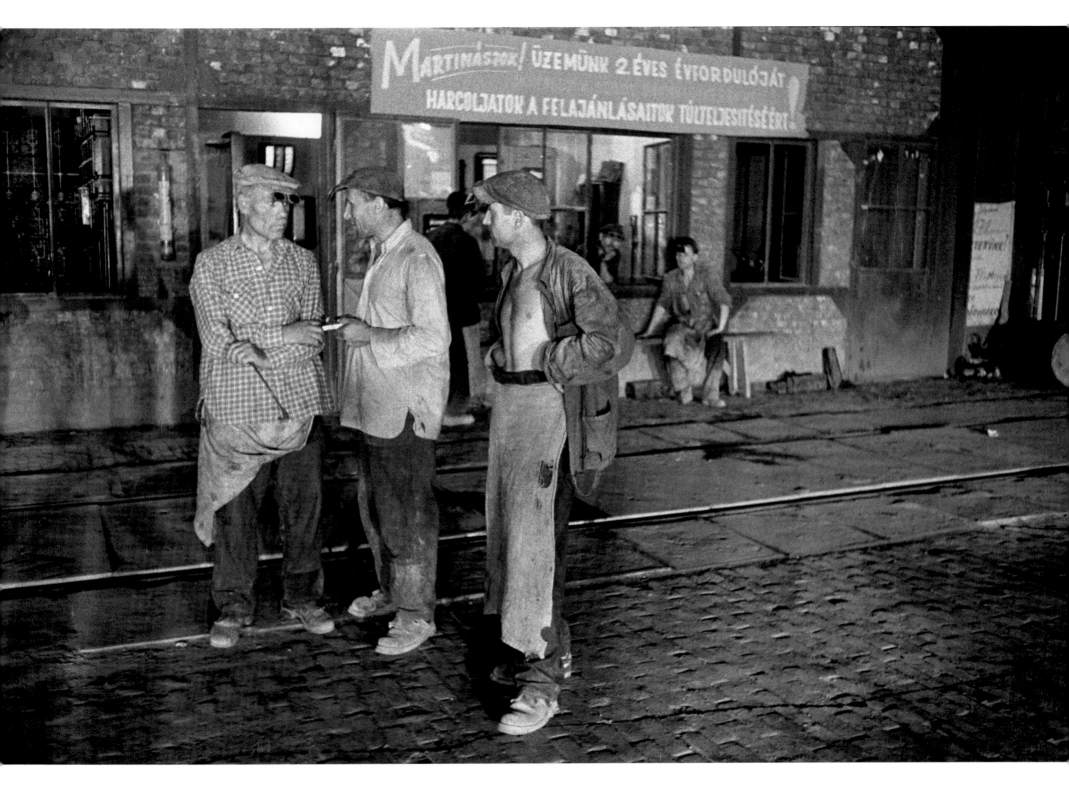

'Steel workers, on this second anniversary
of our company, commit yourselves
to exceeding your goals', says the banner above
the door. In general, the Socialist Brigades
committed themselves to the over-achievement
of their goals on instructions from above.

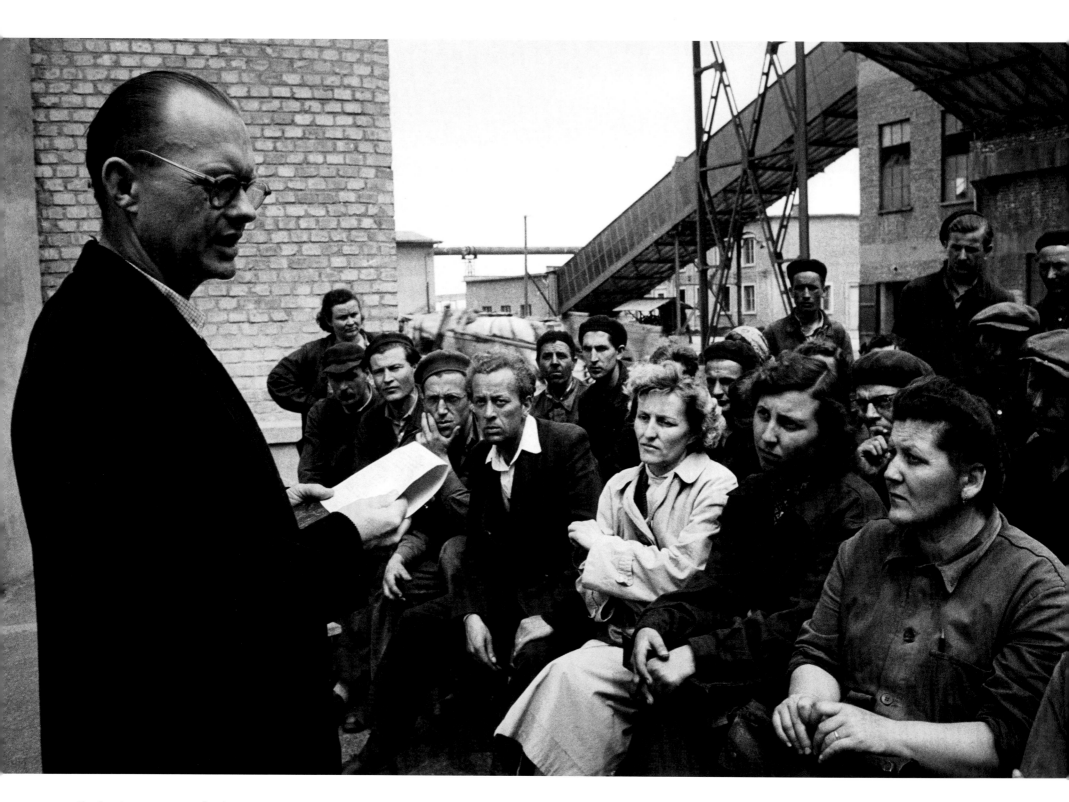

Production meeting in Sztálinváros.
Labour unrest and some strikes began among
the privileged steelworkers months before
the outbreak of the revolution.

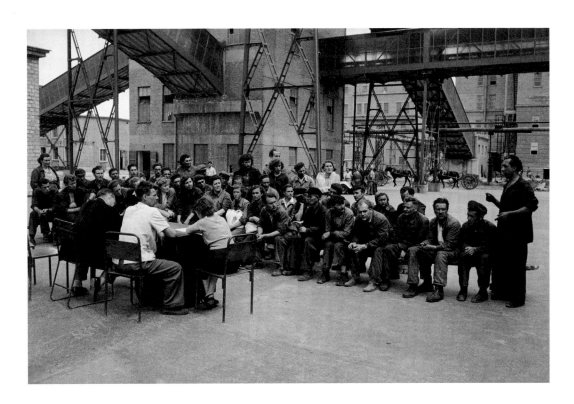

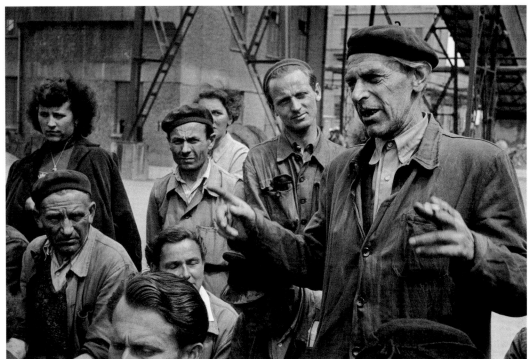

Production meeting in Sztálinváros
in the early summer of 1956.

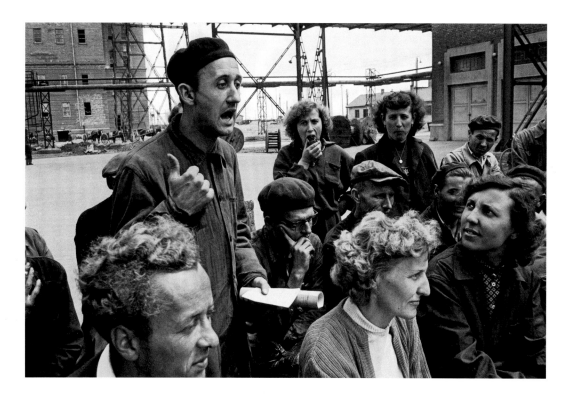

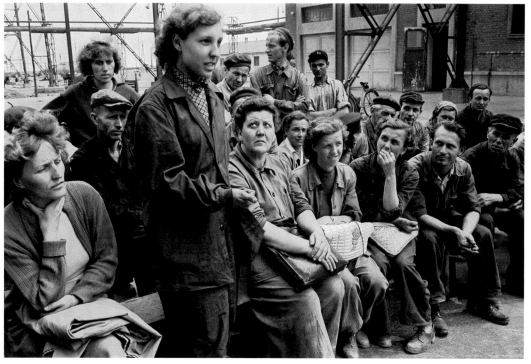

Production meeting in Sztálinváros
in the early summer of 1956.

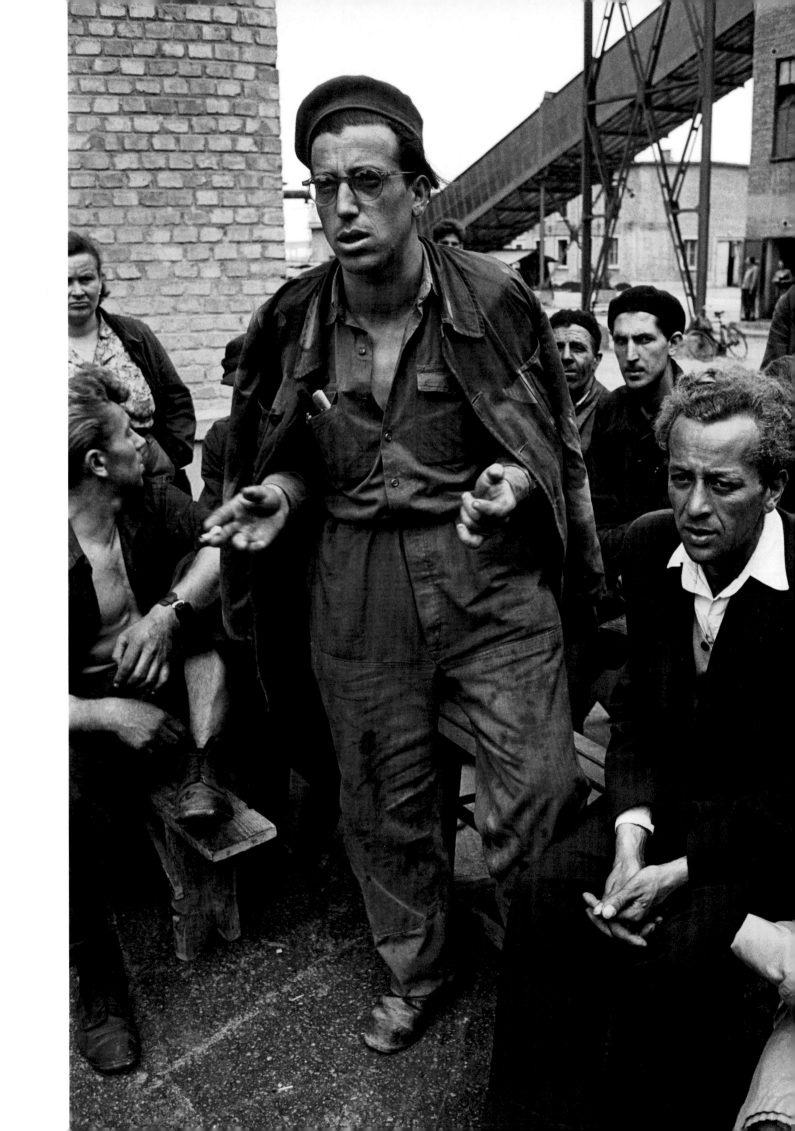

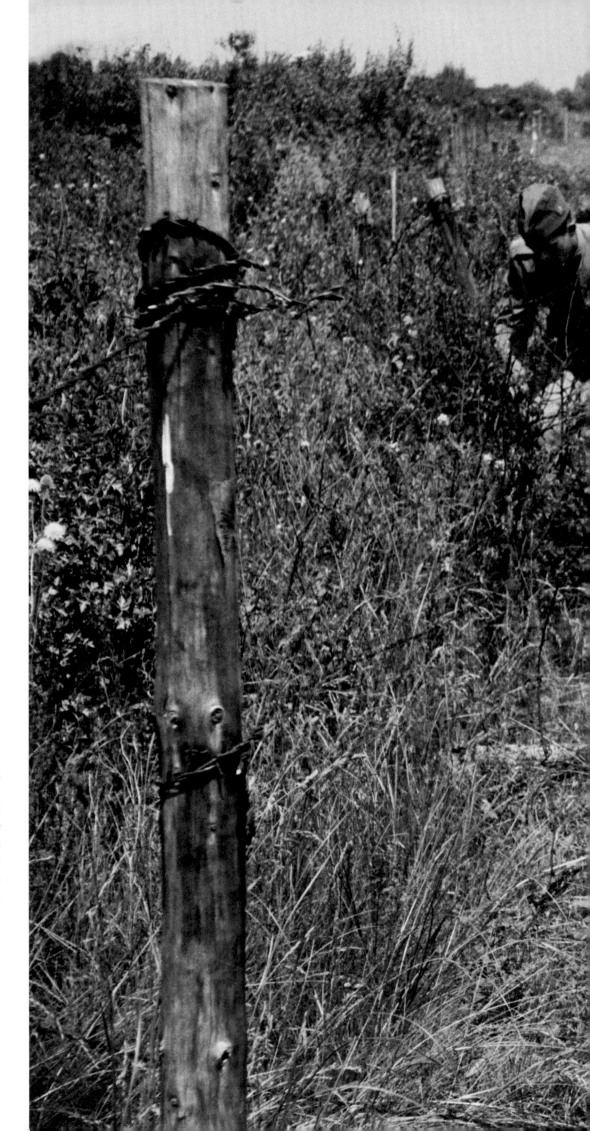

The start of the uprising

The Iron Curtain dividing Europe into East
and West also divided Austria and Hungary.
It consisted of wire fences, land-mines and
watch-towers. Between 10 May and early
September 1956, in a brief thaw before
the revolution, Hungarian soldiers cleared the
area of mines and took down the barbed-wire
fences on the Austrian border.

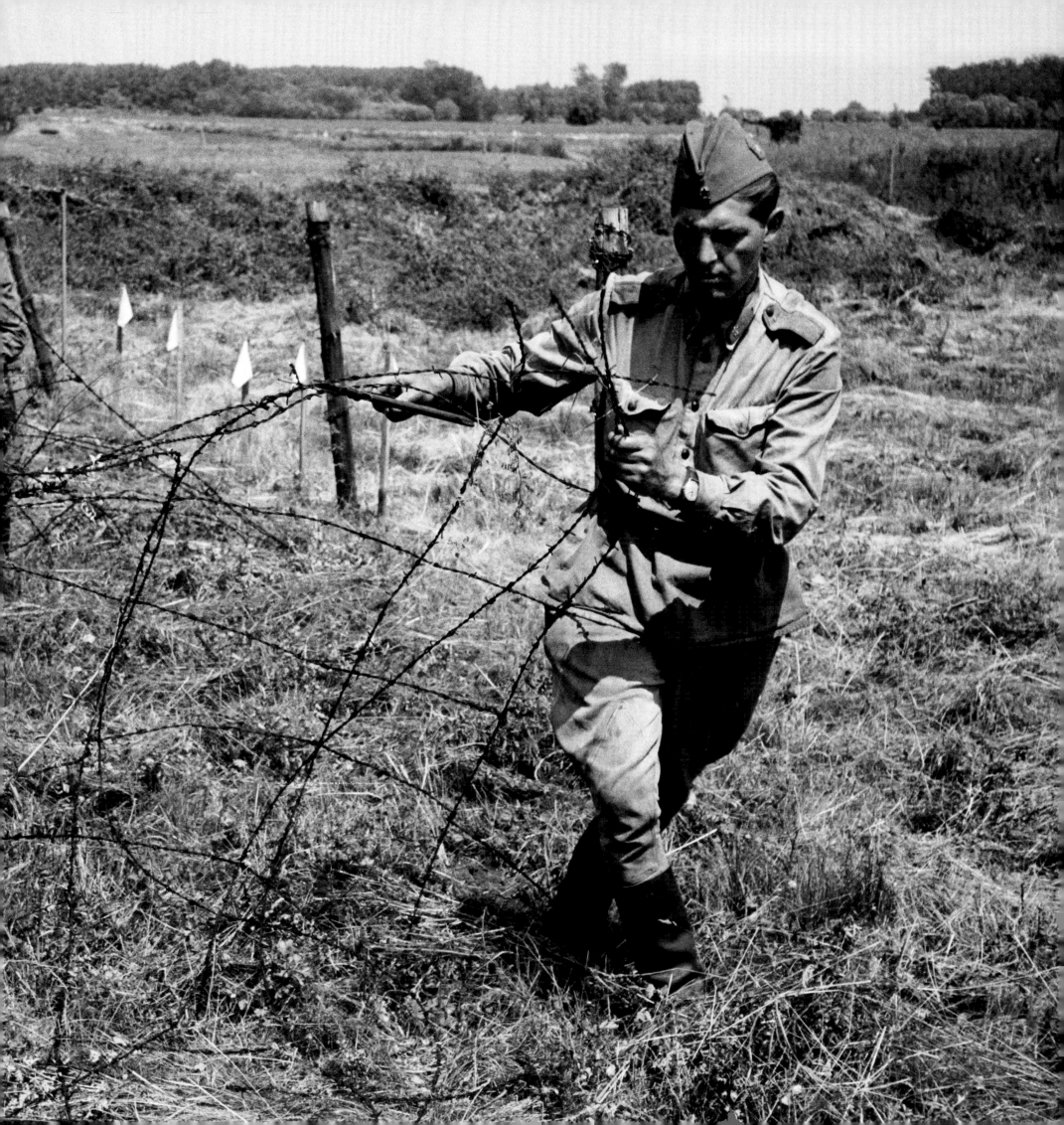

The Petöfi Circle, named after the Hungarian hero-poet of the uprising of 1848, was originally a discussion forum of the Communist Youth League (DISZ – Association of Working Youth). In the spring of 1956, it became a meeting place for intellectuals critical of the Communist leadership. It met on 27 June 1956 to discuss the government's press and information policy. Tibor Déry, liberal writer, during the debate.

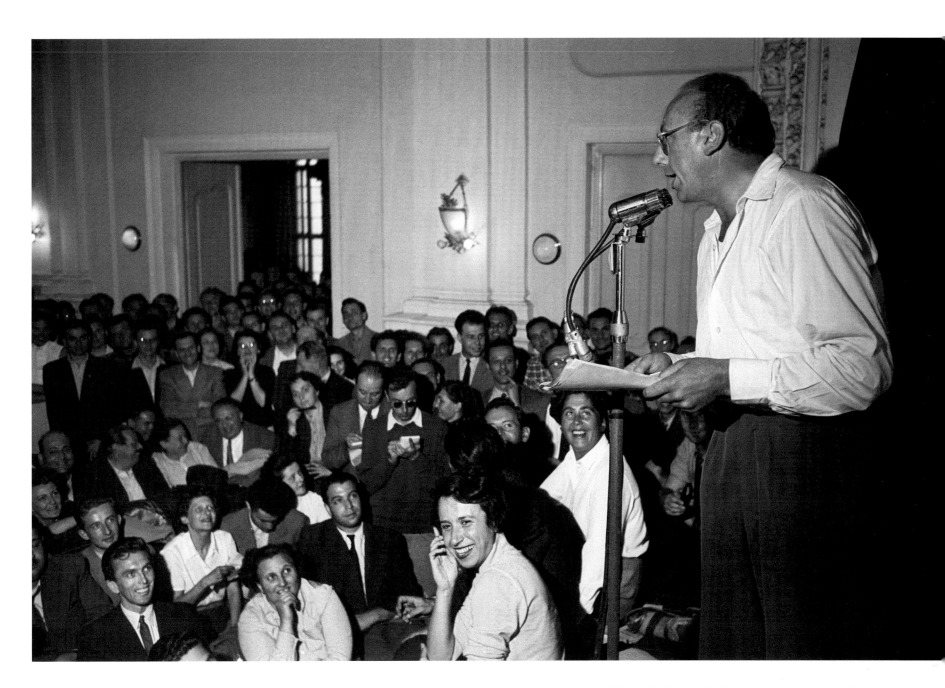

Tibor Tardos, well-known columnist expelled
from the Communist Party the previous year,
addresses the Circle.

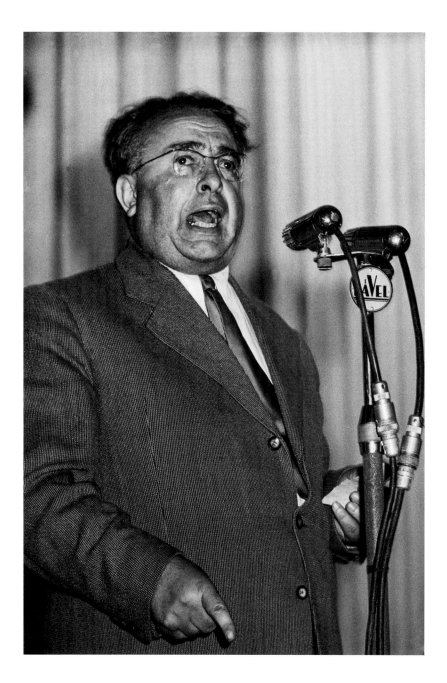

Sándor Nógrádi, member of the Central
Committee of the Communist Party, defended
the party-line against attacks by the audience,
during the meeting of the Petöfi Circle
on 27 June 1956.

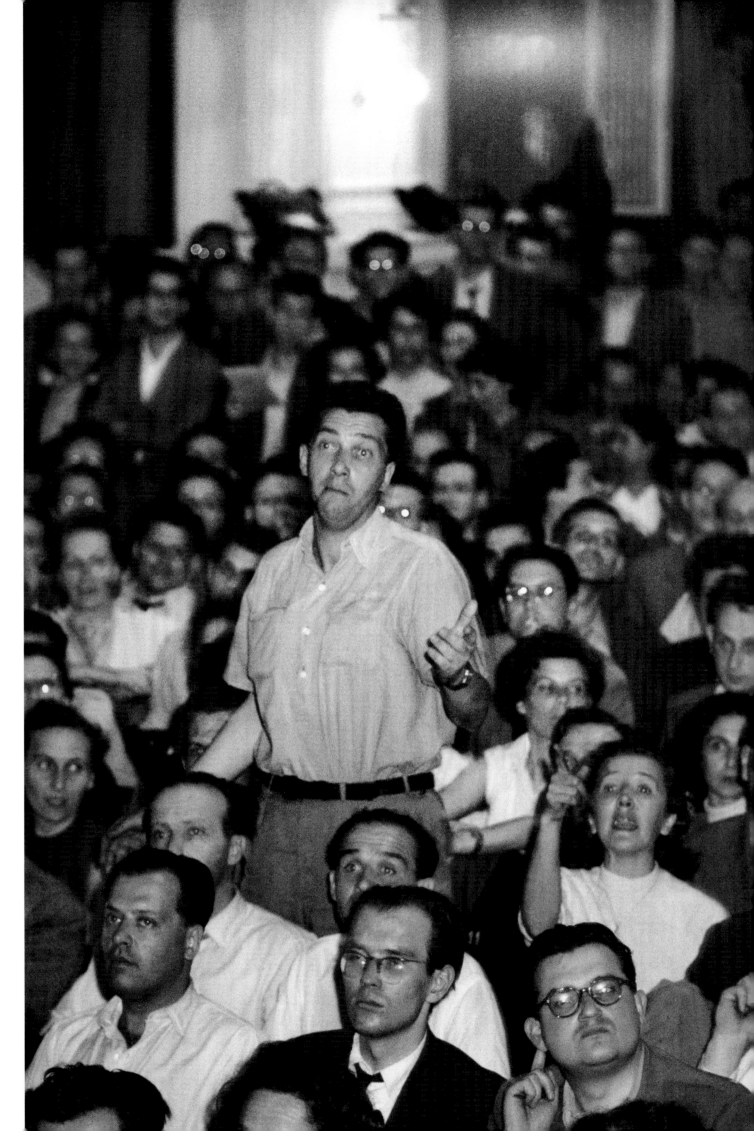

A lively discussion during the meeting
of the Petöfi Circle.

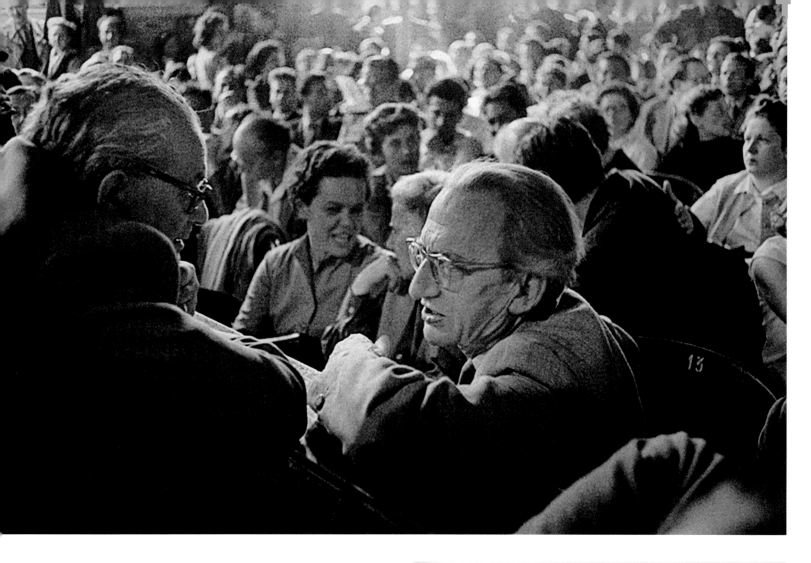

Among the audience at the meeting of the Petöfi Circle are former Socialist politician Árpád Szakasits, recently released from detention, and philosopher Georg Lukács.

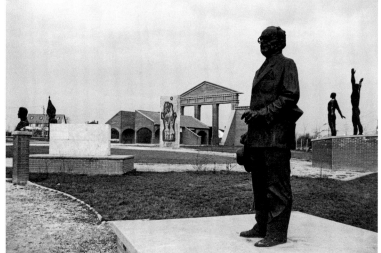

Statue of Árpád Szakasits in Szobor Park (Statues' Park), outside Budapest. Statues from the Communist era, mostly 'Socialist Realism', were removed from Budapest's public places.

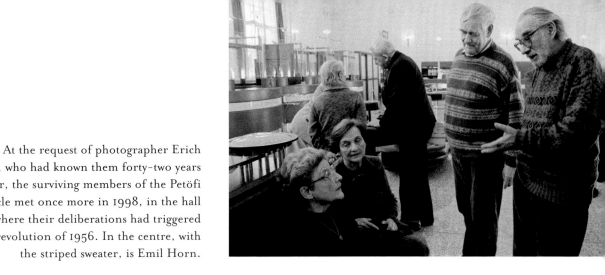

During the conference of the Petöfi Circle on 27 June 1956: Emil Horn, a student; after 1989, he became curator at the Hungarian National Museum.

At the request of photographer Erich Lessing, who had known them forty-two years earlier, the surviving members of the Petöfi Circle met once more in 1998, in the hall where their deliberations had triggered the revolution of 1956. In the centre, with the striped sweater, is Emil Horn.

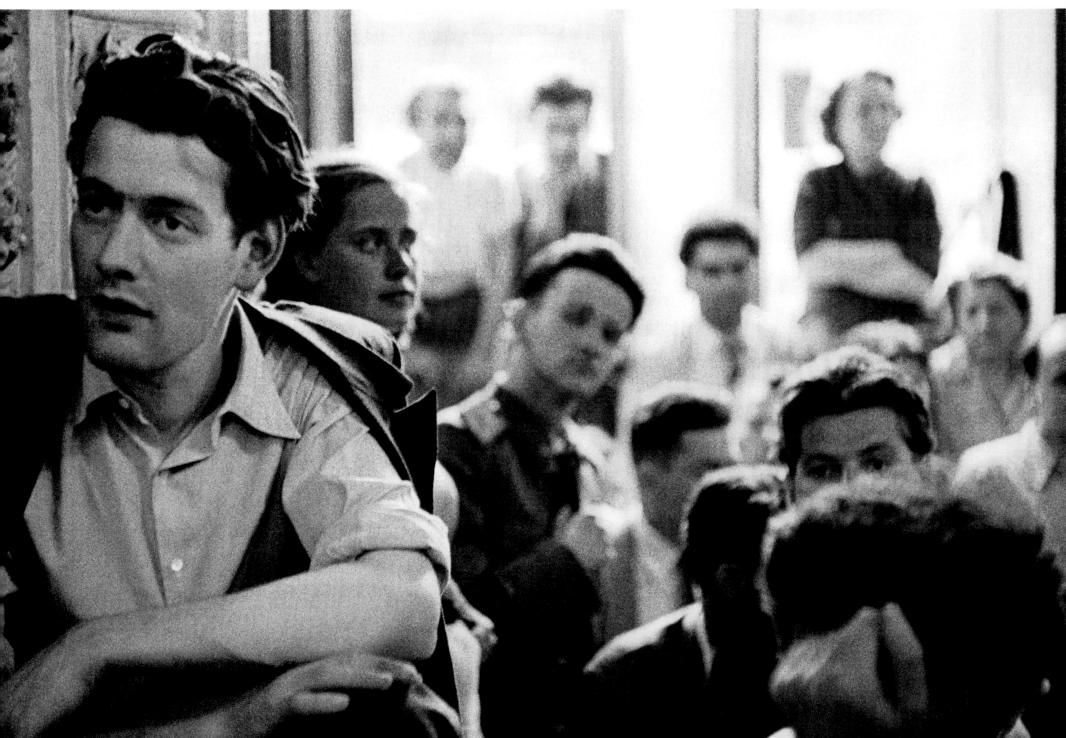

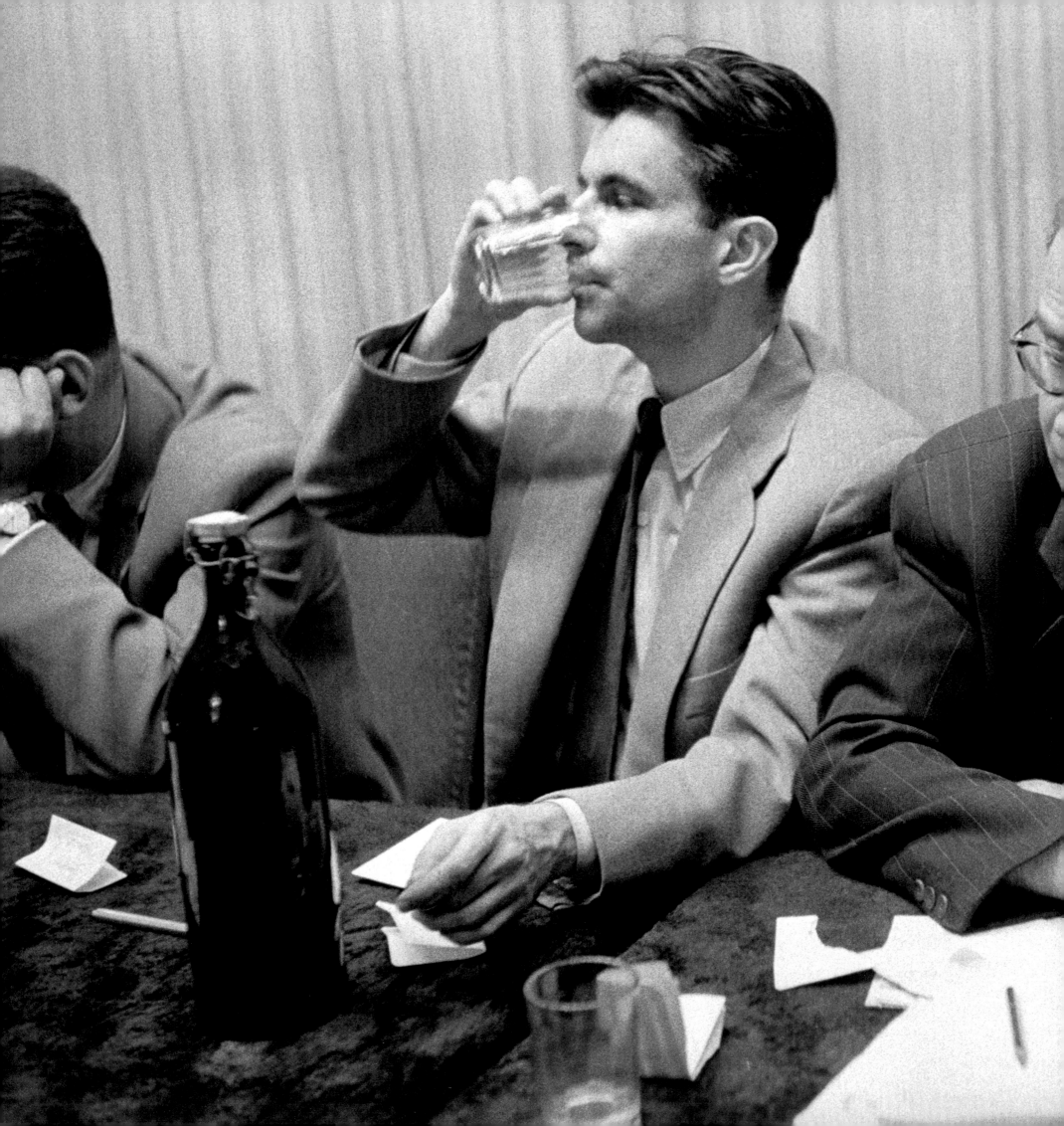

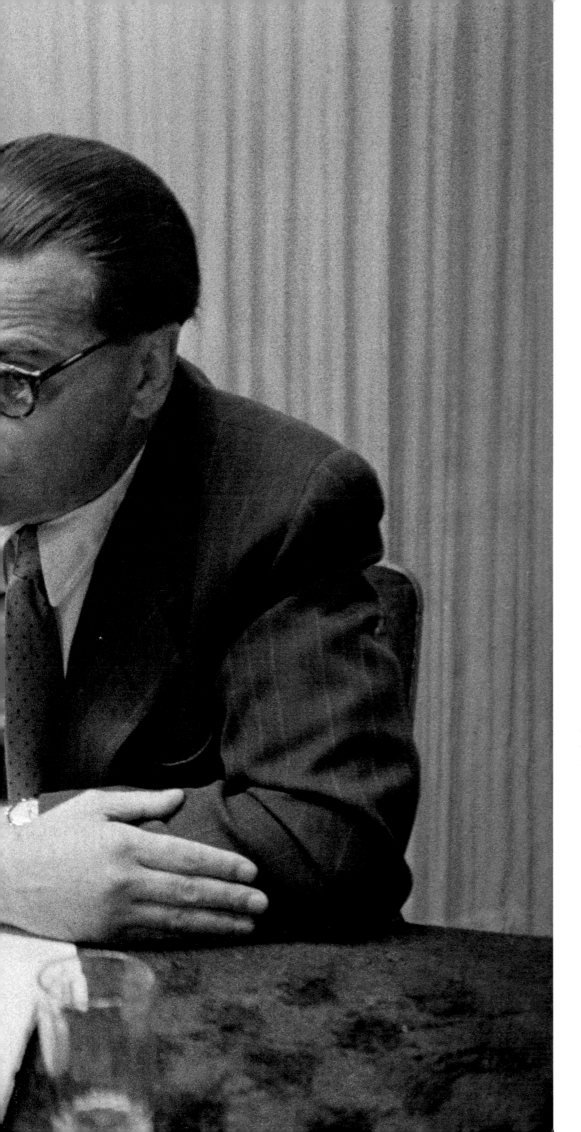

Gábor Tánczos (left), Secretary of the Petöfi Circle, and Géza Losonczy, who became Secretary of State in the Nagy government during the revolution. Losonczy died in prison in December 1957.

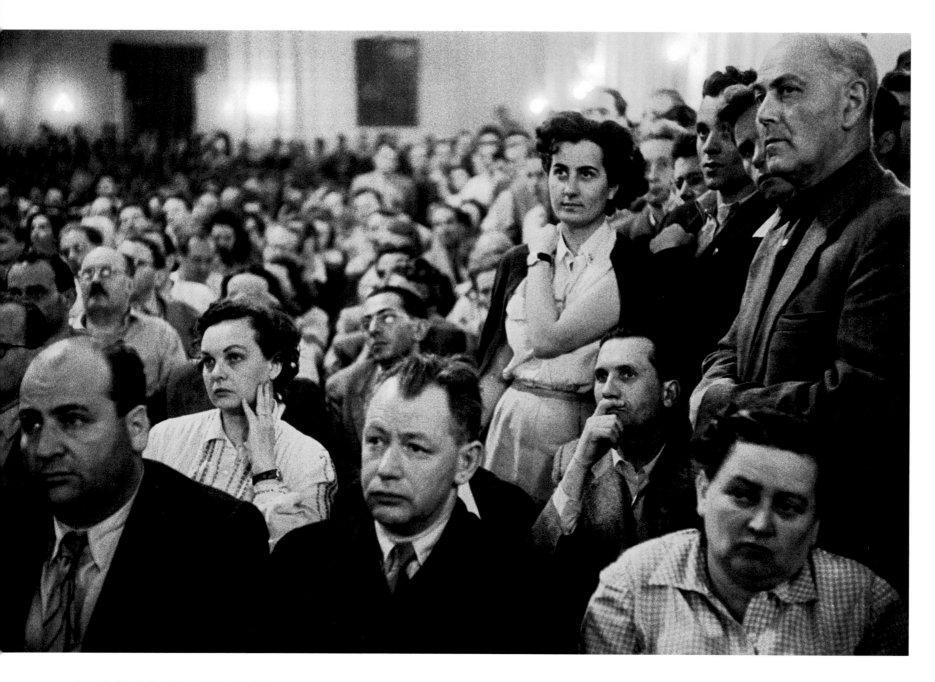

A packed hall for the discussion of the
government's press and information policy
at the Petőfi Circle in the Budapest
Officers' Club.

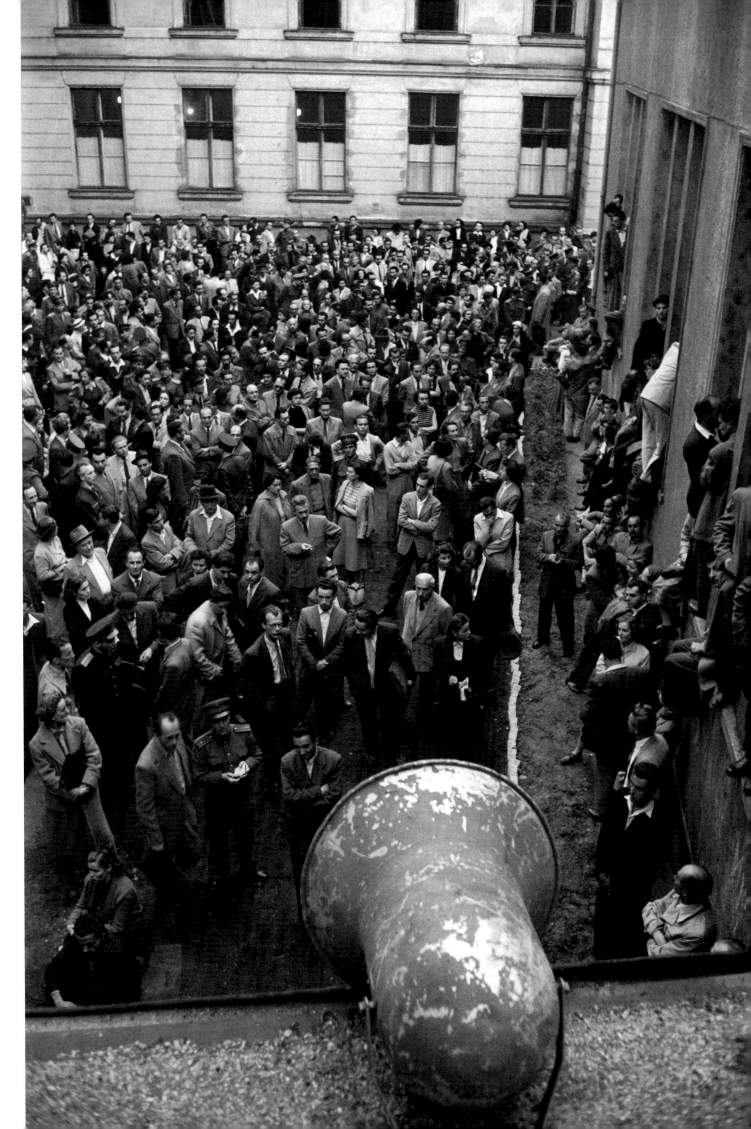

The Petöfi Circle, after two moves to ever larger rooms, finally met in the hall of the Budapest Officers' Club. Six hundred people were expected, six thousand came, to listen to the discussions. The meeting was transmitted by loudspeaker to the thousands waiting outside.

The political actors

Meeting of the regional council
of the National Front, summer 1956.
In the centre, János Kádár, the 'Father
of Gulyas Communism'; on his right,
Zoltán Vas, chairman of the Production
Cooperatives' Land Association.
Vas was the organizer of the Communist
economy in Hungary after World War II.

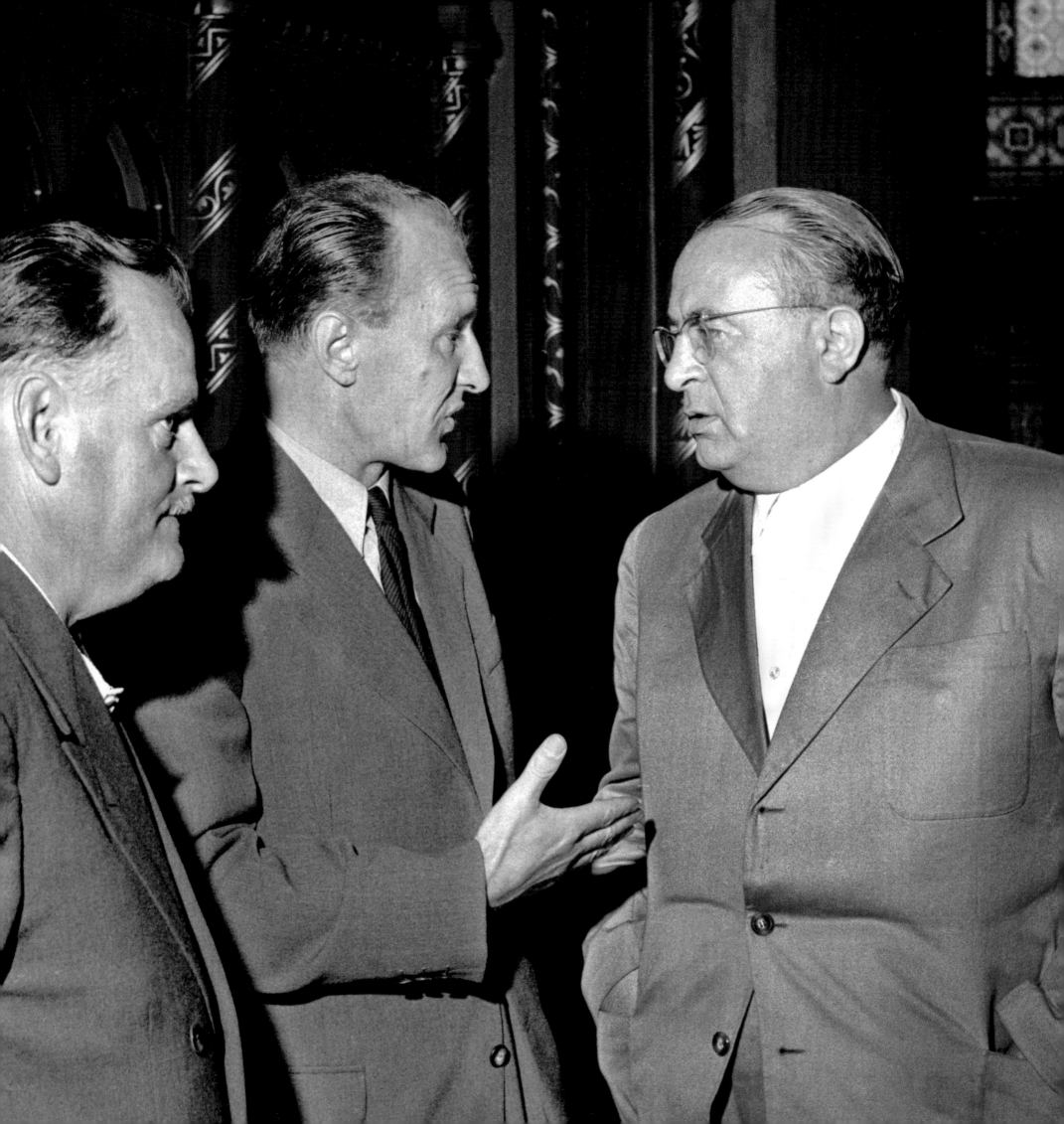

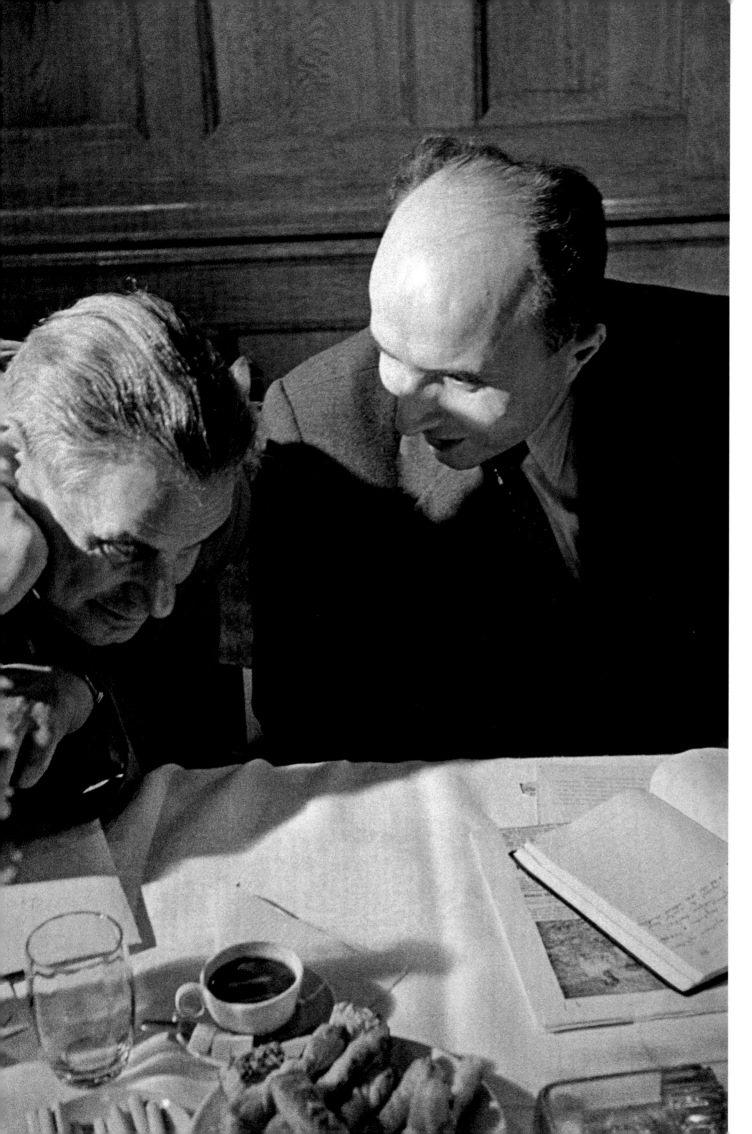

István Dobi, president of the Republic, and Prime Minister András Hegedüs in Parliament.

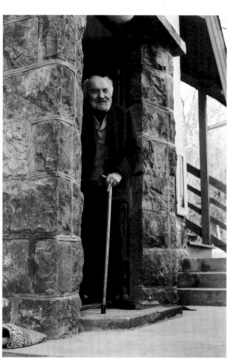

András Hegedüs, Prime Minister from 14 April 1955 to 23 October 1956, at the door of his house in 1998. During the 1960s, Hegedüs distanced himself from the Kádár regime over the intervention in Czechoslovakia. He died in 1999.

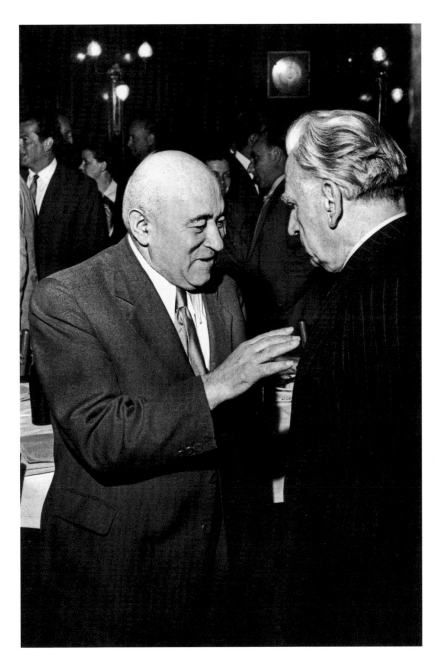

Meeting of the regional council of the National Front, summer 1956. Mátyás Rákosi, First Secretary of the Hungarian Workers' Party, talking to Calvinist bishop Albert Bereczky.

Meeting of the regional council of the National Front, summer 1956. Mátyás Rákosi, First Secretary of the Hungarian Workers' Party, with Calvinist bishop Albert Bereczky, Catholic bishop Endre Hamvas and Rabbi Benjamin Schwartz. The peace pastor Richárd Horváth (a priest who took part in the peace movement) is facing the camera.

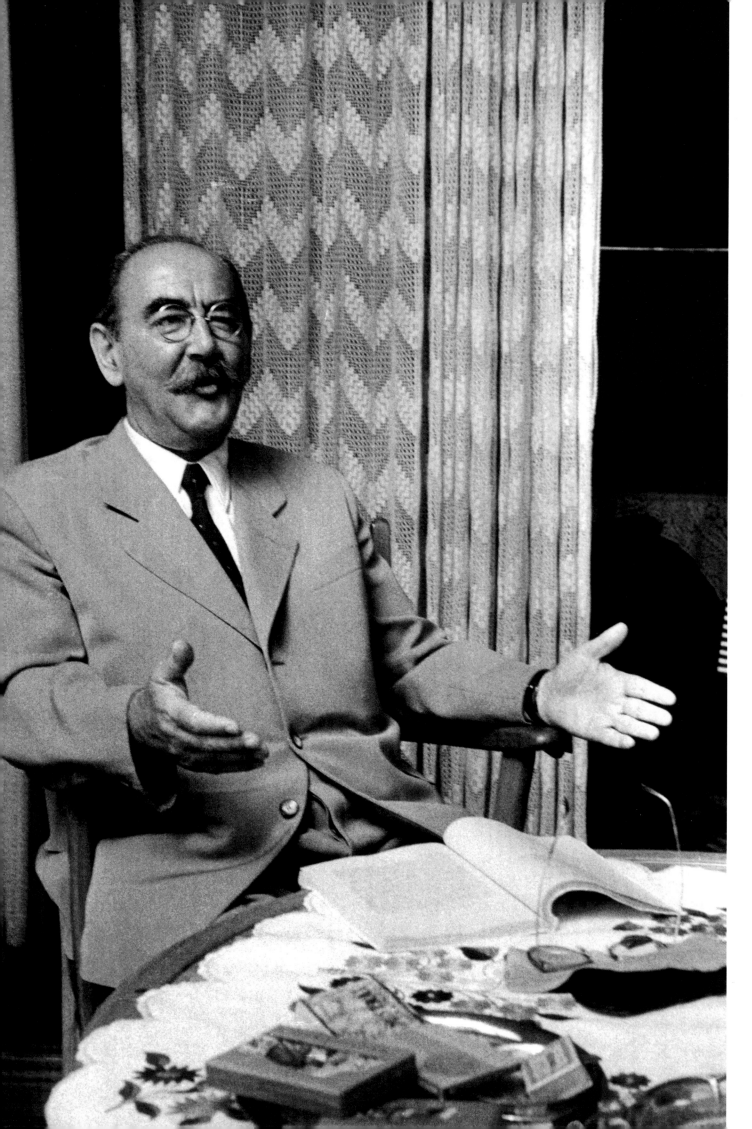

Imre Nagy, Hungarian liberal reform
Communist, in his house on Orsó Street.
Prime Minister of Hungary from 1953 to
1955, he was forced to resign by the
Stalinists under Mátyás Rákosi and lived
in internal exile between 1955 and 1956.
He once again became Prime Minister at the
beginning of the revolution on 24 October
1956. After the Soviets crushed the
revolution, Nagy was imprisoned, sentenced
to death and executed in June 1958.

Mátyás Rákosi, First Secretary of the Hungarian Communist Party, during a meeting of the Peoples' Front executive in Budapest. After his fall from power on 17 July 1956, he was sent into exile in the Soviet Union, where he died in 1971.

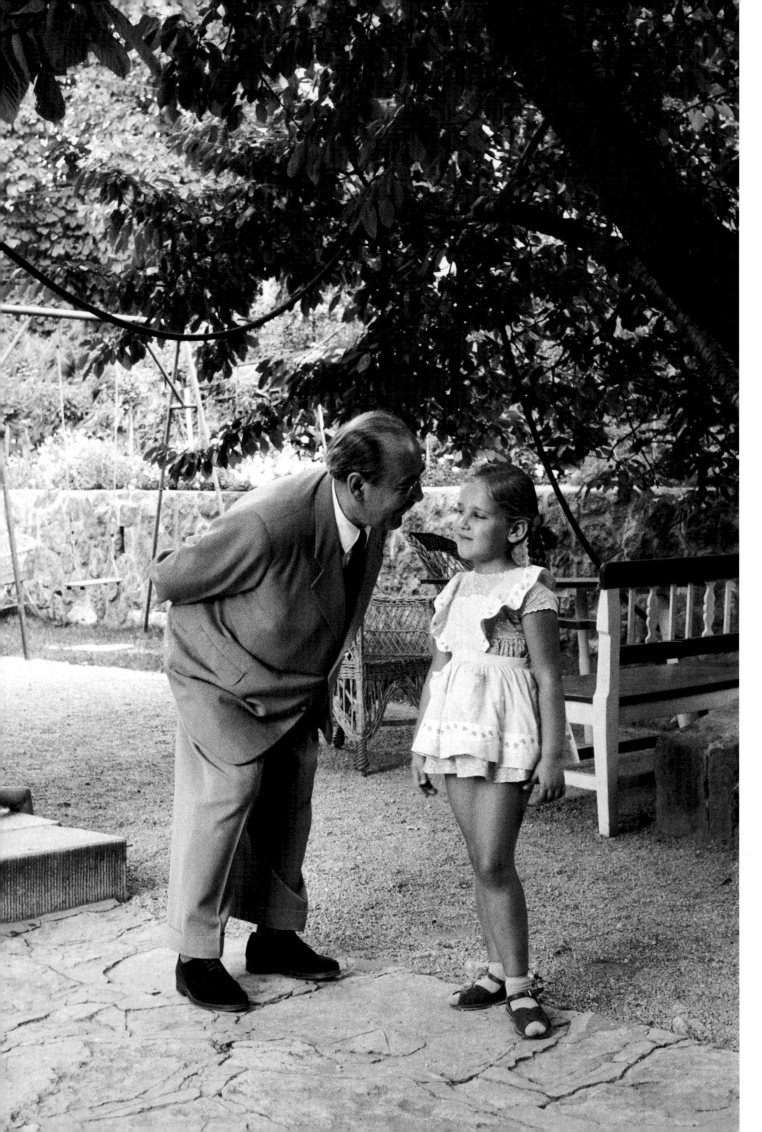

Imre Nagy talking to his granddaughter Katalin.

Katalin Janosi, granddaughter of Imre Nagy, is a well-known painter.

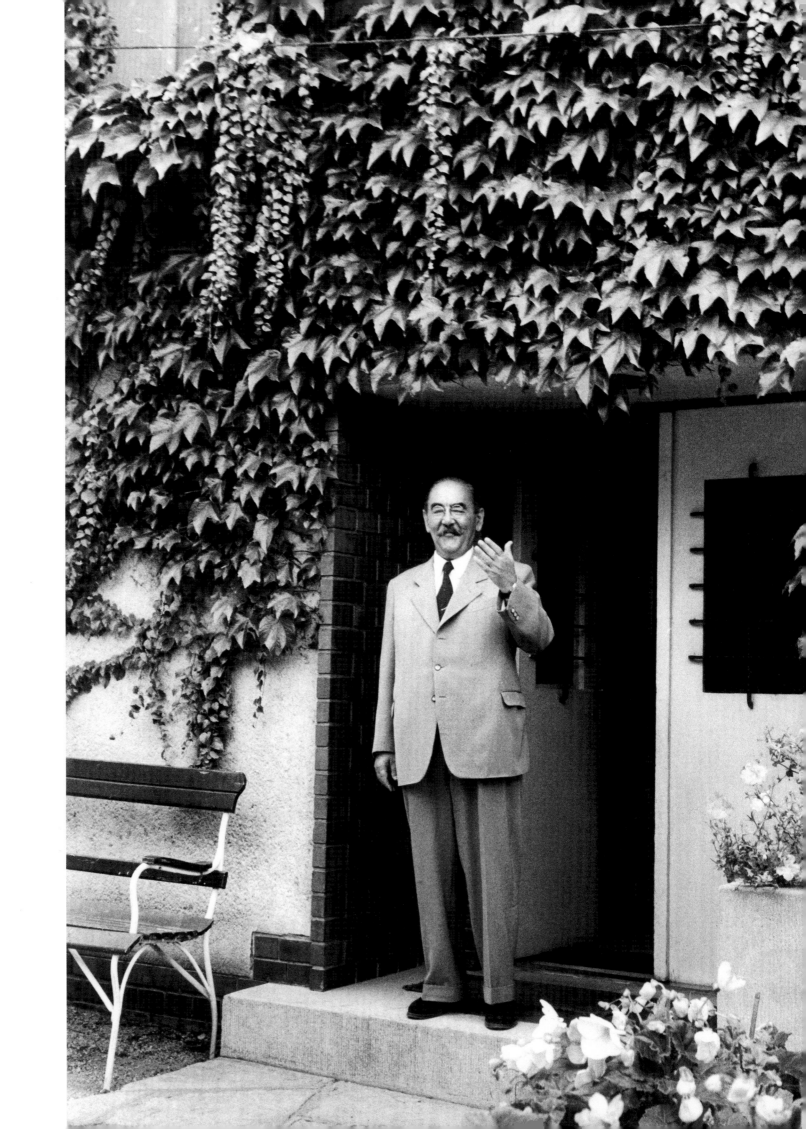

George Konrad

A stroll in Budapest in 1956

'Where were you on 23 October 1956, and what did you do on 4 November 1956?' A young journalist asked me this question at the outset of the 1990s in a small town that filled its weekly municipal paper with poems, reportage, lead items and news.

On 23 October, I had never held a weapon; on 4 November, on the other hand, I had. But as to why it had been so, I had, at that time, no answer. I recall it being a bright and beautiful morning on the first day of the events in question. That day, the first issue of the newly published literary and political monthly *Életképek* – or in English, *Images from Life* – on whose editorial staff I served as a volunteer, was due to appear. I sat in a corner room on Andrássy Street. No one else was present – the others had gone off to some gathering. It must have been around ten. I allowed myself a grace period before devoting some time to reading several amateurish manuscripts. There was a deep drawer filled with the poems of round-headed payroll clerks and complaint-filled tales of mustachioed veterans. A considerable number of curriculum vitae began approximately like this: 'There were ten of us, and we were often hungry.' Every job or student application had to have a curriculum vitae attached. Precise information as to the class of the parents needed to be included by the second sentence. Usually it began like this: 'I come from a middle-class family.' Because of these rules, the letter 'X' stood next to my name in the list of names of schools and universities. 'X' signified classless, unreliable, just barely to be tolerated, but, in accordance with local

resolutions, also capable of being banished. As for the other invitees, their respectable letters: 'W' for *Worker*; 'F' for *Farmer* – just as elite, 'S' for *Salaried worker* – good as well, but not quite as good, 'I' for *Intelligentsia* – neither good nor bad – these remained to be tested. But 'X'! Already suspicious in its mere form. A decent Hungarian name doesn't begin with an 'X'; 'X' is a cosmopolitan letter. I was X-like, a harmful element, which was no news to me. I had already had letters next to my name: either a 'J' or the three letters 'Isr', depending on whether they considered it necessary to put the stark annotation 'Jew' or the more decorative 'Israeli' – they, the agitated compilers of lists of names, part of the upright, reliable majority who even took pleasure, perhaps, in recording the evil ones' names in a register.

Suddenly I found myself once again among the columns of demonstrators; I had stepped off the pavement and joined the youthful demonstrators, whose then-small heads resembled my own. Some walked arm in arm and waited at every street corner for the state police to move in and disperse the columns. Many leaned out of the windows; curious, shocked, encouraging faces. The newspaper salesman abandoned his niche; his papers blew through the streets. Up to now, one had been allowed to wander through the streets except on state holidays, to cheer on the Party leadership gathered on the grandstand. A miracle of nature, how, within an hour, the population transmogrified itself into a people. Enough of paralysis, we have a full right to the streets.

Strange, now they're afraid of us and we are no longer afraid of them. You can write what you want on a sheet of paper and nail it to a tree trunk. An entire rhetorical structure has collapsed. Insurrection of language; everyone is a journalist; the whole city a wall poster. A public holiday for the out-of-line. What was illegal just yesterday is permitted today, simply because we're doing it and asking no one for permission. The many frightened individuals have banded together, are shouting out various solutions and mutually emboldening themselves towards greater self-confidence. The erotic magic of the masses is seducing the police, who don't even dream of shooting, into melting in with the others. Their own words rebel against the regime: revolution was considered a beautiful word in school – so now you have it. The people's hour finally arrives. He whom others have always spoken for, now wants to say something himself. This is no hour for sobriety. That they lie and we applaud, that's the way of all things. If people reject the power of the liars, they are an enemy of the power of the people. But this is now being expressed by a relatively large number. Riff-raff! Go back home! They refuse to go. Warning shots. The people shoot back. The monsters are immune to bullets. A nightmare! Within hours, everything that for years, suggested the order of things dissolves into nothing.

With only slight reservations, I tagged along with the crowd. Admittedly there were reasons to be there; out of a combination of compulsion and politeness, I had already marched along to the demonstrations on 1 May with hundreds of thousands of others. Among the organizers of the present procession, there were several people who, even during my high school years, fired with enthusiasm, had hurried along at the side of the marching columns, calling out from time to time: A song! Or who had burst into song at the first lines of a political tune that held true to the party line. Now they too were there on the spot. From inside a car, they directed the masses, acting like insiders. This time, however, newcomers surfaced at every step to set the tone and cough up their ideas. Whoever felt the inclination to make his mark as a producer of possible solutions bumped up against a grateful public. Whether a small poem or a clumsy rhyme, his creation was widely broadcast. But that wasn't enough; something had to be done, set afire, torn down! Earlier on, there had even been fires in Poznan. Is a decent peasant uprising imaginable without at least a castle being set on fire? To simply attack the red-white-green flag and to cut or burn out the coat of arms, the garland of grain, hammer and five-pointed star in the middle, was a relatively cheap solution. But for the rest of the flag to remain unscathed while the round coat of arms was burned away, this required a certain understanding of things. Every craft requires a skilled pair of hands. I hardly felt at home amid such violent scenes, just as I had previously been unable to tolerate the circle dance of loud laughter in the university corridors. The cult of collectivity hardly made me drunk; I retreated from my fellow students, who had vociferously forgotten themselves within the political campaign. The memory of those

processions welled up inside me, as well as those I had fled; they constituted a majority. This time, however, I did not make myself scarce.

It occasionally happened that someone marched along for a while, then had enough of the whole thing and turned his back on the marching column. The tram closed down its operations, old women and babies in strollers waved from the sidewalk. The loudest and most enthusiastic were those who had loudly and enthusiastically greeted the Communist takeover, nationalizations and extension of absolute power in 1949. The poet engaged in grand gestures; with a sweet-sounding and deep voice he called out, 'People, this is a revolution!'

I would prefer to present myself as patient, in no way as someone filled with the fighting spirit, and not at all as a revolutionary. My simple-mindedness, rather, was aligned with stubbornness. I carried my machine-gun more the way a citizen carries his umbrella, sensing it might be of use; after all, safe is safe. In my memory of the demonstrations leading to the downfall of the regime, images of clumsiness alternate with images of religious consecration. The once-tiny, almost non-existent opposition swelled to a mighty, fear-inspiring strength. It hardly required an organization; people gathered on their own in the square, as if an inner decree had summoned them there. There are heroes, who in such times keep a firm grip on the flagpole and place themselves before the mouths of shotguns, unbuttoning their shirts and crying out with naked breasts, 'Shoot, if you dare!' These are the kinds of situations I moved away from. But I was able to observe waves during which the natural fear of death waned, people cheerfully and exuberantly stepped down into the void, and mothers with their children carried the flag through a hail of bullets. Revolution is a celebration of voluntary sacrifice. No normal phenomenon. Though there is shooting, though there might even be a volley of fire, many people gather in the square. And then the symbolic pulling on the ends of the rope begins. Who is more determined, who morally stronger? And look, on one end visibly more people are pulling, on the other, visibly fewer. The equilibrium tilts. Normally cautious people remain in the square with death-defying courage, exuding a celebratory mood.

To stand in the square isn't enough. What counts is to move from one symbol to another, to overturn statues, open prison doors, occupy the news headquarters, printing presses, the radio buildings, the television, the network centres. Flags are waved from the balcony, and a humanist scholar is pushed forward before the gathered and overheated crowd to formulate such solemn and awe-inspiring sentences as he has never before spoken.

On the day after the outbreak of the revolution I did nothing in particular. I sat at home, flicking the dial from one radio dispatch to another, as the news reports swung back and forth. I tried to write an account of the preceding days, bought bread and meat; we set aside a reserve of powdered milk for our child, I paid a visit to the Writers' Club, which I had access to because of several reviews I had written,

and from which I held a scholarship and where, on that day, canned food was to be distributed. In an editorial office, four men clung to the four corners of a table; all of them had once sat behind it, all of them had been let go for political reasons, all of them laid claim to this desk. On the third day I succeeded in getting out of the way of a salvo of fire from an insane man jumping from a window. Carrying a stretcher around was enough to make one lose one's mind. On the fourth day I went to the university, and as a young poet and translator ran across the corridor screaming: 'Boys! Who wants a machine-gun?' I volunteered, and soon thereafter, now a member of the student-organized National Guard, I supported myself and my machine-gun on my elbows against the driver's cab of an open truck. Along with my writer colleagues, all of whom were around twenty, we were able to take over the editorship of our monthly journal from the old guard, those over thirty. My editor-in-chief had seated himself in the chair of the head of the Budapest city council, the multi-party system was installed, we resigned from the Warsaw Pact, and it seemed as if the Soviet troops would pull out too. But they marched in with yet another four thousand tanks and fired their canons at the spot from where machine-guns had fired at them – even at places from where no one had shot at them – simply for the sake of their own security or because it pleased the soldiers to do so. General strike, permanent firing, a theatre performance extending out into the entire city. When a boy or a girl unexpectedly caught themselves with a gun or a stretcher in their hands,

they didn't even pause to consider their own future; they lived in a compromised present, thinking neither of fame nor prison. Among the fighters, the prisoners from the mines were perhaps the most courageous, as were the other, general, prisoners, who had been freed, some still wearing prison garments. And certain young men and women on the square, welfare cases who had returned home from institutions. The year 1956 is very possibly the most memorable year of my youth: the sudden fading out of fear and the unexpected upsurge in courage.

Promenading fur coats, Persian lamb collars, winter coats trimmed with braids and tresses, old Hussar uniforms; in the anteroom of the council chairperson and mayor respectively, one could appreciate various costumes. In the middle of the first floor of the town hall, in the chairperson's room, sat my boss, the designated editor-in-chief of our not-yet-published journal, a poet gesticulating with wild arm movements. He had simply occupied the chairman's place in the leather chair behind the desk and become the leading man among the local powers. Our mutual friend, the eminent ethnologist, read out an inscrutable, puzzling, yet respectable piece of logic that appealed to those searching for some sign of approval. The editor-in-chief called the previous chairman: it would be better if he stayed at home, nothing would happen to him; he would send a National Guardsman armed with a machine-gun, a student just like me, for his protection. The editor-in-chief gave the secretary instructions and took the stamp in his hand, as if he were head of

the town hall. This was taken note of by everyone. The outer offices were teeming with strangers, all of them waiting for a stamp allowing them to found a party, or grab some money for start-up costs, or take custody of a car, or a building, or anything else one might lay claim to. They praised the armed youth with honeyed words; the fresh-baked editor had stowed his machine-gun beneath his chair and was patiently waiting for the potentate seated inside, with whom he wanted to discuss their literary journal. The gentlemen received their stamps, and I could observe which rhetoric belonged to which coat. Without the persistent derring-do of the daredevils from the street, the gentlemen in the anteroom would not have been able to hang around so hopefully. The good husbands and fathers, who had made their way from their one-room apartments to the factories, must have swallowed a great deal before they too, surprisingly, joined the ranks of the street fighters. Also unforgettable were the scenes in front of the Budapest Party headquarters: the hanging of the half-naked, stepped-upon, spat-upon bodies lying on the ground, who had met their deaths via bullets and beatings. Hung by their feet, with their heads pointed downwards. These sacrifices to the justice of lynching were mostly men of the State Security Service. They had to pay for the fact that their headquarters were so terrifying. But when I looked the dead person in the face, these reflections had little meaning in hindsight. All sorts of still-buzzing heroes surrounded me, hand grenades beneath their belts and a machine-gun draped over their shoulder. I left the scene, and stole away.

I entered a café to get myself a strong drink. An elderly woman sat at the piano; her platinum blond highly-piled hair was so perfect it was as if we were in the midst of the most pastoral peacetime. Outside there was a clatter of footsteps, someone was running; many followed behind him, and, on the steps to a cellar, they shot him. In the university building I found my favorite lecturer; we remained standing for a moment: 'Humanists with machine-guns?' he asked. 'Well, in times of change, yes. Safe is safe,' I replied, and neither of us were entirely certain how to take this. Evenings on the way home, while I was wearing a National Guard armband and shouldering a machine-gun, umpteen women bade me, from the windows of their rooms, do them the favour of bumping someone off, right there on the second or third floor, yes, right there in that corner apartment. The popular longing to execute someone didn't manifest itself in me in an obliging manner. I went home to listen to the radio and read Erasmus and Tolstoy. On Lenin (today Teréz) Boulevard, I found Tolstoy's *Childhood, Boyhood, Youth* in the trash in front of the Horizon Bookstore.

I was able to fish these out from among the discarded books awaiting cremation; several years later, they appeared in my reading list at the university in a new edition from Hungary's Helikon Publishing House. To say that I was a wildly committed freedom fighter would be a radical exaggeration. But why then, did I want a machine-gun? This pubertal desire might have been a remnant from wartime and the years following it. Sometimes I imagined armed

troops hurrying up the stairs to liquidate us. From which corner of the hall would I be able to fire most effectively? I had quite an accurate aim; during my brief military training, I had actually been awarded the title of champion marksman. Vera, my wife, found contentment in cooking during those days; a delicious bean soup with dumplings and smoked sausage sat on the table. Vera was satisfied with the news that leaked out through the neighbourhood and from our circle of friends, and felt no great desire to roam the city with me, where someone might be standing with a loaf of bread under his arm and, thanks to a tank cannon, his head would disappear just like that, while he stood pressing the bread to himself. It made me think of the body of a chicken that continued darting about even after someone had placed it on its back and hacked its head off with an axe.

I moved through the streets, where, within a short while, much dust and garbage had gathered. I read the appeals that were fastened to almost everything with tacks. Many of them decisively encouraged the complete withdrawal of the Soviet troops. Nor was it enough for them to leave the country; at every train station they needed to beg the heroic Hungarian people for forgiveness — those whom they had hatefully insulted with their groundlessly long and drawn out visit and the recent shootings which had reminded us of the Russian suppression of the freedom struggle of 1849. Even in the café on the corner I heard impetuous speeches. Someone wearing a coat with a Persian lamb collar promised

Konrad Adenauer's arrival. If only the bearer of this news hadn't added that the Chancellor would arrive on a white horse. Even before I left for home, like a reporter, I informed Vera of what I had seen and heard (the telephone worked in certain places, and I had enough coins), and stopped at the Writer's Union, where even now a lively bustle reigned. Delegations came and went, embassies kept themselves informed, members arrived, a young storyteller maintained he had written a story and shot two Soviet soldiers. As accompaniment to this claim, an old poet let go with a skeptical fart entirely appropriate to his strange art. A feeling of significance streamed outwards from the executive committee. There, preparations were being made to draw up and publish an explanation. It would need to be both brazen and velvety soft, euphonious yet explode like a bomb: in other words, a masterpiece. Several people in the restaurant were discussing how far back one would need to go. To the establishment of the one-party system — in other words, back to 1949? Back to 1945, to the invasion of the Soviet troops? Or still further back? Where should we find our footing? What would be a reliable point of departure? From how far back should we set out? If there were no absolute starting point, couldn't our present revolutionary day be the beginning of a new calendar? The present day with its state of drunkenness, its sense of its own importance, the exhibition and spitting-upon of the dead? Even more dead on the sidewalk — liberation goes hand in hand with killing. One reporter has information about the withdrawal of Soviet tanks; another has exactly the opposite

information, namely that they are arriving. The railway men reported that the caterpillar tanks were also rolling inland on wheels.

Upon which the Old Man – understood to be Imre Nagy, the Prime Minister – simply waved them aside and said one couldn't take the word of the railway men seriously, they always played the role of well-informed insiders. He too had an older cousin with the railway, oh yes, if even one out of every three of his stories were true, then Uncle Imre knew a great deal. On the last evening, that of 3 November 1956, a Saturday, we walked to my parents' for lunch. No trams were operating; we talked politics over a cup of coffee with my father, since we were in a rush to get back home before the curfew. On that day a confident voice seized hold of me: we had become a neutral, parliamentary democracy; my contemporaries and I would be allowed to publish our journal. With my machine-gun slung over my shoulder, I visited the director of the newspaper-publishing house, who complied with all my requests. 'Yes, of course, we'll market the paper in an edition of sixty thousand copies.' We spent a familial evening; a new reality had developed. There were already parties, newspapers and politicians of various shades, everything already seemed to be functioning on its own, I would no longer be needing my machine-gun; nonetheless, it was soothing to know it could be found there in the bedding box. Were someone to rap on the door in the grey of morning, I could calmly ask, weapon in hand, who was there. As Budapest was startled

from sleep on the morning of 4 November 1956 by the thunder of artillery, I lay at Vera's side in a narrow bed in the small room beside the kitchen, previously known as the maid's room. Towards three, Vera had come in from the large common room, perhaps because she was cold and didn't understand where I had gone, and crawled under the covers with me. I had written something the night before, astonished how a government under a multi-party system, that for so many years had seemed unnatural now seemed so natural to me. Had my fantasy been too weak? Do we only consider natural that which is possible? I had kept myself awake with strong tea; I too was cold, and tried, snuggling close to Vera, to fall asleep. The old couch contained a coldness that brought us especially close to one another. Should armed soldiers try to take me away, I would fire, I imagined to myself in the dark, with my arms around Vera.

Then come the moment of awakening, identical for all the people. Women and men equally prop themselves up in their beds, the men provide expert advice, yes, hostile tank fire from a T-54. Then they all turn on the radio and listen to what will be quoted decades later in the newspaper articles: 'The Soviet troops have invaded our country with the obvious goal of toppling the lawful regime. We are assembled in our square. Our troops are engaged in battle.' Darkness still prevailed in the maid's room, as we continued to snuggle up to each other, for Vera already knew what I was thinking even before I had thought it. If our troops were engaged in battle,

we wouldn't leap to our feet, but rather would stagger out of bed. I couldn't have known that, were I to leave the apartment, the lawful Hungarian government could now be found in the Yugoslavian embassy. Vera already knew that I wouldn't be able to remain idle, that I would have to set off, if the Fatherland called. Therefore it was appropriate for us to hug – we were entitled to that – for outside there was shooting, even if not in our immediate neighbourhood. Clever people stayed in bed, curiosity didn't drive them outside toward unknown adventures. Better people took a fresh bath, put on clean underwear and took themselves – a soft-boiled egg and a cup of tea in their stomachs – to the slaughter. With my machine-gun slung over my shoulder, I trotted down the staircase, where no one as yet had stuck out his nose. Behind several apartment doors I could hear noises, and, as I passed by, also creaking floorboards, while peepholes were being opened and closed. On the street, my gaze was drawn to the left; I immediately saw a tank column threading its way across the Great Boulevard. A seemingly endless armada of tanks clattered along from east to west. I pulled back behind the arcades of the buildings, but then continued on in the direction of Ring Boulevard. A man accosted me from the landing of a building, pulling me inside with him. 'If they see you with that machine-gun, they'll blow you to pieces.' For what reason, actually, did I necessarily have to take a weapon with me? In the university building machine-guns were sitting around by the crateful. For the present I just had to succeed in getting there. I took the weapon back

home and stowed it away in the bedding box. I was given another cup of warm tea, shoved Maurice Merleau-Ponty's book, *The Adventures of Dialectic*, in my shoulder-bag, and set off anew. On the boulevard, there was a large gap between the tank columns and several pedestrians dared to cross the embankment road. Soldiers with machine-guns on the roof of tank trucks looked around without prejudice. Not far off, in smaller streets, at windows and in entranceways, people snooped about and spied.

On an empty lot weapons are being distributed from the back of a truck. I hear news of successful resistance by rebels, one of whom I encounter at the university. The gatekeepers know me, I go to the area of the Revolutionary Committee, to the Dean's office, where some people have gathered; I also meet Éva, in her dark blue ski pants and yellow-blue pullover; with dignified discretion, she reaches her hand toward me. What are we doing there? Well, yes, we just happen to be there; we are printing flyers, giving and taking advice, telephoning, maintaining communication; we have more than enough arms and canned ham. The Russians had not yet attacked the university, and we didn't shoot at them either. The public buildings were already in their hands, but the university was still ours. I call Vera to say I have arrived safely and that, for the moment at least, there is no fighting. Vera says she is cooking green bean soup; she still has a bit of smoked meat. Here it is teeming with the craziest among the philosophy students, buzzing about and trying to seem important; for various reasons, they feel the story couldn't be

taking place without them. I too belong among them, I am not alone, certain gazes come to rest upon me. I believe that great significance must be attached to my decision and my conduct. In war things happen in a haphazard way – a person is intent on either escaping, or having his fill. And he eventually succeeds in doing one or the other, perhaps only at the expense of his companions or by gunning down certain hostile people. In hindsight our generation endowed all that lay behind it, and all that it was forced to remember, with a certain moral significance. Late at night on 4 November 1956, I was standing guard, a machine-gun slung over my shoulder, at the single window of Budapest's philosophy department along with the budding painter Éva Barna. Along Váci Street, the engine rattling of a tank could sometimes be heard. This was the more banal part of the affair; the extraordinary part was Éva's beauty and deep, meaningful voice, and above all, what she actually said. She had read Camus's *The Myth of Sisyphus*, which I didn't yet know, in the original language. I had already, on the other hand, devoured *The Stranger*. It is perhaps not possible simply to begin a story of such merciless perfection. Inspired by low motives, by jealousy, I made ironic remarks about Camus. In December, Éva emigrated and met Camus, and afterwards corresponded with him. Between them was only the cost of travel; between Éva and myself, the Iron Curtain.

While we watched the street, I hugged Éva, touching her ear with my chin; after some rattling and a half turn, the barrel of a cannon stared at us, taking our window into its sights. Leaning against the wall of the window's niche, I tracked the precise devastation the cannon would cause. It damaged nothing, but exuded the smell of the unusual, so that it seemed appropriate to remain at the window, in order to inhale more deeply the beautiful scent of Éva's hair. Our watch came to an end, the pairs separated, drew back into the seminar rooms, taking gymnastic mats and blankets with them. Éva went back to her husband; I didn't even look to see in which direction she disappeared, I had to occupy myself with producing the flyers. The intellectuals could be found gathered there, the occupiers must be persuaded in Russian to give up their reprehensible conduct; they would be surprised, were they to recall the Marxist truth that a people that suppresses another people cannot themselves be free. In my version the Russian sentences turned out a bit complicated, and the text was more of a treatise than a pamphlet. With a mutual effort of wills, my version was shortened and simplified, and I gratefully agreed to the changes. I no longer kept composing pamphlets at the university. My notebook had been empty for days. An unproductive time.

The night passed, with screaming and panting in the distance. I cannot remember where I slept; perhaps I also found a place on a gymnastics mat or in the room where the military uniforms and quilted coats were piled up. The university blossomed during those days. In the yard, trucks stood at the disposal of the student revolutionaries, on the landing cratefuls of machine-guns, still oiled and wrapped in oiled paper.

There were enormous amounts of packing material and wood shavings for wrapping our valuable cargo, the canned ham and peach preserves donated to the heroic Hungarian youth courtesy of Dr Otto Habsburg. At the time, I had the feeling of living in a permanent movie, in which events — for example the actions of the Russians and the students, these panting and snoring figures — went on and on, while I, the circling moviegoer, kept watching so that things would be observed and there would be someone who remembered, since the event would only be charged with meaning in retrospect.

That night it happened that someone's pistol went off during the cleaning of the firearms. Although the room was full, no one was injured. I slept several hours and couldn't free myself of the question of what the devil I was actually looking for here. The nation's young weren't here. A few mineworkers perhaps, yes. Many of the working-class assistants attached to the Chair of Marxism-Leninism had also gathered around. And, of course, several young Jews: poets and aesthetes. The radicals. The larger portion of the students felt that events had developed to the extent that the wisest thing to do was keep your distance. I said that the Soviet interference in local affairs was unfair, and that I wanted to interfere in local affairs as well, and equally armed. That was just fine up to a point. But now the actual question of who was to be shot presented itself. We students sat together; among us there were certainly those who had already killed, but the majority surely not. Should we defend the university? Should they go

ahead and lay siege to us and shoot us up, should we return their fire until the last cartridge was used up, up to the last drop of blood? Should we retreat from room to room, should we allow the university to be laid siege to by the canons and the mine throwers stationed on top of Gellért Hill, our mountain of boulders, while we all went to our destruction among the rubble? Whether the afterlife would consider us to have been counter-revolutionaries or martyrs, was its business. How long did one have to put up resistancefor? Until they were dead? The philosophy students believed the conscripted Soviet soldiers weren't to blame. I understood — I had eaten with them in a field kitchen, where we National Guards had also been allowed to seat ourselves after putting our weapons aside. We ate, made conversation, the Russian lads said the same thing as the Hungarian policemen, that they would gladly stay out of the whole thing, though this was sadly not possible, that they were longing for home. 'It breaks my heart, little brother, but if I were given the order, I would fire away at your house.' We thanked our hosts for the cabbage soup with meat dumplings, took up our arms again and went on our way. Each of us stayed alone with his doubts in the morning fog. Suddenly the fog lifted, and dazzling sunlight fell on the window. Should the nation continue to strike? For how long? To shoot at someone from behind like a guerilla, like a sniper, from a dark hole, from a dormer window? Wildly determined shooting? But at whom? At the occupying forces? At the collaborators? Just like that?

In reaction to my impatience, the oldest member of the revolutionary committee advised me to go out onto the street with a pistol, look around at what was going on in the city, and, should I have the feeling of needing to shoot one of the keepers of the peace, hunt him down; in short, I should experiment as to whether I was suited to terror, and shouldn't retreat from the onset of darkness to report back to the others about my experiences. I should watch out for myself, the armed sentry guard said, and then let me out onto the street: 'Right now there's no shooting, run along!' A longhaired type in a cloth coat emerged from the university gate and started on his way for a walk through the city. Pistol, penknife, apple, fountain pen, notebook — he reassured himself by checking his coat pockets to make sure he had everything he needed. Press yourself against the wall, force your way into the dirty grey plaster! People hang around between the armoured tanks, tank infantrymen have a smoke. Work is being done in the bakeries; the rumour in the shops is that there will be bread. There's a long line in front of the store, sometimes a machine-gun salvo can be heard, everyone presses themselves against the wall, but luckily the shooting was taking place not in this, but the next, street. A truck delivering bread arrived, the driver harvested the appreciative gazes, and whoever could manage to grab a whole loaf of still lukewarm bread and take it home was intoxicated by his small strategic success. I run into Johanna, my former French teacher with her silver grey hair. 'Where are you going?' She has a crippled student, to whom her French lessons are very important. 'But they're shooting!' 'A person has to do his work, and at some point he has to die anyway!' counters Johanna. I meet my neighbour Diósi, a bulging rucksack on his back. 'Where are you coming from, neighbour?' He's been to the Jerewan Bar and has helped himself to several bottles of good booze. Plundering is already underway on Rákóczi Street, the Russians have opened up the shops, and the rabble is following in their footsteps. Wherever there is something to plunder, you will always find plunderers. That's clear. Strange, however, that during the revolution even the rabble didn't rob stores. And just as strange that Mr Diósi is an honest employee of a trading company. On 6 November the city seems to be coming to life around the tank infantrymen. The general strike goes on. But the children need bread and milk. Everyone has a day off, most of the country has stayed home, people cruise the streets. Those in the power structure, in blue-grey quilted jackets, loiter around among them. The very same corners and faces. You have to wind your way around the tanks; we don't necessarily talk to the occupiers.

People don't believe the newly arrived troops can be talked into withdrawing. The tank infantrymen fan out like a traffic barrier. On the street corner, the sound of disappearing steps, leaflets from the Soviet commanding officer: 'Resistance will be followed by tough measures of revenge.' At the university the guards greet me. 'What's going on?' 'Helplessness.' I tell the head of the revolutionary committee residing in the dean's office that I am neither capable

of shooting a Soviet soldier nor a Hungarian collaborator, especially as it would be more damaging than profitable to do so. One had to find another solution. The majority voiced the opinion that one couldn't separate the occupiers from the collaborators, since everything was in their hands. What remains is selective unrest. The majority will fall into line with the occupiers. If we continue with the armed struggle, we will be fanatical assassins. If we lay down our arms, then we will have lain down our arms, which will have consequences; we will have to prepare for a modus vivendi, then we will make the transition to a graver illness, then we will decide on a cautious, long-term historical strategy, then the constant and permanent Party and its verbal power will be mobilized into action. No heated discussion concerning this took place; if they attack us, we will defend ourselves, though they haven't yet attacked. Then the news arrived that they had shot several rebellious students in the yard of the School for the Visual Arts and that they were also combing the neighbourhood cellars, and whatever students they found, they would drag to the Academy yard and shoot. Then an overexcited student arrived and called on us to follow him to a barracks at the edge of the city in New Pest, he had found two trucks; this was the right place for us. I asked him why we should go there. 'Because you will get shot.' 'From where?' 'With hand grenades from Gellért Hill, thrown from the mountain of boulders.' 'But one can't shoot back with machine-guns from the barracks.' 'No, we surely won't be able to shoot back.' 'Then why should we go there?' 'Don't you understand? So that we can rot together!' 'That I don't understand,' I countered. Éva wanted to accompany the students. I grasped her hand tightly, as she tried to climb onto the large wheel of the truck. A Soviet officer arrived, white flag in hand, and handed over a scrap of paper containing a brief message in Russian. If we didn't clear the university, they would, by way of raising the stakes, raze it to the ground tomorrow. In our own interest and that of the university, we go home; we keep several documents for ourselves and crawl off, one by one, leaving our weapons, truck and canned ham behind. I keep guard duty. At our door. I haven't taken the machine-gun out of the bedding box. I stand at my post talking to a noted conductor, a reserved, cordial and absent-minded person. Appropriately, he utters his opinion: 'In the end people are left in the lurch. We don't believe this as long as it doesn't actually happen. We Hungarians have always counted on the gullibility of our leader. We believed the Germans. What became of it? We believed the Russians. What became of it? And now we believed the Americans, that they would help us and that the Russians wouldn't dare to invade because public opinion was so powerful. And what became of it? We'll even abandon ourselves. Be suspicious, young fellow! Above all, when you are tempted by hope. Hope leads you into the pit. You needn't have any qualms about seeing it as the road to a mass grave. I have my music here with me; just hook me up to the violin. That's the way I am. You, if my intuition serves me correctly, have devoted yourself to literature. I'm telling you: develop a secret language!'

The following day, I went to the Writers' Club. Inside all sorts of foodstuffs were being distributed. Even the editorial staff of the new literary journal — in other words, my diminutive self — got some of the eatable goods. The city already had the battle behind it as bullets whistled along Bajza Street anew. The wall of the building was even hit by shots, though the machine-gun salvos from the armoured tank, intended merely as a warning, swept over the embankment. We turn off the lights and watch from behind the heavy curtains, as two young men armed with machine-guns run across to the other side of the street and jump over a low garden gate, as the door leading from the front yard into the house must surely be locked. They come back, looking helplessly around, all the front doors are locked, and not one of them is going to be opened for them. 'We ought to let them in,' I suggest. 'Have you gone crazy? So that they can fire away at us in here? So that the tanks can all gather here and attack the Writers' House?' We abstain from inviting the two young men in and are relieved when they make themselves scarce around the corner. On the shelves all around us there's a great deal of paper. Explanations, elevated diction, dignified texts. One writer or another continues to arrive. Even a group from the Russian garrison headquarters turns up. The spiritual leaders are called on to negotiate. Discussion between hotheads and real politicians. There's no more show of strength involved. We still can't imagine that those like ourselves will be kicked out of this house, out of all the universities and off editorial staffs. The losers

disappear in all directions and don't cling to the company of the others present. There will be no basis for collaborative politics for some time. Whosoever's power is derived from the people must send the Russians packing and make room for parliamentary democracy. That way leads to the gallows, or to prison. Whosoever's power is derived from the Russians must guarantee the smooth functioning of the police-controlled occupation and the one-party system. We can withdraw, that would be the wisest thing to do. The West has handed us over to the Russians and doesn't want to get involved in a war on our behalf. We can shoot at them a little, in response to which they'll raze our city to the ground. The best case would be for the defeated masses to set up a revived satellite regime under their noses. Then we could hide in an even deeper cave, from which no kind of envy can cast us out.

After the Soviet tanks arrived for the second time, in even greater numbers and angrier than on the evening of the rebellion, two hundred thousand out of ten million Hungarians left the country, mostly young people, half my classmates, most of my friends and loved ones, my sister and cousins. Fifty-sixers? After a brief, heroic inner struggle, the decision: are you going? Are you staying? Whoever could leave left, fleeing westwards from something evil, from revenge or something like it: what had been and — well, yes — what had been exposed. In the cold and snow our youth crossed the carelessly guarded border. Even Vera telephoned

back and forth; what she heard was enough for her for the most part, she didn't care to see the fallen, the burned, and the hanged, no matter which nation's sons they might be. She simply longed to get away and into the arms of more trustworthy people. She would go to Paris to teach English and Russian, she would establish the basis for our livelihood there, rent an apartment, we should follow behind, she would take care of everything, but we should leave no matter what! I shouldn't be so ponderous! Our friends and cousins arrived, they wanted to leave tomorrow, I should join them. I stayed. I said I was a more constant presence here in Budapest than were the heads of the government. Admittedly, I didn't want to swim along in this current, I wanted to know what was going to happen here, in these streets. I didn't want to tear myself away from this not-yet-concluded story. I wanted to be neither particularly dexterous nor normal; it was a simple life I wanted to have. Always the same stairwells and cafés. Among those with whom I converse in my mother tongue, most stay put in their ancestral place, few of them ever leave. Just before Christmas, Vera, in the company of my sister Éva, set off. They even made it to the border, crossed it during an evening snowstorm, continued their march in the darkness between Austrian conscriptees, then suddenly once again caught sight of Hungarians. Most probably they had circled the same mountain twice. They were exhausted. My sister tried again the next morning and succeeded. Vera turned back on Christmas Eve and arrived home, somewhat unhappy that I hadn't put

up a Christmas tree. We went down to the street, where we managed to find a small tree and some decorations. We had gifts, an improvized dinner, candlelight, familiar merriment.

In 1956, I stayed. Whenever I had the opportunity of leaving, I stayed, sat myself down at the table, and wrote something. Whenever I had to reach some kind of big decision, I preferred to make no decision, allowed things to run their course, ran with the times. I had to learn to tread carefully, with fear as my travelling companion, so that it would have no power over me. After 1957, people no longer fastened thoughts they had entrusted to a piece of paper onto a tree trunk with tacks. The soul turned towards the wall and pulled the blanket over its head. The larger portion of one's memories had died; keeping them alive proved an unprofitable business. At the end of the drama comes revenge: death sentences. In the fall of 1959, I was working as a social worker. On a sunny afternoon I had some work to do on Százház Street, which has been partially torn down and rebuilt since then. If a 'slum' existed in Budapest back then, it would surely have been Százház and Jobbágy Streets, near the East Railway Station. Not only because of their shabbiness, poverty, population density, as well as their large population of gypsies, but also because of their human warmth and openness. Everyone knew everyone else, people lived on the streets. As I turned the corner, sobbing could be heard from every quarter. What had happened? That day, their next of kin had been allowed to go to the

central prison to gather up the belongings of some ten boys and a girl. They had been hanged. Rebels of 1956, mostly still minors, true daredevils, who had blown up Soviet tanks. In the spring of 1959, the authorities encircled the street. A troop of young people was rounded up from house to house, and a portion of them sentenced to death. In the time since the judgment had been carried out, it was deemed that they had reached maturity. I had some work to do at a young widow's house, whose children were hanging around. 'What did your husband die of?' 'They hanged him.' He was chairman of a workers' council and didn't even own a gun. A person who is merely shot accepts his fate in a secret script; one sentenced to death plays a serious role in the ritual. In what way is ascending a footstool beneath a low-hanging noose different from other movements, from standing still, from having one's hands folded behind one's back? Had humans grown accustomed to the formal frame of the prison, did they only speak when asked to, and remain silent when they weren't? If they absolutely wanted the lives of those captured, then let them have them, let's get the whole thing behind us!

Notes from the year 1986: I receive visits daily from journalists from the West. I give one interview after another about 1956, take part in memorial events. My writer colleagues took up vows of silence, refrained from every careless utterance. My afternoons are planned, committed, the Italians are coming, the Germans, the Dutch, the Swedes, God only knows what drives them on. Only outlaws like myself are prepared to talk openly to them, or at all. There is a need for international pathos. We supply this through various forms of nutrition. Some – Hungarian, Czech, Polish and East German dissidents – have signed up to a common explanation in memory of 1956. But only we, the upright patriots, uttered not a sound. At the fat writers' regular table, they pondered what reprisals this mutual explanation might bring down upon itself. The Politburo is embarrassed, talks of an escalation, and considers various means of revenge. The police patrol the streets in twos or threes. According to the rumours, battle units numbering sixty thousand men will be dispatched to Budapest. Motorized policemen in leather jackets pester drivers. One taxi driver thinks it's as if they had been fed on tiger's meat; one simply can't calm them down. On the radio old leaders brag about their victories of thirty years ago. The armed suppression of the revolution is a victory for them. If we hang, then we have overcome all doubts. Mass arrests are a victory as well, as is the reality that two hundred thousand people have fled to the West. Order and law-abiding only rule for them if they, and only they, are in power. But the authority has grown weak with age, new powers are knocking at the door, the Kádár era is coming to an end. He who yesterday remained loyal to Kádár because only worse could follow, would now be happy were he to abdicate. All send reminders of changes, impatience is growing, developments are moving quickly, something must happen, but caution still prevails, even if mixed with rage. The more cautious gather

around the courageous, who might possibly be able to get something going. From the time of 1956 I recall the sudden fading of fearful natures, the unexpected acts of courage. In the meantime, the revolution of 1956 has become a classic. It is the one development possessed of world historic significance that we in Hungary have been responsible for this century. It might be, after all, that we could still bring the whole thing to fruition, without shedding even a single drop of blood.

Notes from the year 1989: Imre Nagy, the revolution's previously loyal, moderate and professionally-mannered Prime Minister, was hanged, with the approval of his successor János Kádár, on 16 June 1958. His remains were buried in an unknown place, in a neglected and unmarked corner of the central cemetery, along with others sentenced to death. On the thirtieth anniversary of the execution, several hundred people demanded an honorable burial and democracy too. We opposition members had gathered in downtown Pest at the memorial flame for Count Lajos Batthyány, another executed Hungarian Prime Minister. After taking blows from the rubber clubs of the police attack commandos, the demonstrators continued their gathering at ever different venues, so that they filled the entire city centre. Thirty-one years later, on 16 June 1989, the actual burial took place. Beside Imre Nagy and several of his fellow accused, we laid an unnamed rebel fighter to rest in an unmarked grave. Around one hundred fifty thousand people had gathered in Hösök Square (Heroes' Square). In the early morning we continued to debate with friends whether or not we should take the children with us. Everywhere in the media and among the people there was a great deal of talk about the revolution at that time. A gap in the curriculum vitae had been filled; we saw the face of our youth in the mirror of remembrance. The dead came back to life. If it wasn't granted to the nation to be sovereign, the legitimate Prime Minister at least had the possibility of being so. Knowing what awaited him and aware of the mentality of those who would give orders to his judges, he declared himself not guilty and refused to ask for mercy; he did what he did, he stood by his word. Hungary no longer belonged to the leader of the merriest barrack in the laager, the then already mentally confused János Kádár. Instead of deciding on an armed living father, the country had decided on a dead father for its coat of arms, the executed Imre Nagy. It required a certain liberation to be able to decide thus. Not long thereafter János Kádár died as well, and the repressed remembrance of the revolution unfolded itself from the briefcase of materials that had been kept under lock and key. We recalled our shared history, so dramatically mirrored in our private histories. These memory-encumbered activities are of a thoroughly Central European nature. We grieved for the dead, the bullet holes in still-viable bodies, for the heroes equally as for the fools. This gigantic, collective reburial was a symbolic turning point. Democracy had returned to Hungary.

Translated from Hungarian by Michael Blumenthal

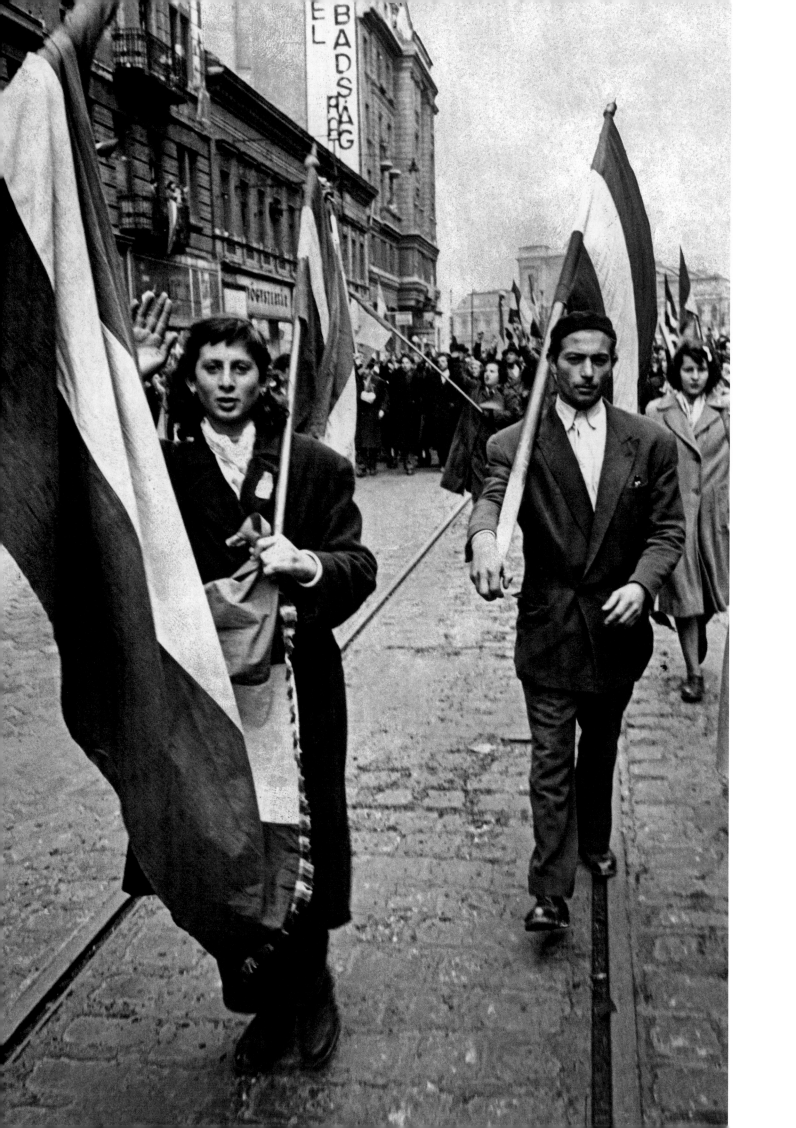

THE REVOLUTION

Previous page
During the feigned Soviet retreat from
Budapest, on 29 October, happy crowds
marched through the city.

Attila Szigethy (left, in profile), head
of Györ's Transdanubian National Council
during the days of the revolution.
Szigethy was arrested in 1957. In prison,
he committed suicide under unexplained
circumstances.

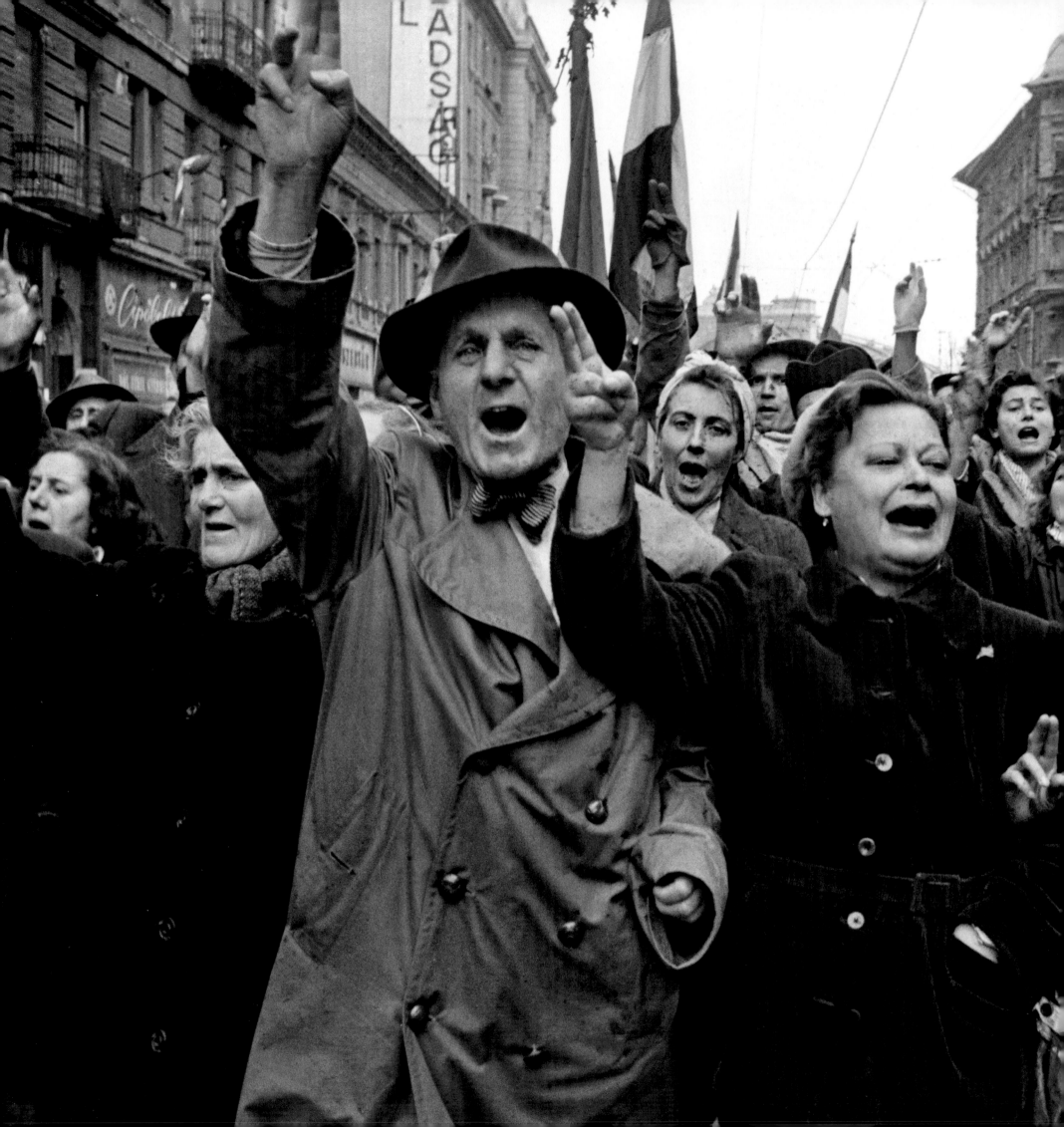

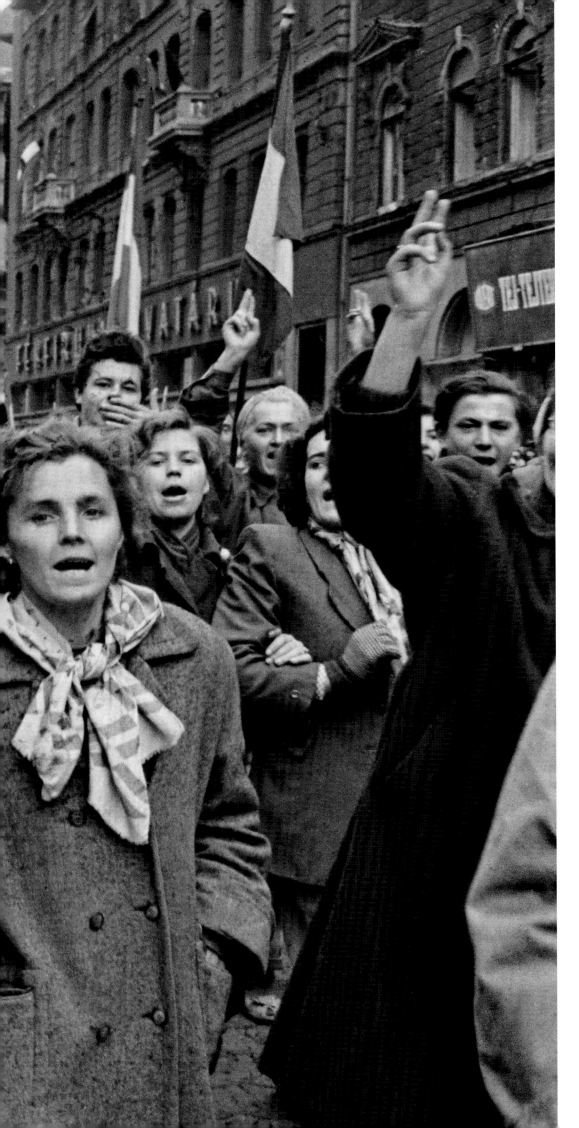

During the feigned Soviet retreat from Budapest on 29 October 1956, jubilant crowds surged through the city.

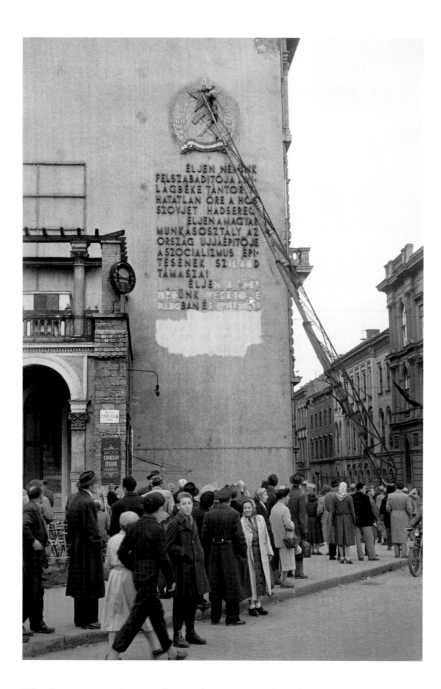

The Soviet-minted coat of arms that was introduced
in 1949 is removed from a building on Clark Adam
Square, 25 October.

An enthusiastic insurgent recites Petöfi's *National Song* in the shattered shop window of the Soviet bookstore in Váci Street.

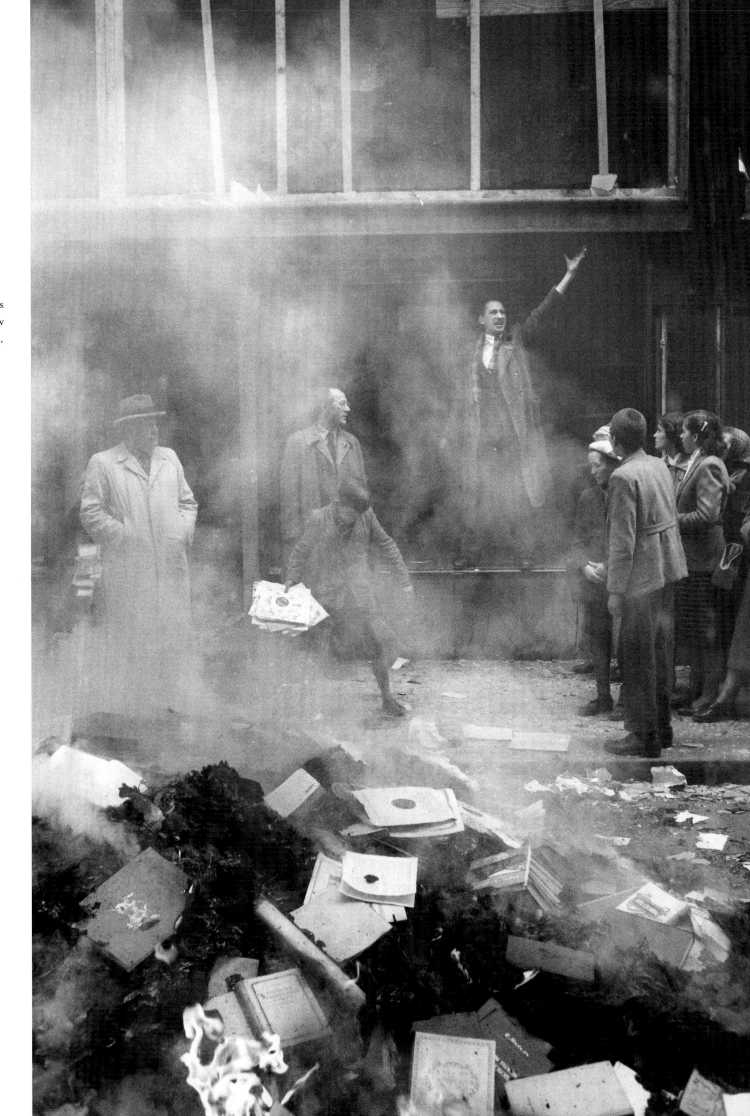

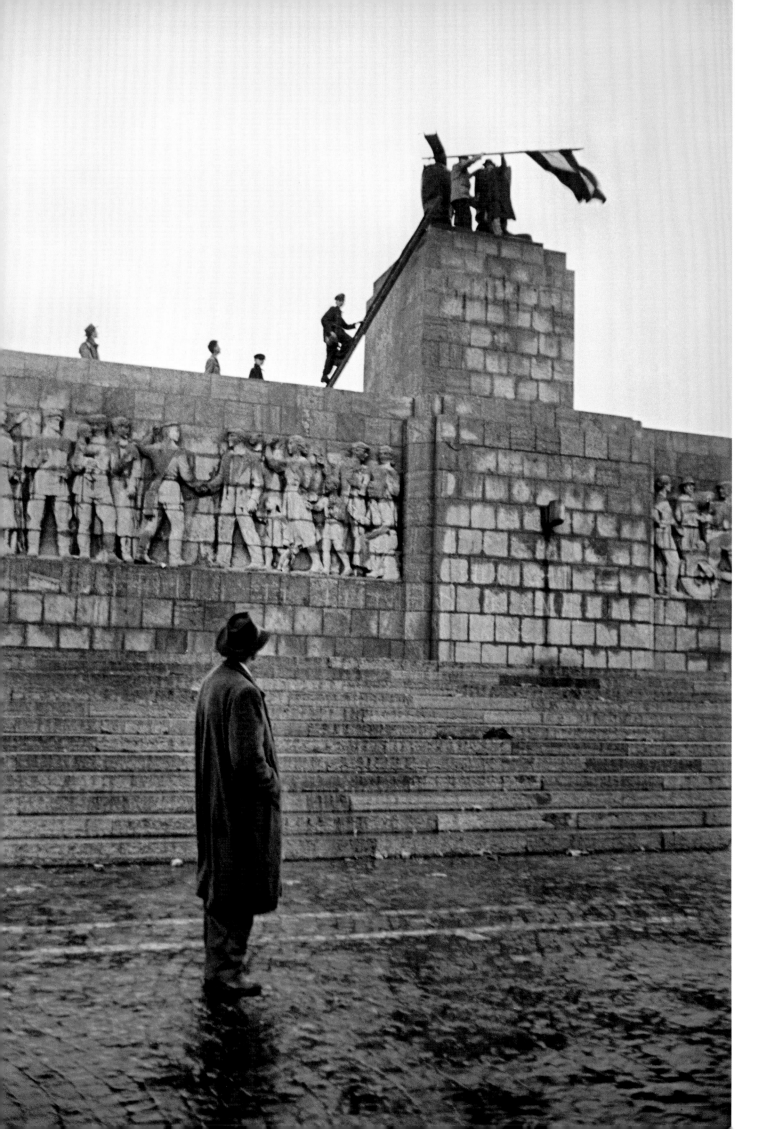

A pair of bronze boots is all that is left of the huge Stalin monument, destroyed during the night of 23 October 1956.

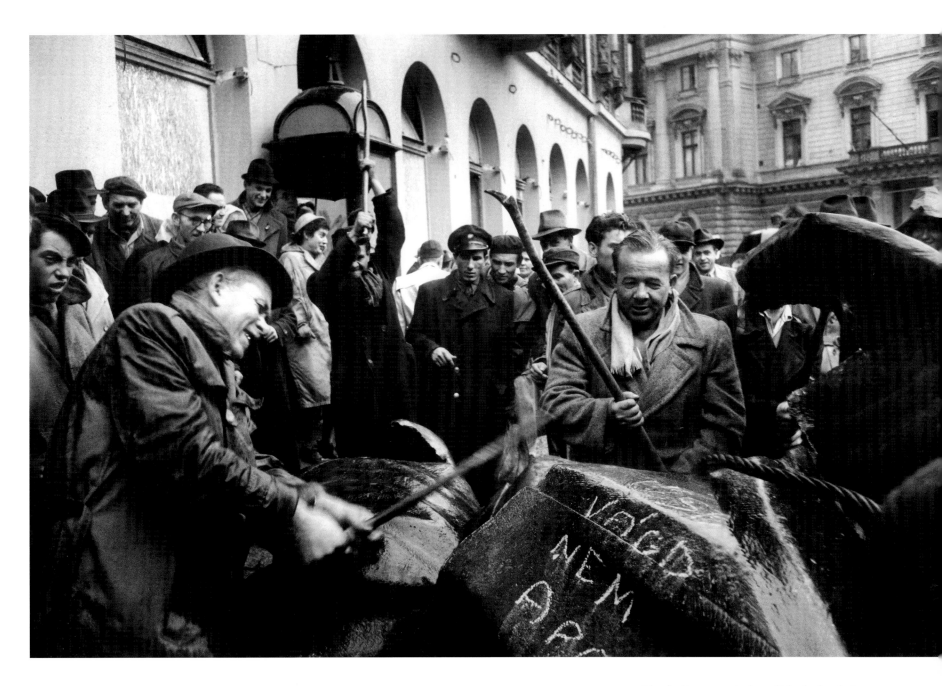

The Stalin statue is demolished after being overturned on Felvonulási Square (Parade Square) and dragged downtown, near Blaha Lujza Square. 'Go on, keep banging on it! It's not your father' is written on the statue in chalk.

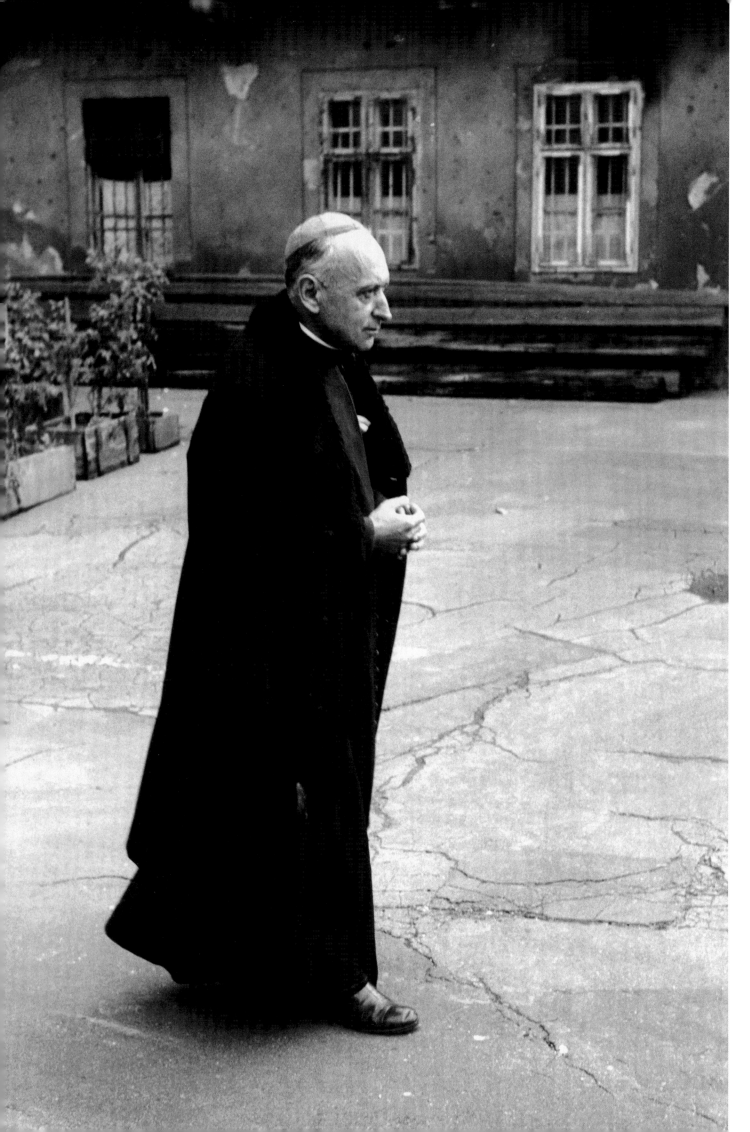

Cardinal József Mindszenty, Archbishop of Esztergom, Primate of the Hungarian Catholic Church. He was arrested in 1948 and sentenced to life in prison. He was liberated on 30 October 1956 and returned to Budapest accompanied by Major Antal Pálinkás–Pallavicini. Pallavicini was sentenced to death after the end of the revolution and executed on 10 December 1957. The photos were taken on 31 October 1956 at the Primate's Palace in the Castle of Buda after the Cardinal was freed from prison.
On 4 November, he fled to the American Embassy in Budapest, where he remained until 1971, when he was allowed to leave Hungary as a result of an agreement between Hungary and the Vatican. He lived in Vienna until his death in 1975.

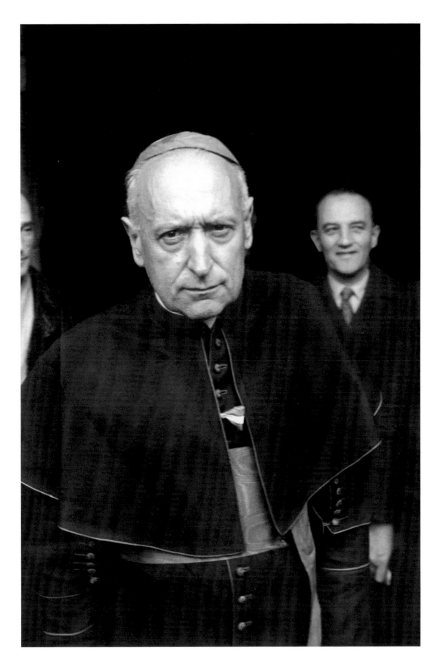

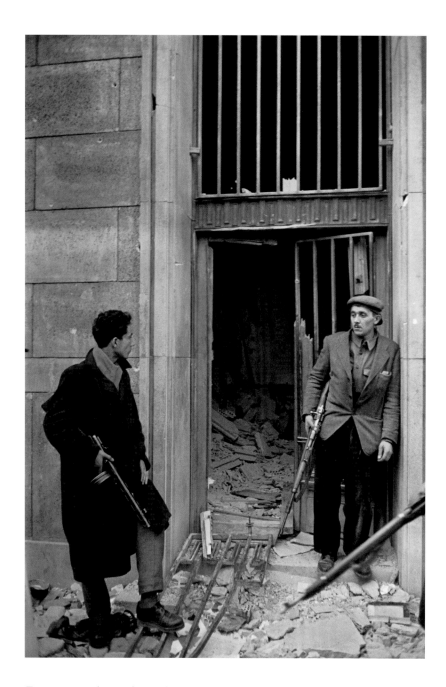

Entrance to the Budapest headquarters of
the Communist Party on Köztársaság Square
(Republic Square), the afternoon of
30 November 1956. The Party building was
stormed and occupied by the rebels during
late morning of the same day.

Armed rebels with a desecrated flag on Köztársaság Square. They had cut the Soviet-produced coat of arms of the People's Republic out of the flag on 23 October. The tattered flag then became the symbol of the revolution.

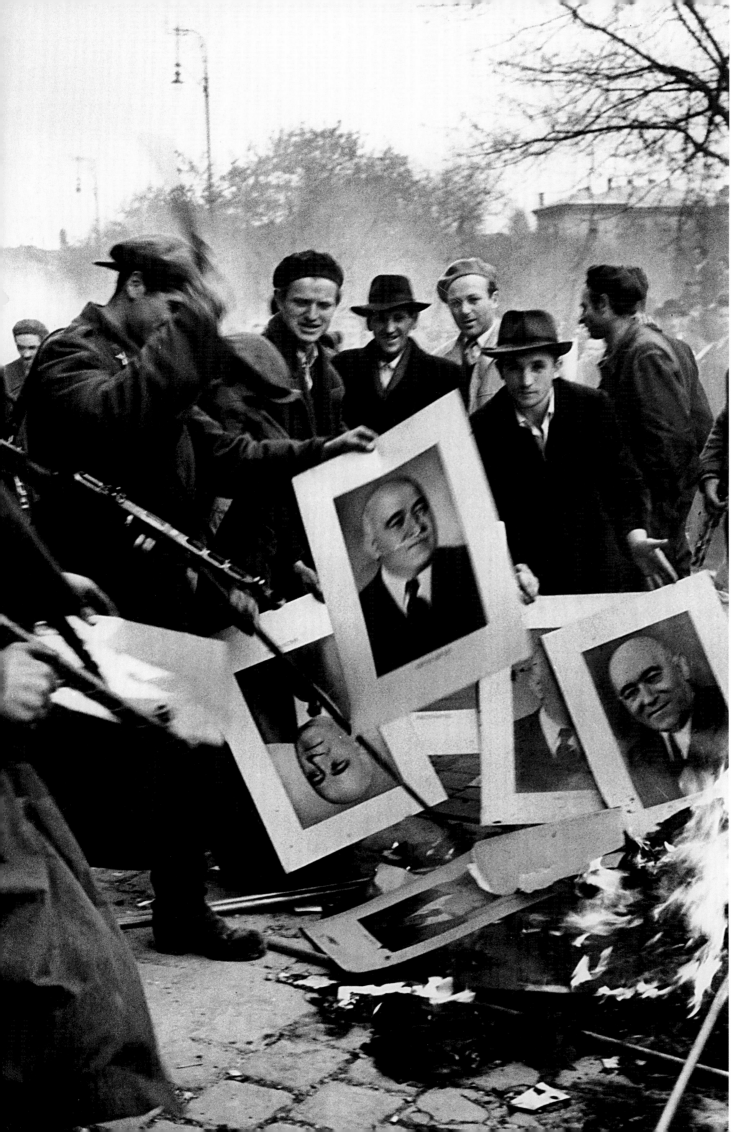

Outside the newly occupied Budapest headquarters of the Hungarian Communist Party, insurgents and passers-by burn pictures of Party Secretary Mátyás Rákosi.

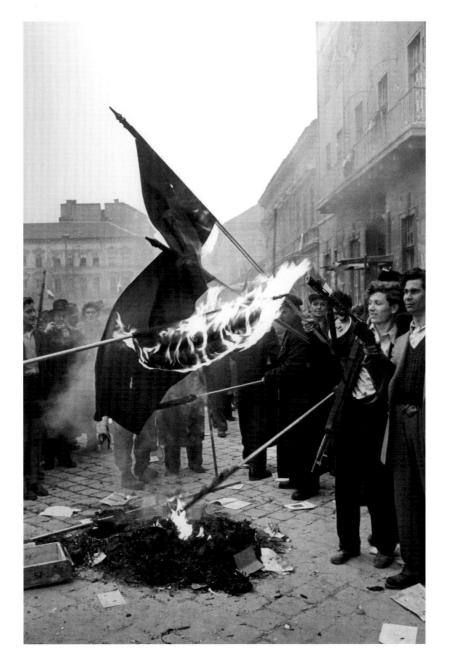

Insurgents burn red flags on
Köztársaság Square.

The former Budapest headquarters of the
Hungarian Workers' Party is now the seat
of the Hungarian Socialist Party. 1998.

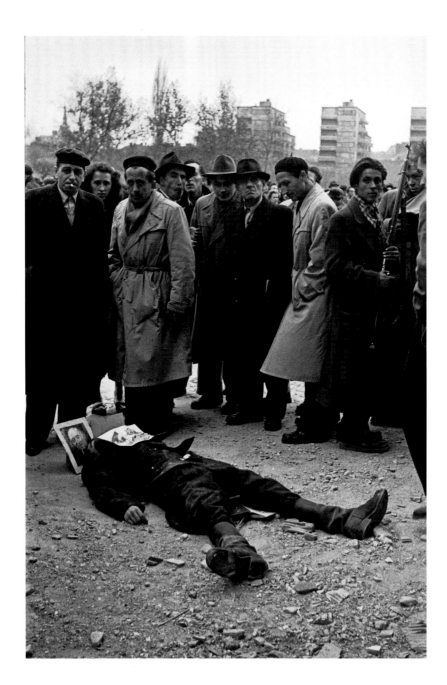

A dead AVH man, killed during the storming
of the Budapest headquarters of the Hungarian
Workers' Party, is decked out with a picture
of Rákosi.

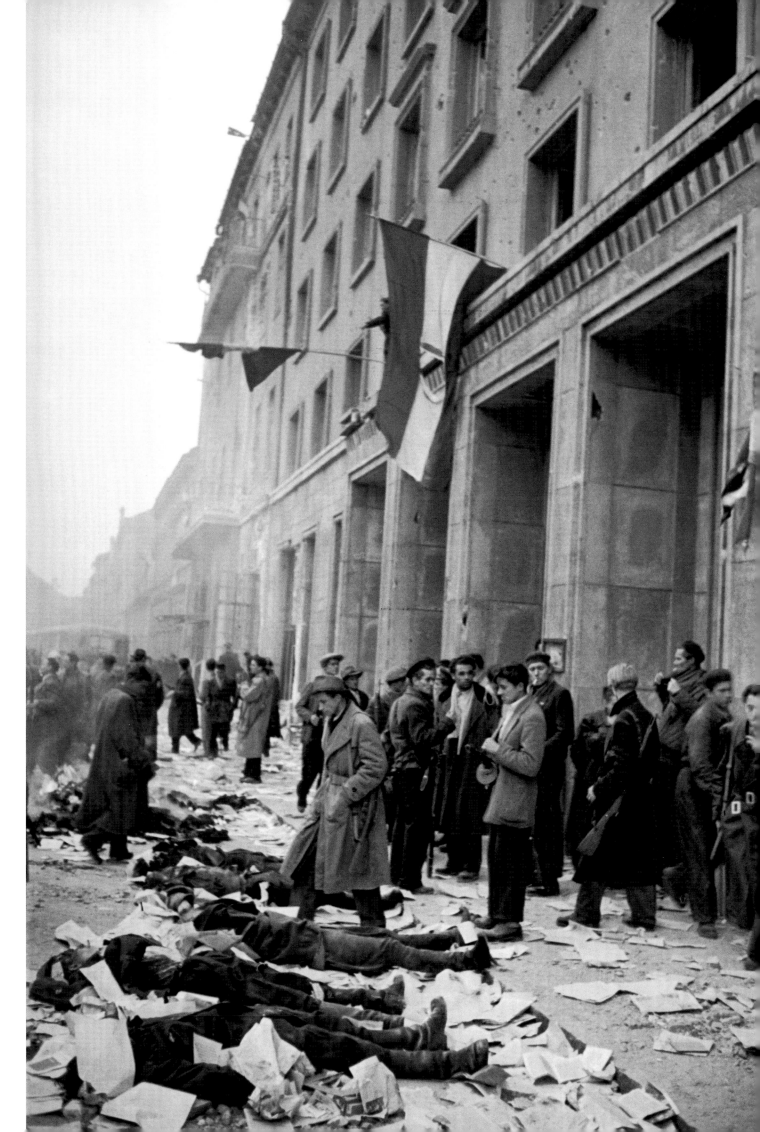

Dead bodies of the Secret Police, who had been ordered to protect the Budapest headquarters of the Communist Party, lie lined up in front of the conquered building.

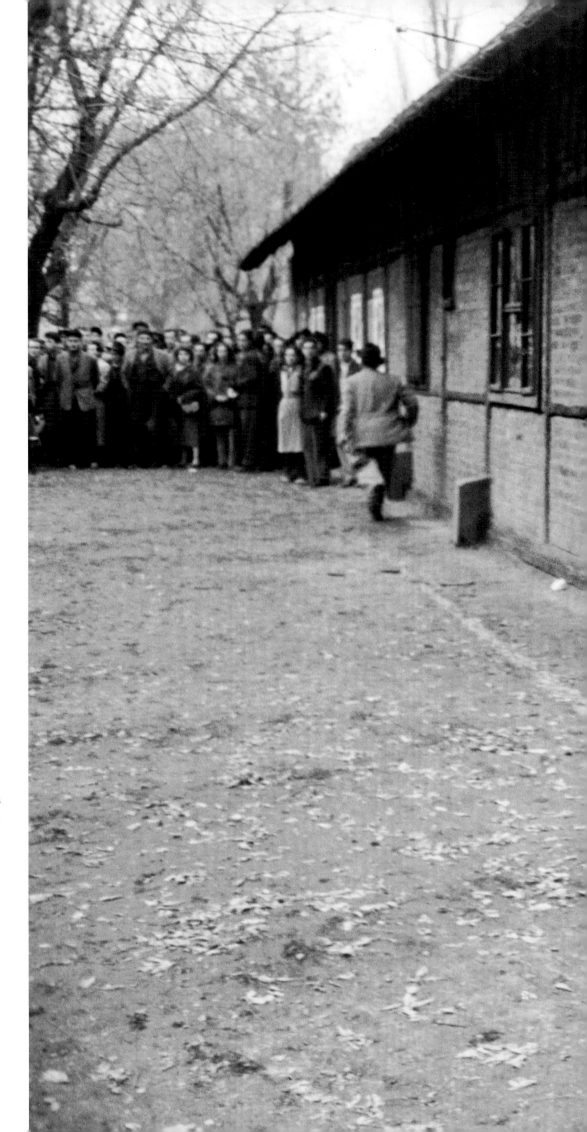

While an insurgent reloads his gun
in Luther Street, near Köztársaság Square,
curious citizens look on from afar.

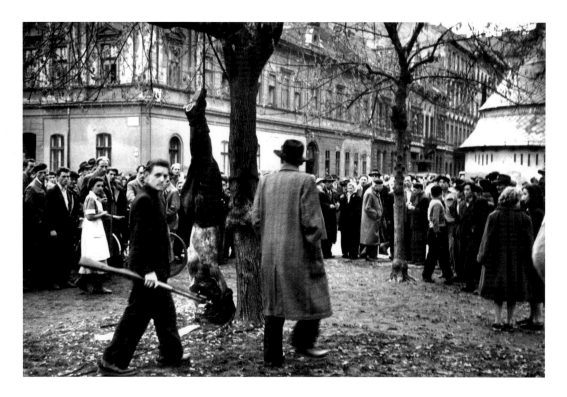

Lynch mob justice on Budapest's
Köztársaság Square outside the Party
headquarters on 30 October.
The remains are those of József Papp,
First Lieutenant.

Panic on Köztársaság Square. Street
shootings continued to take place even
after the attack.

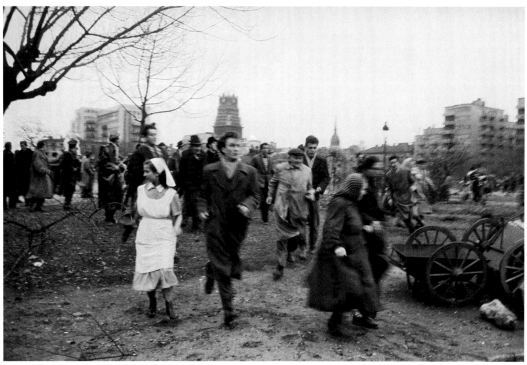

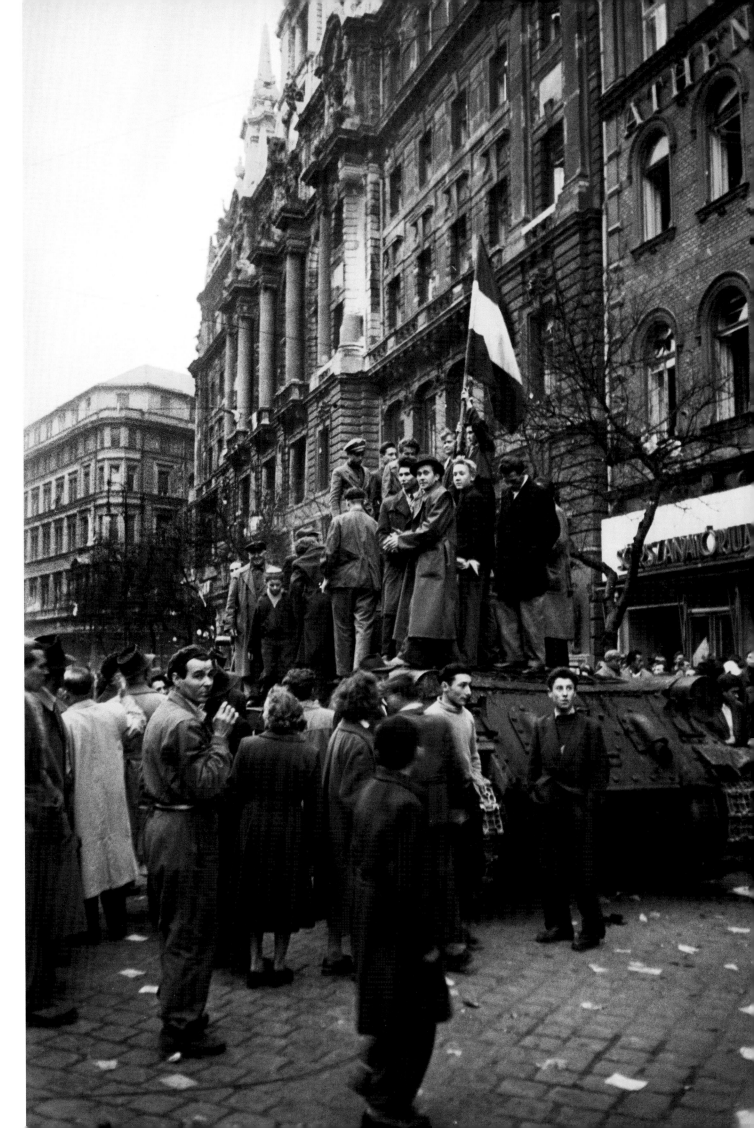

Rebels in front of the New York Palace
along Lenin Boulevard (today Teréz
Boulevard), near Blaha Lujza Square.
On a captured Soviet tank, a flag bearing
the national colours.

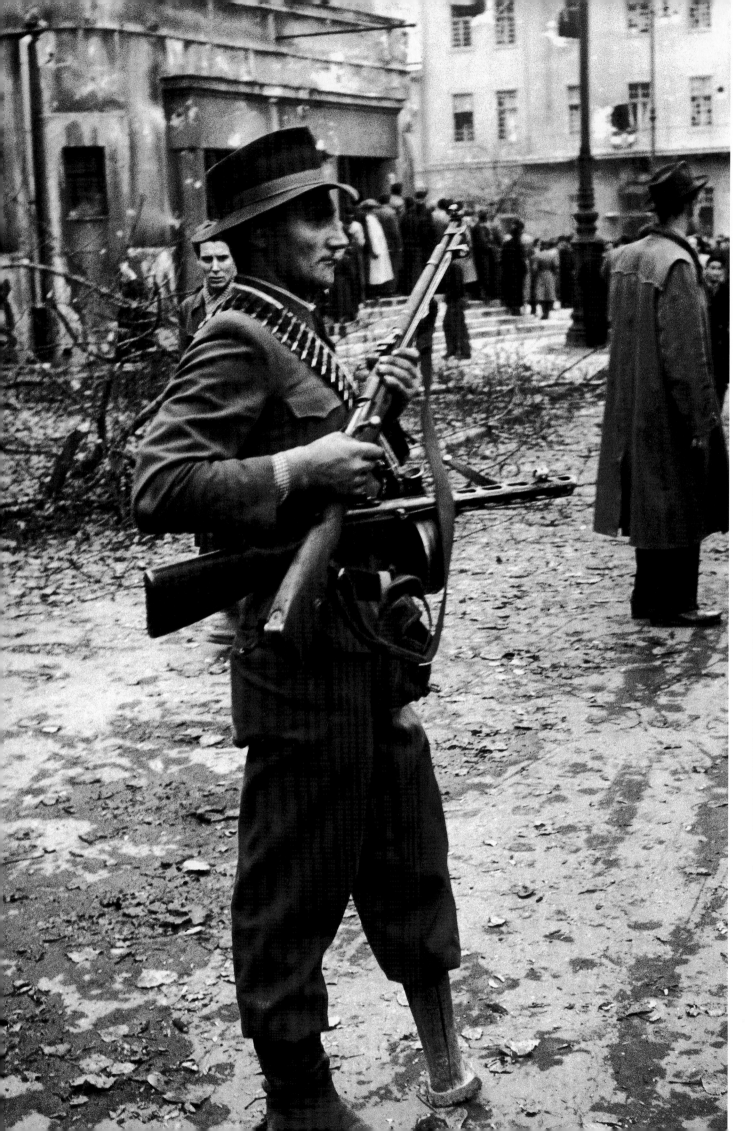

János Mesz, 'Janko of the wooden leg',
one of the leaders of the rebel group
Corvin Lane, at the Erkel Theatre on
Köztársaság Square, 30 October 1956.

János Mesz's memorial to the rebels who
fell at Corvin Lane in the battle against
the Soviet intervention after 4 November.
In the Hungarian folk tradition, a carved
wooden stele indicates a gravesite. The
memorial was erected at the beginning
of the 1990s.

Corvin Lane around 1 November 1956
during the days of the cease-fire.
In the foreground, a captured Soviet
truck, a BTR-152 APC, on which
a Kossuth coat of arms has been drawn.
On the left can be seen the Corvin
Cinema, from which the rebel group
took their name. The cinema is still
in operation today.

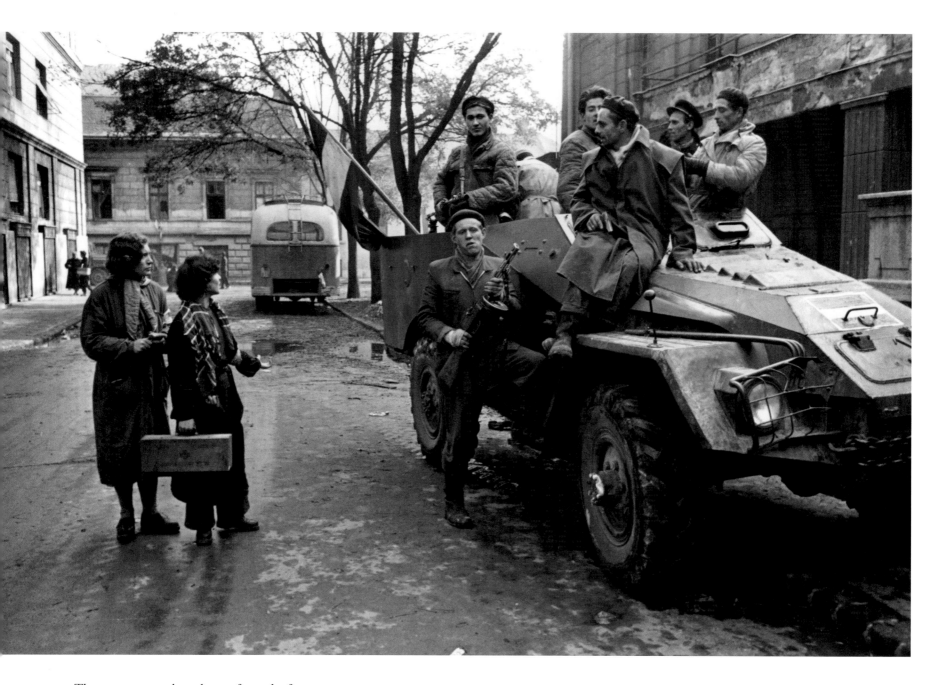

The same captured truck seen from the front,
with armed rebels on top, on Corvin Lane.

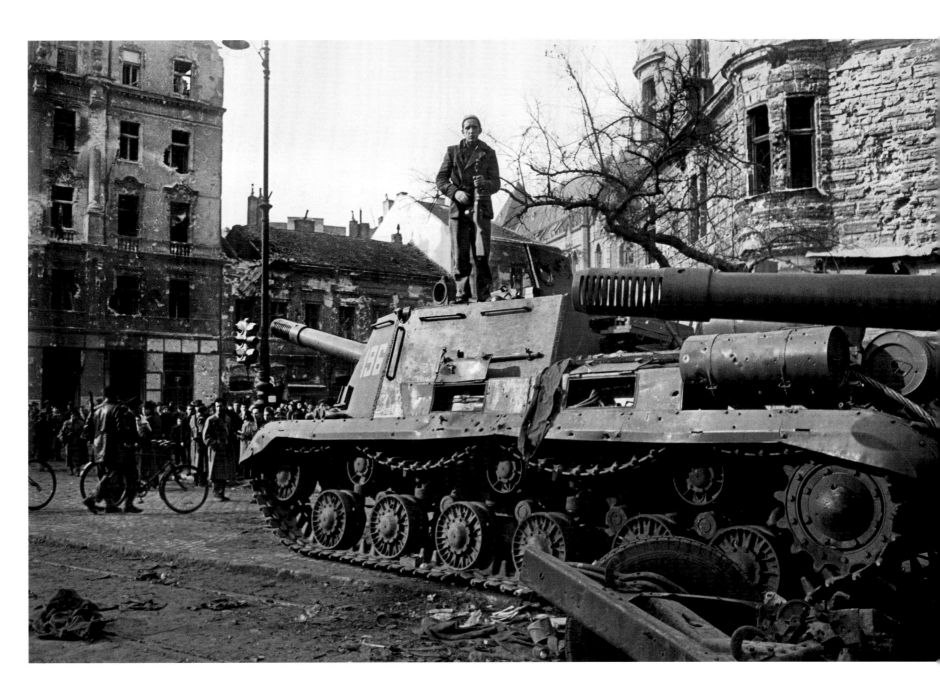

Out-of-action tanks, an armed rebel atop one
of them, on József Boulevard, across from Práter
Street, during the early days of November, 1956

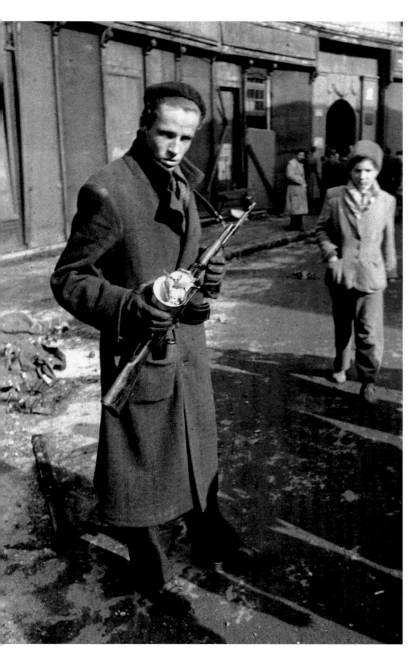

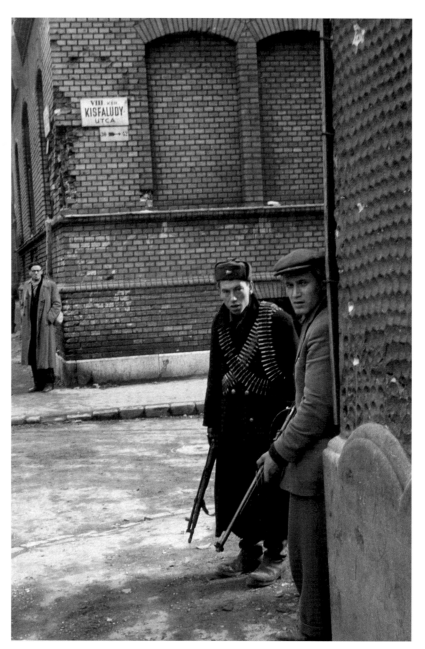

An armed rebel in the vicinity of Corvin Lane.
In his hand is a Soviet-style automatic machine-gun,
called a kalashnikov.

Two insurgents at the corner of Kisfaludy
Street in central Budapest.

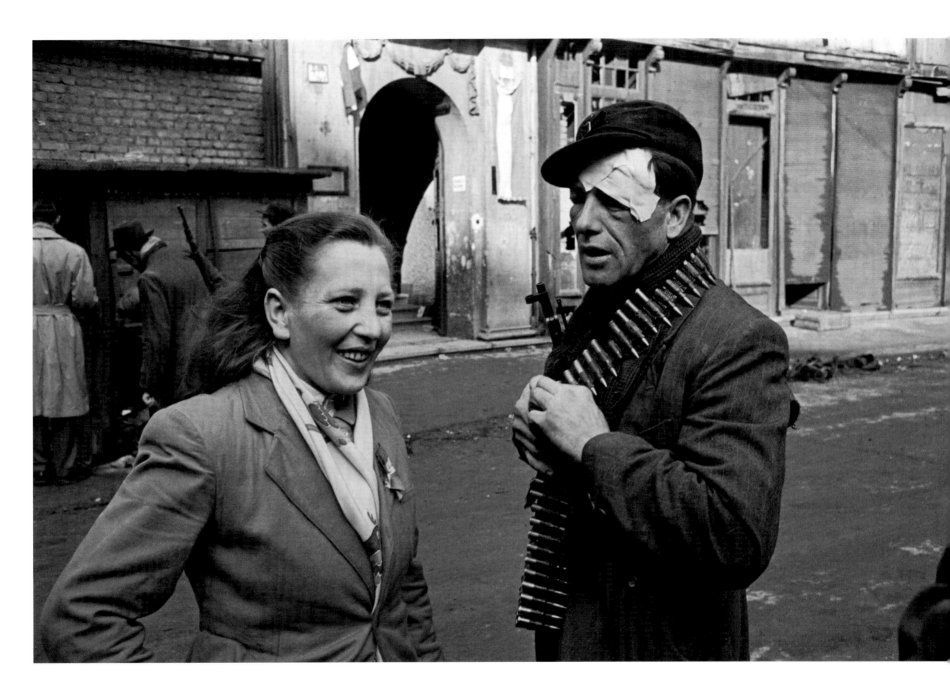

A wounded revolutionary, ammunition
slung around his neck, a kalashnikov hanging
from his shoulder. The death toll between
October and December 1956 is estimated
at 2,740 Hungarians.

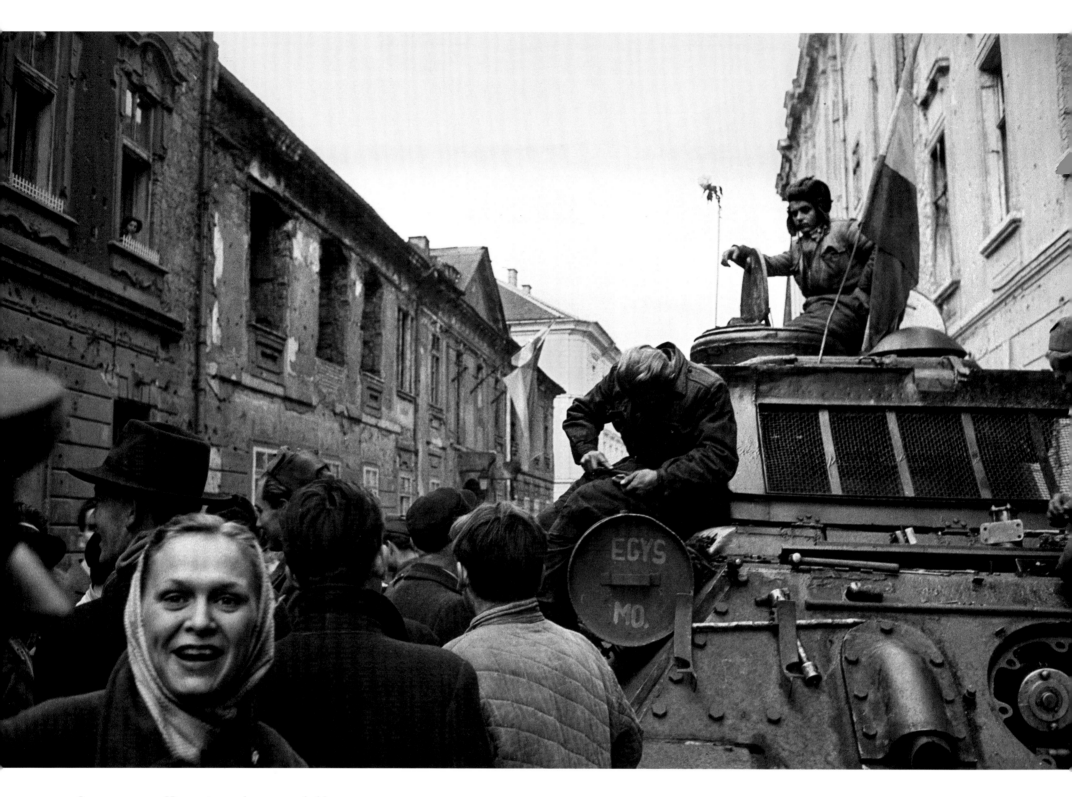

Insurgents on a Hungarian tank, surrounded by
joyous citizens who did not know that the Soviet
retreat, announced for 31 October 1956,
was only feigned.

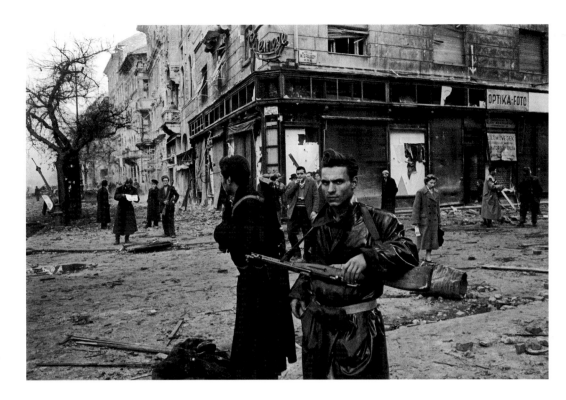

A street scene in downtown Budapest after days of heavy fighting.

A street scene in downtown Budapest at the end of October 1956: civilians, a Hungarian soldier, insurgents with rifles.

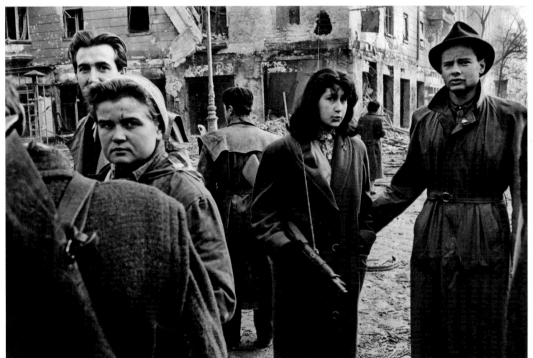

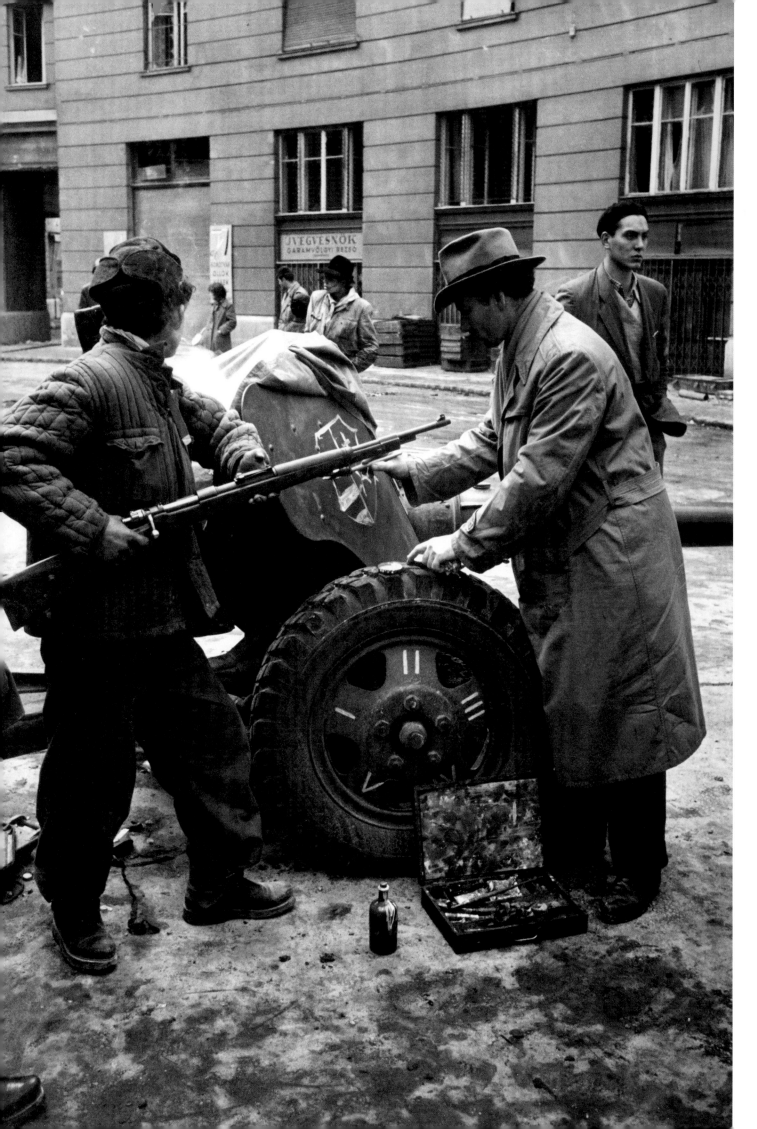

A painter applies the 'Kossuth coat of arms', the emblem of the 1946 Hungarian Republic, to a captured Soviet cannon.

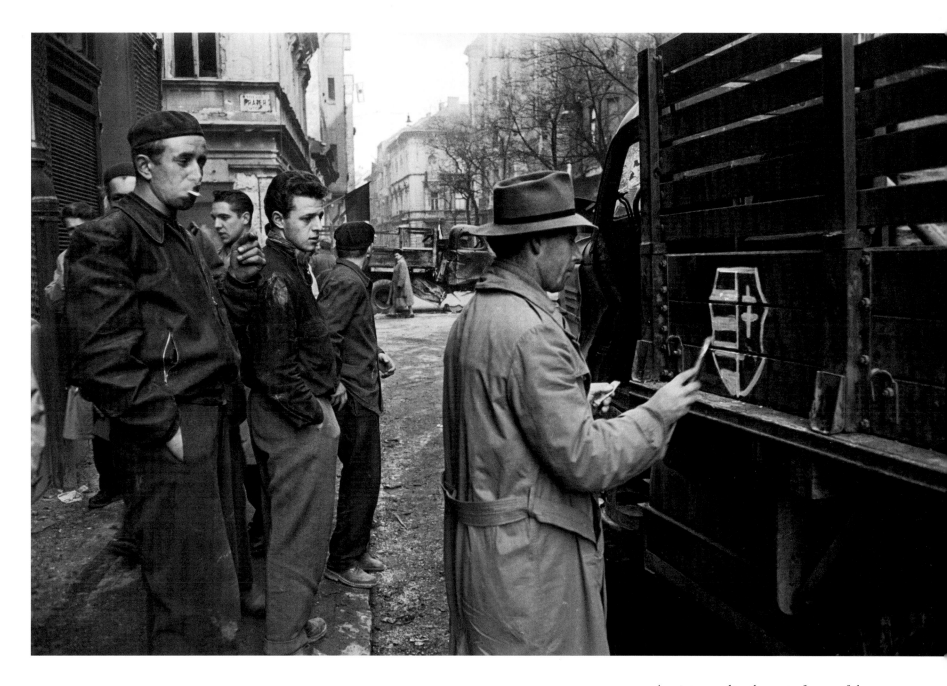

A painter applies the coat of arms of the
Hungarian Republic of 1946, the 'Kossuth
arms', on an army truck, to replace the
Communist emblem.

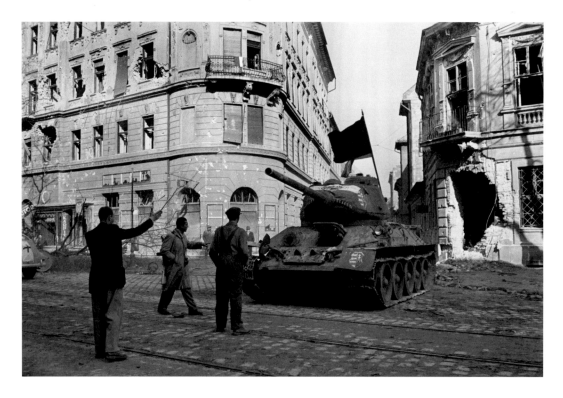

A T-34 tank with the Hungarian national emblem and one black and one Hungarian flag is manoeuvred into position as a roadblock.

Life must go on between battles: Budapest shoppers eye a Soviet tank.

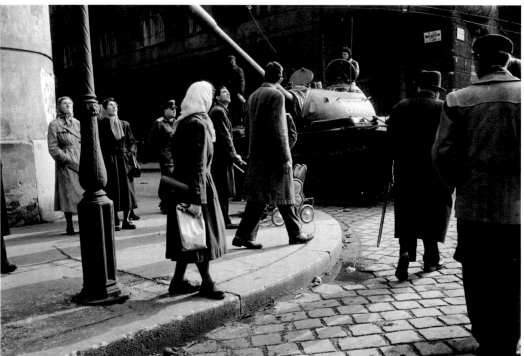

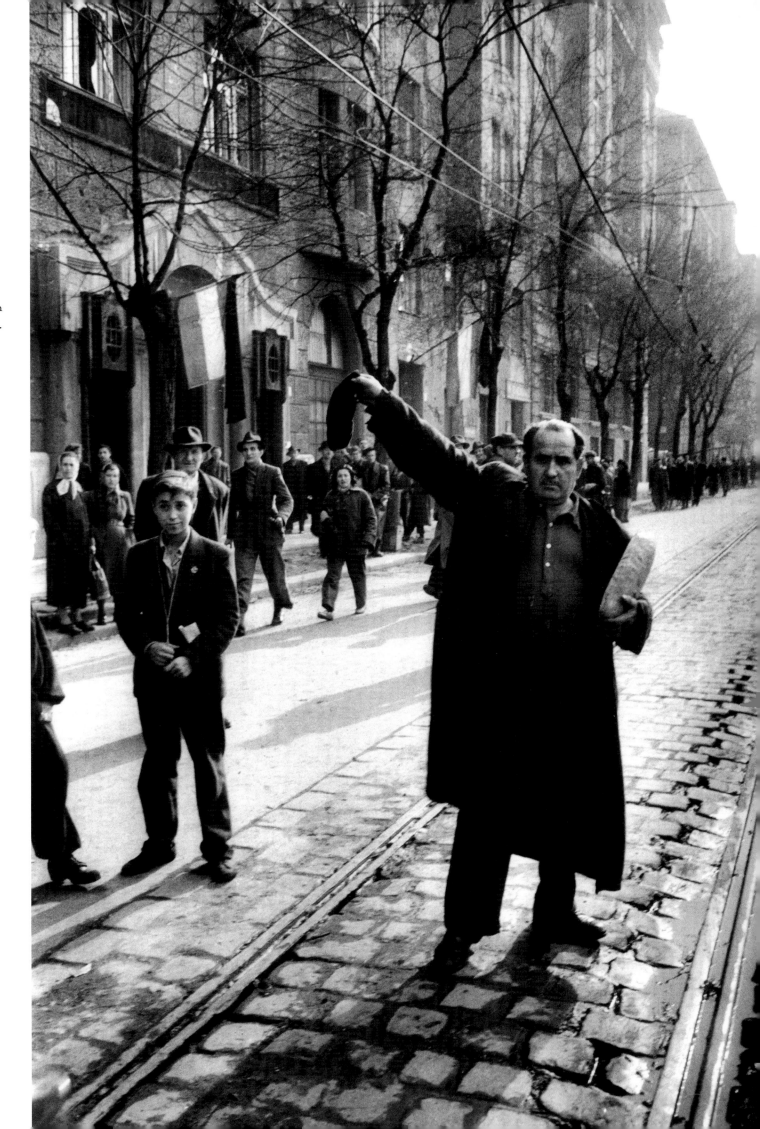

A man directs a T-34 tank on
József Boulevard.

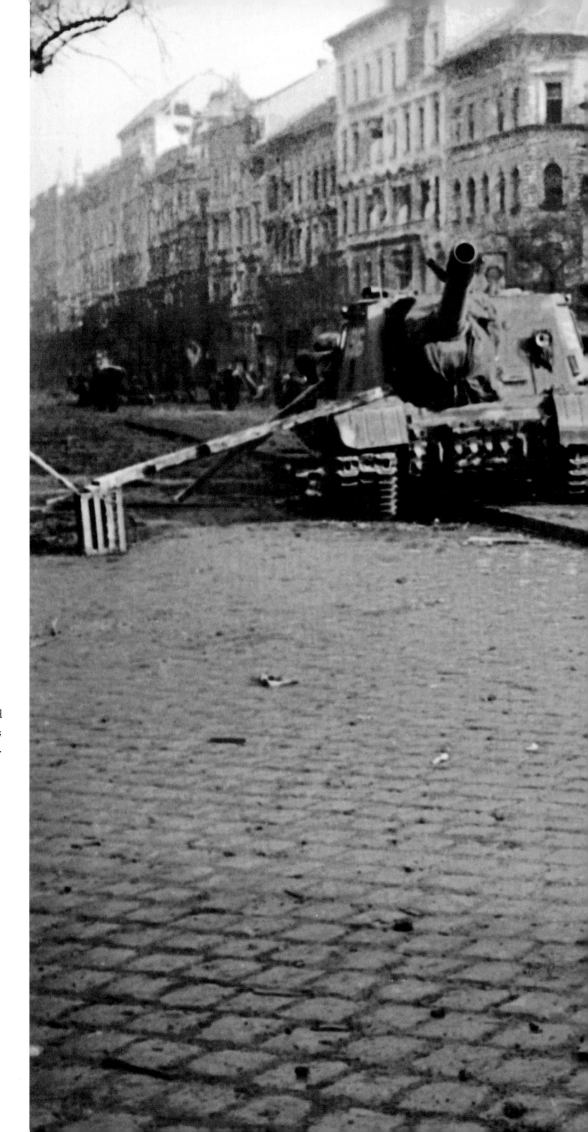

A Hungarian soldier whose armband
shows that he has joined the insurgents;
a disabled Soviet ISU-122 tank.

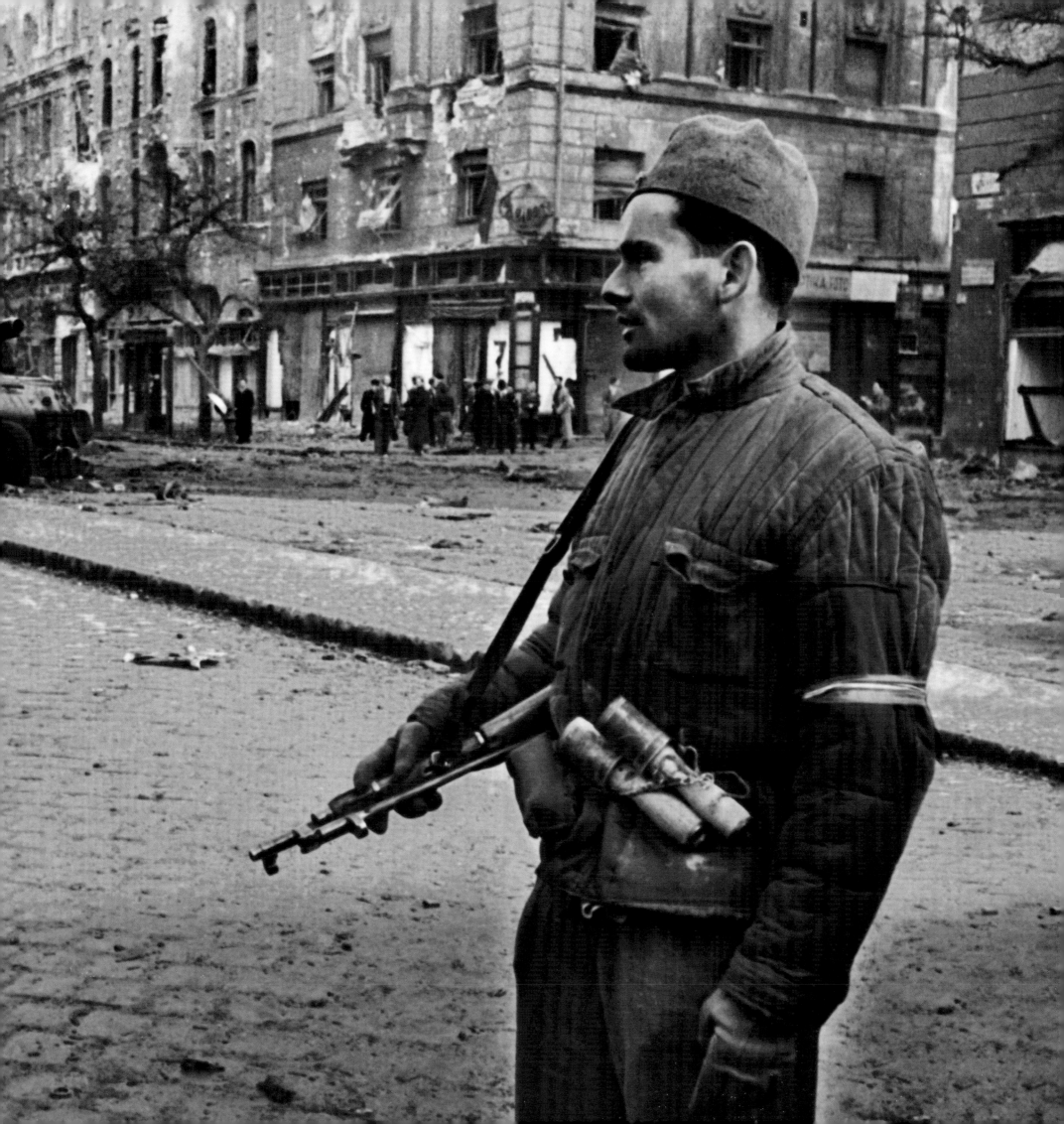

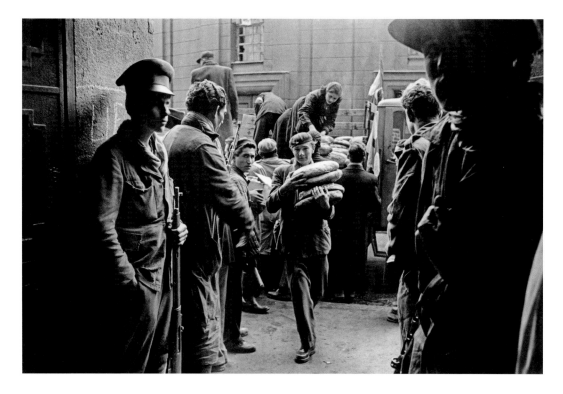

Bread is brought to the insurgents
of the Corvin Lane group.
Its headquarters was in a private
apartment near the Corvin cinema.

Insurgents resting.

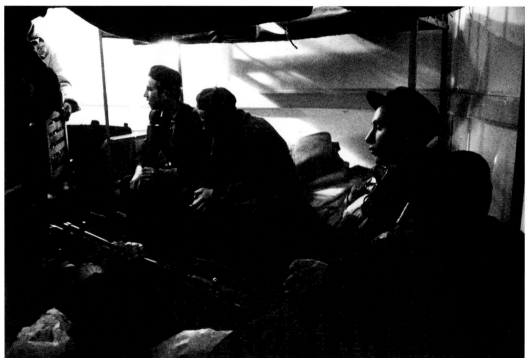

Headquarters of the Corvin Lane group of insurgents, commanded by Gergely Pongrátz.

Gergely Pongrátz, commander of the 'Corvin Group' of combatants, sitting outside his former headquarters on Corvin Lane in 1998. He managed to flee to the United States, where he became a farmer. Pongrátz returned to Budapest in 1990. He died in 2005.

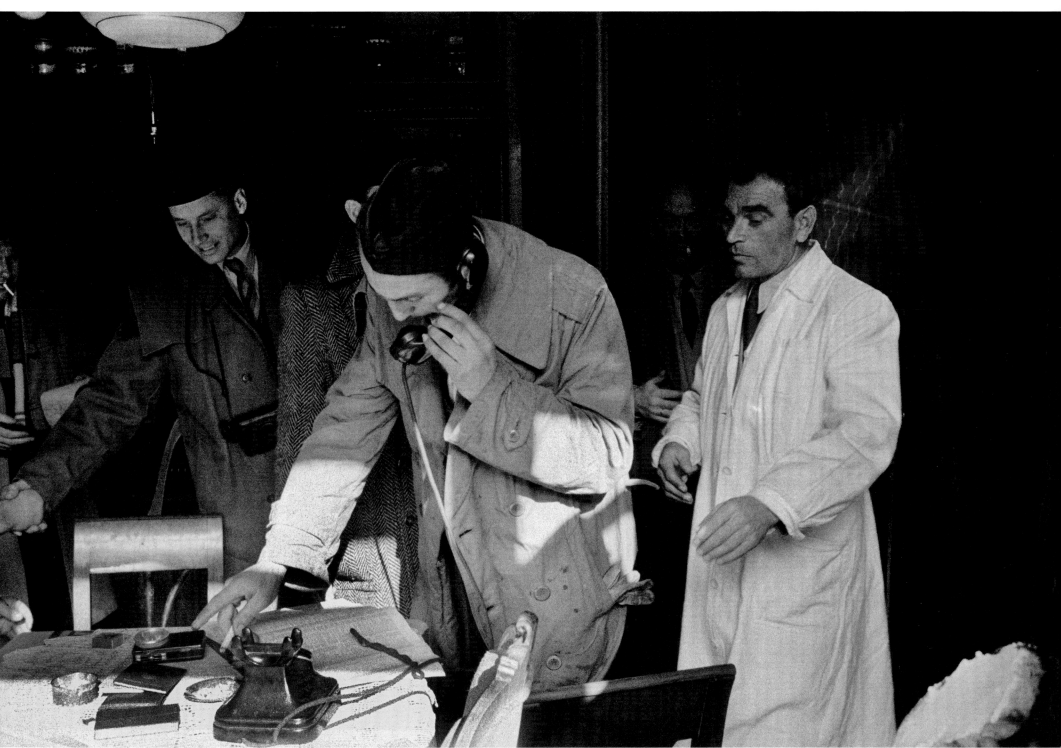

Corvin Lane in the days of the cease-fire:
a makeshift Red Cross ambulance and
a nurse; on the left-hand side, a disabled
grenade-launcher.

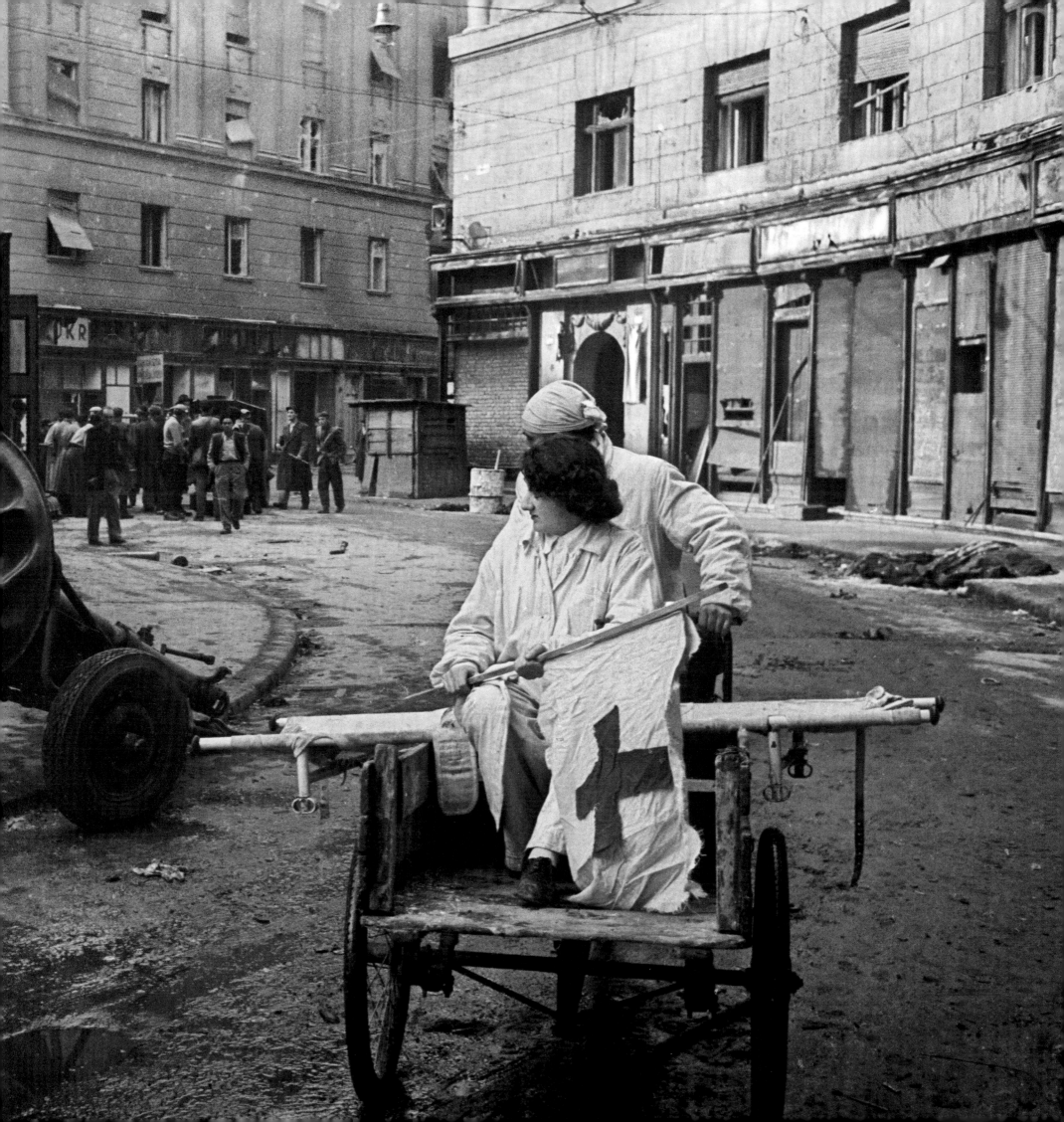

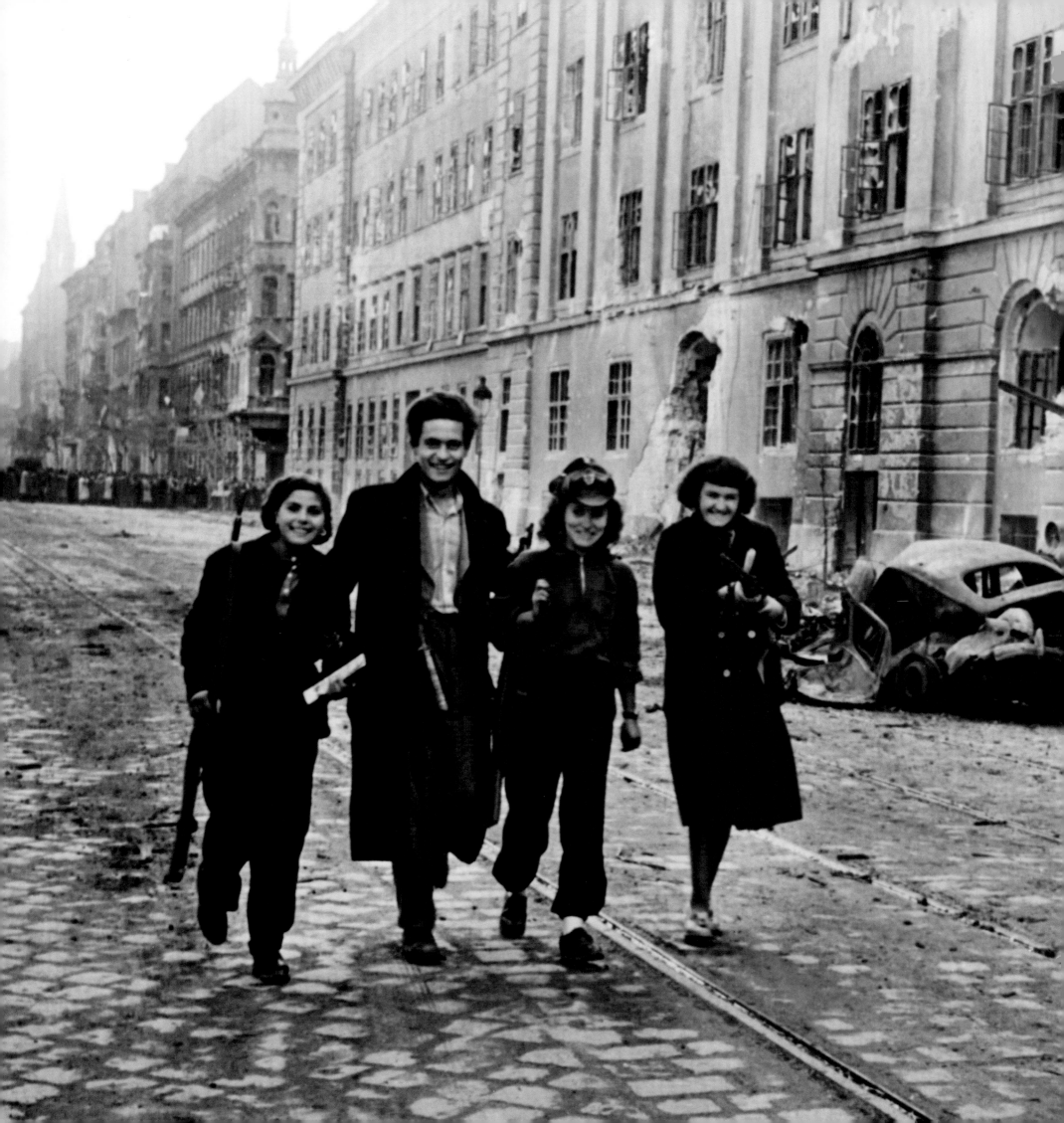

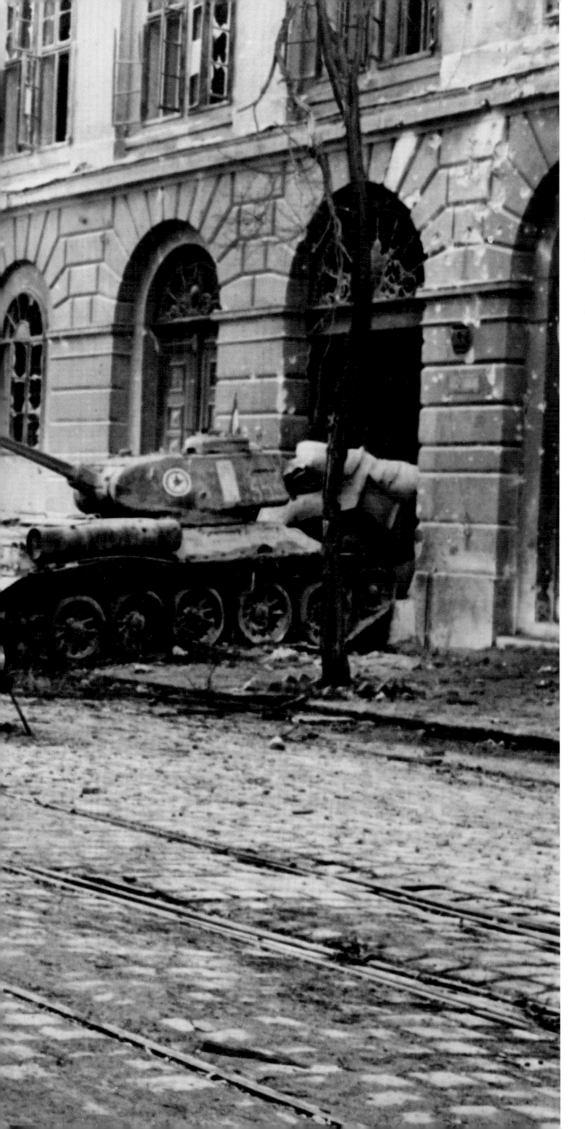

The Kilián barracks. In the entrance is
Colonel Pál Maléter's tank with which
he reached the barracks on 25 October.
On 3 November, Maléter became Minister
of Defence in the Nagy government.
After the revolution, he was sentenced
to death together with Imre Nagy
and executed. Insurgents walk home
after a day of fighting.

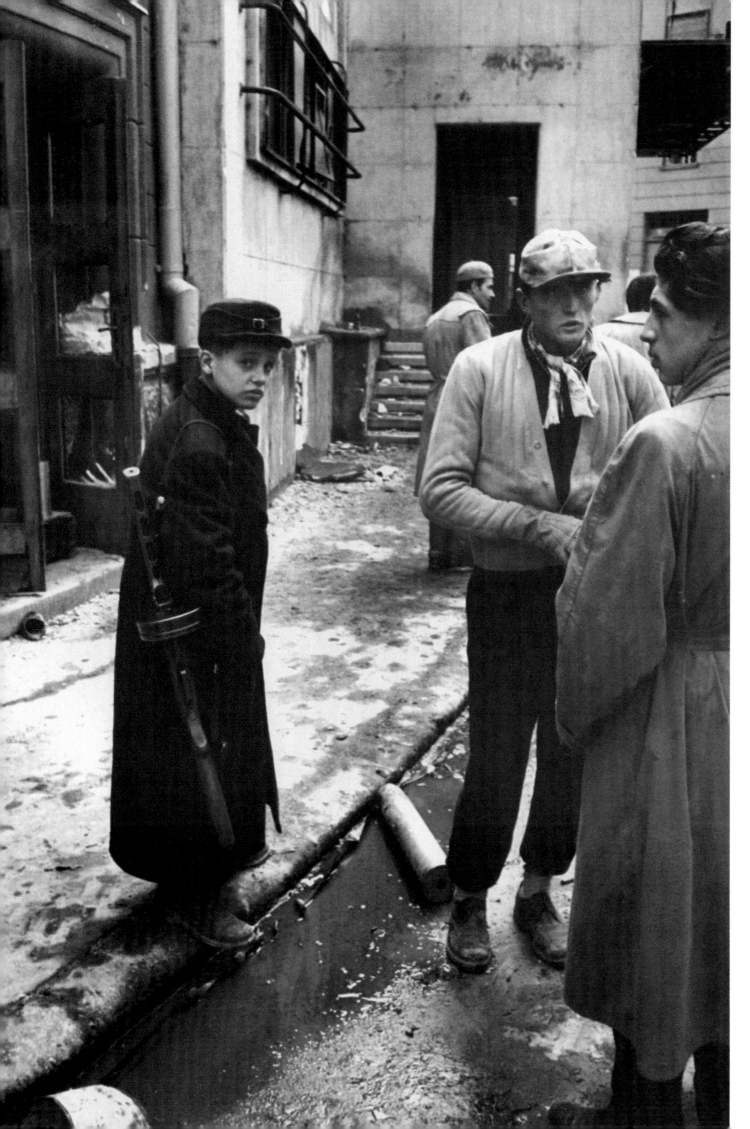

Corvin Lane in the days of the cease-fire,
around 1 November 1956.

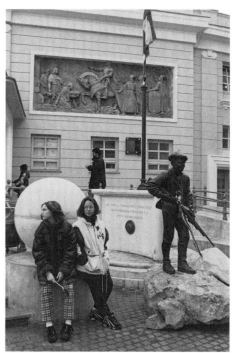

Statue of the 'Pest youth' at the
entrance to Corvin Lane, 1998,
the work of Lajos Györfi.

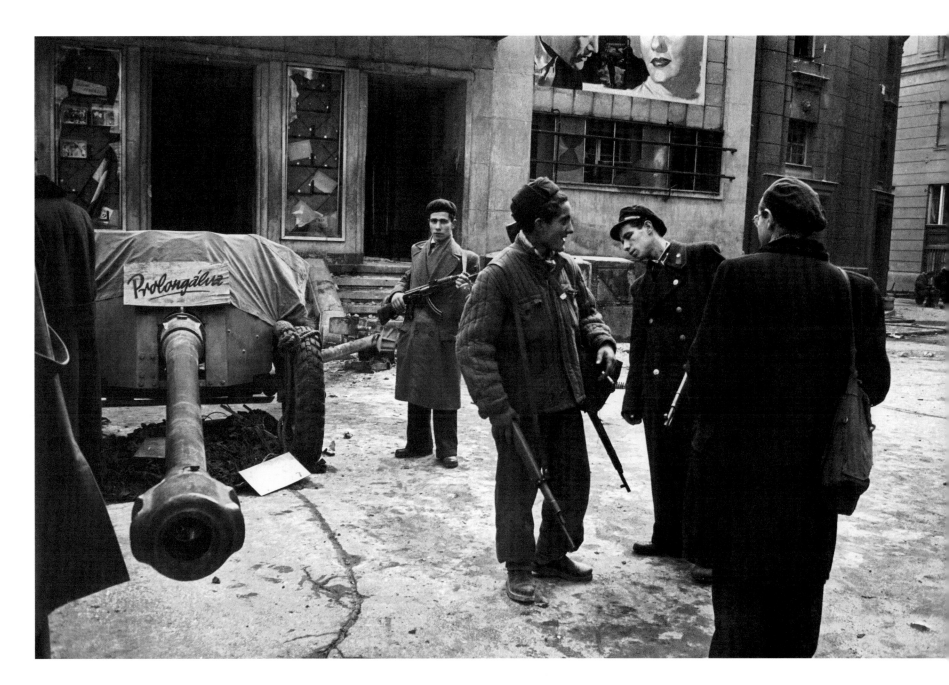

A railroad employee admires the rifles of a girl combatant. On the cannon in the snow (left) is a sign from the Corvin Cinema, saying: 'Extended'.

A Hungarian soldier, the red star on his cap replaced by the Hungarian national emblem; a lorry with black flag collecting bodies of Hungarian insurgents. The Hungarians buried their own, but left the Soviets where they lay.

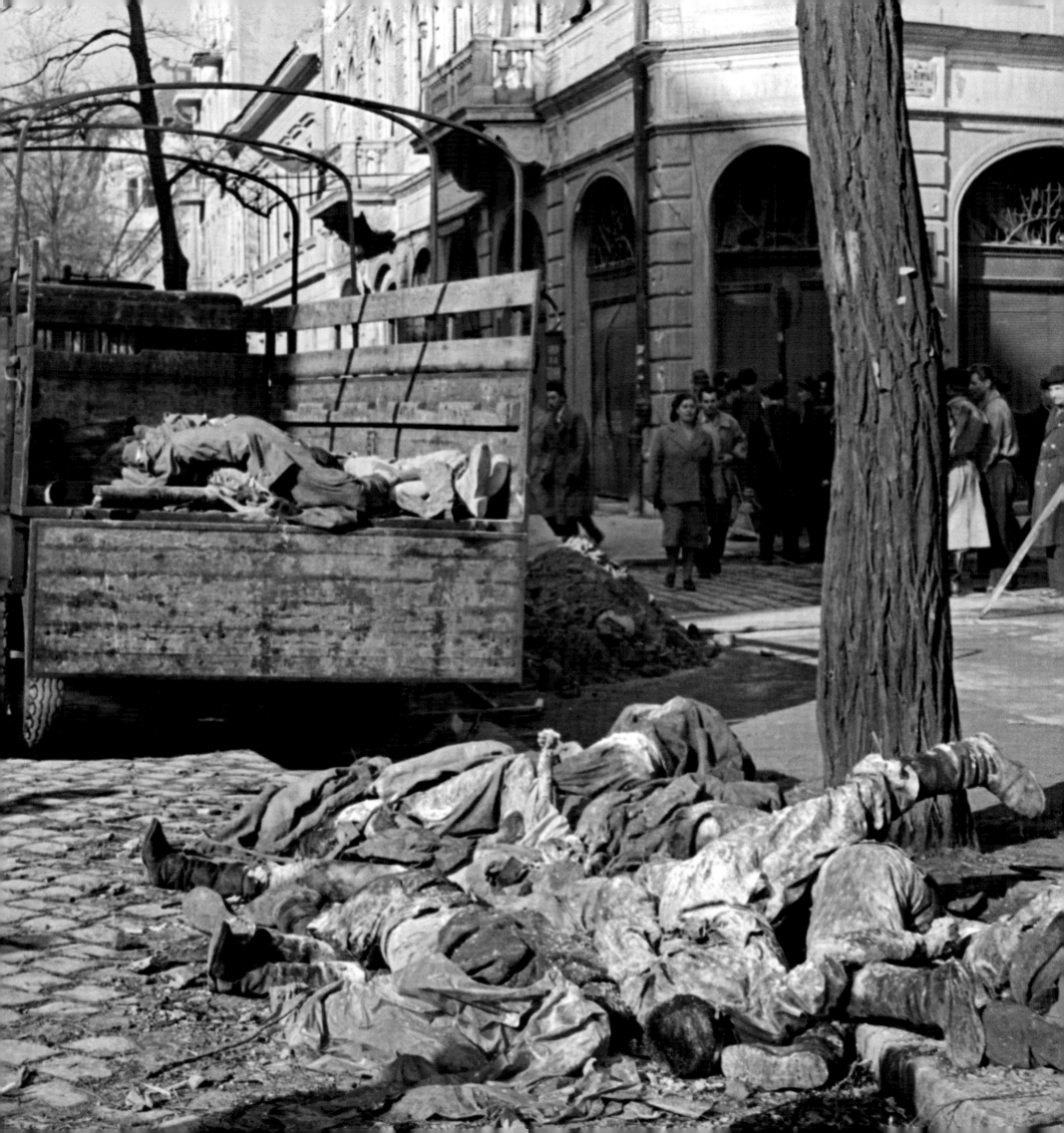

In front of the Parliament building, Hungarians read leaflets published by the insurgents, announcing the withdrawal of Soviet troops.

Uncensored newspapers with the Hungarian
national emblem reappeared in the streets.

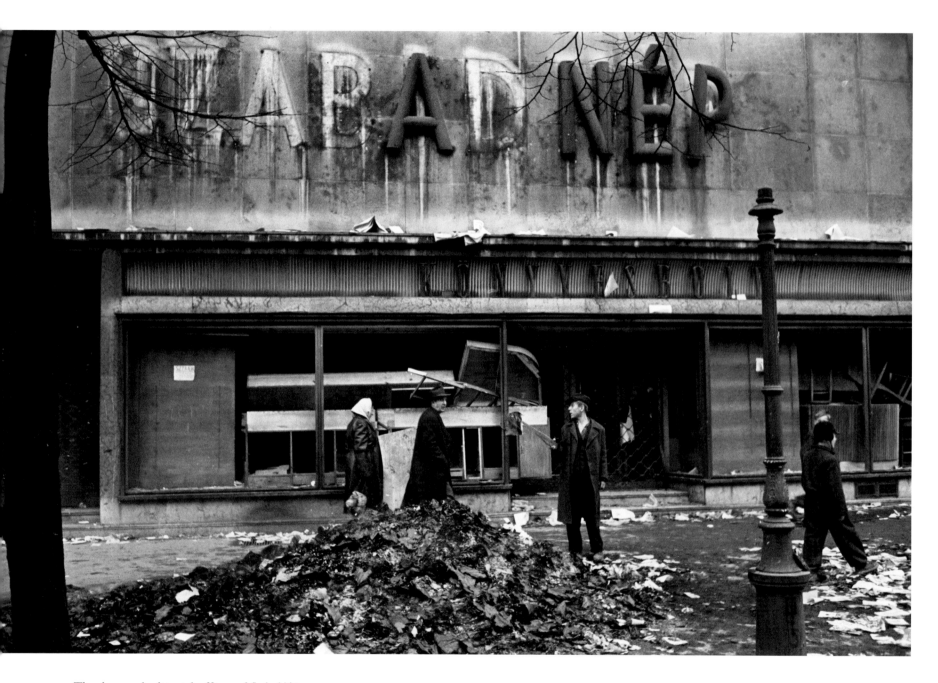

The damaged editorial offices of *Szabad Nép*
(Free People), the principal daily paper
of the Communist Hungarian Workers' Party.
The surviving inscription reads 'The People'.

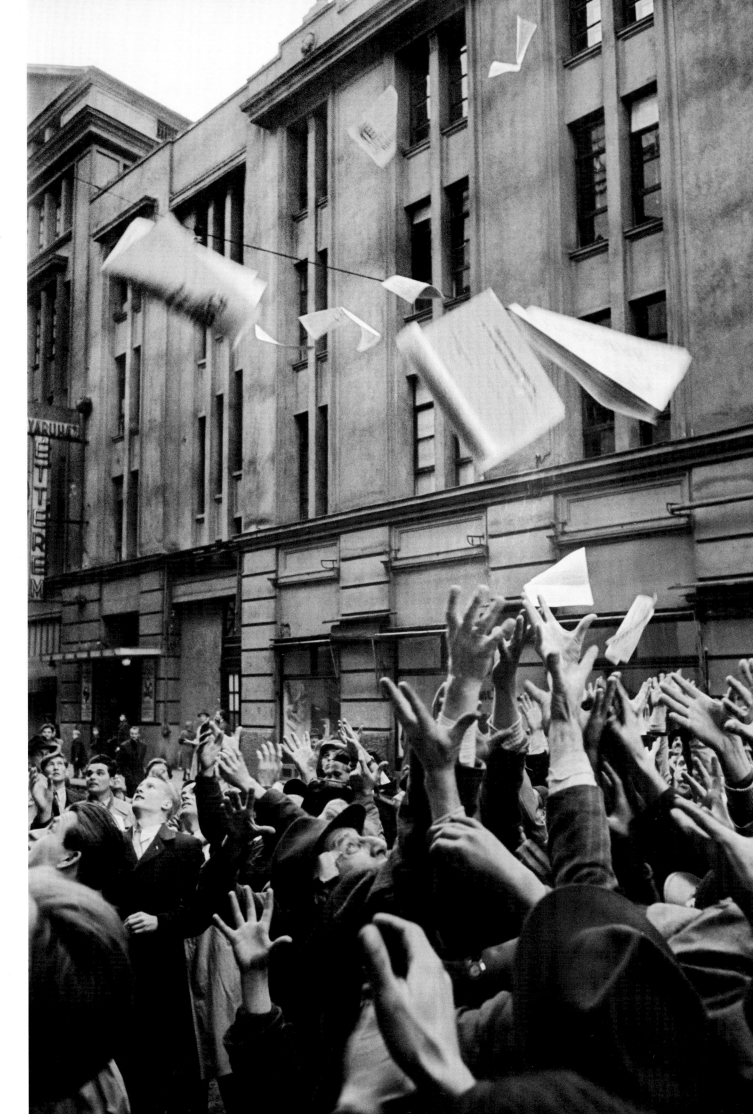

Outside the former central office of *Szabad Nép*, crowds try to catch the first edition of *Függetlenség* (Independence).

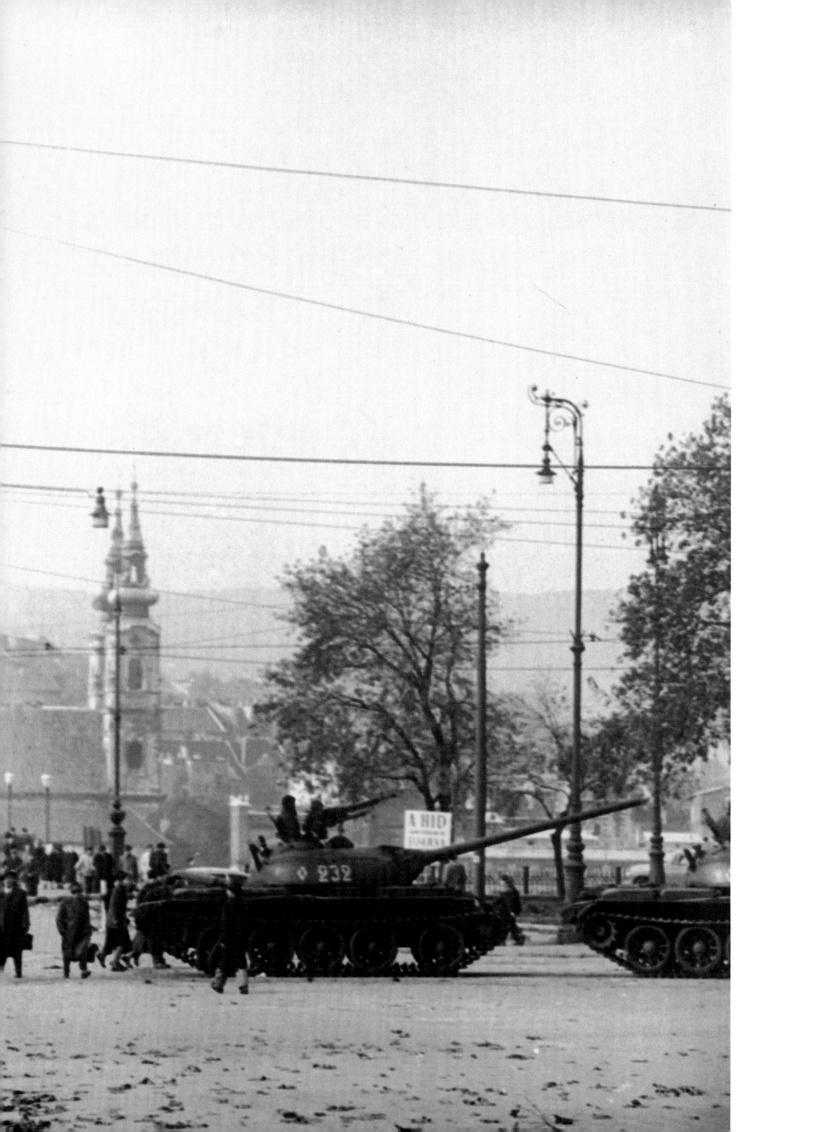

THE FAILURE

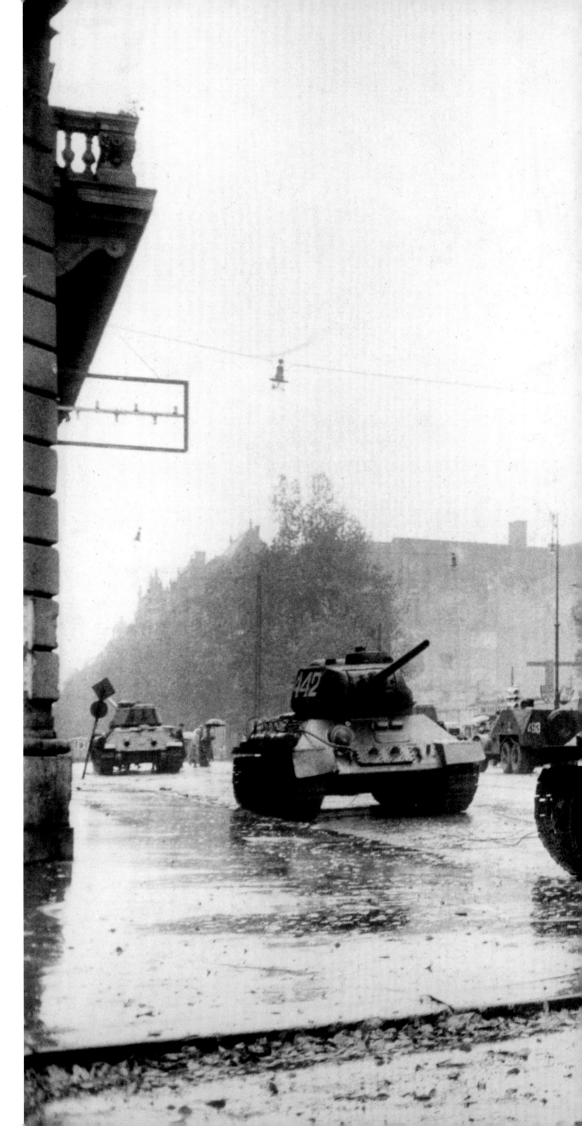

Previous page
A formation of Soviet T-54 tanks on the Pest side of the Kossuth Bridge emplacement following 4 November 1956. The T-54 was the most modern Soviet tank of its time. The bridge has since been torn down.

Heavy Soviet T-34/85 tanks protect a street crossing on the Pest side of Kossuth Bridge. These heavy tanks proved too unwieldy for downtown battles, and many were destroyed or captured by the insurgents. The visible markings on these tanks – 430, 433 and 442 – show they are Soviet armoured vehicles; the Hungarian army did not have such tanks.

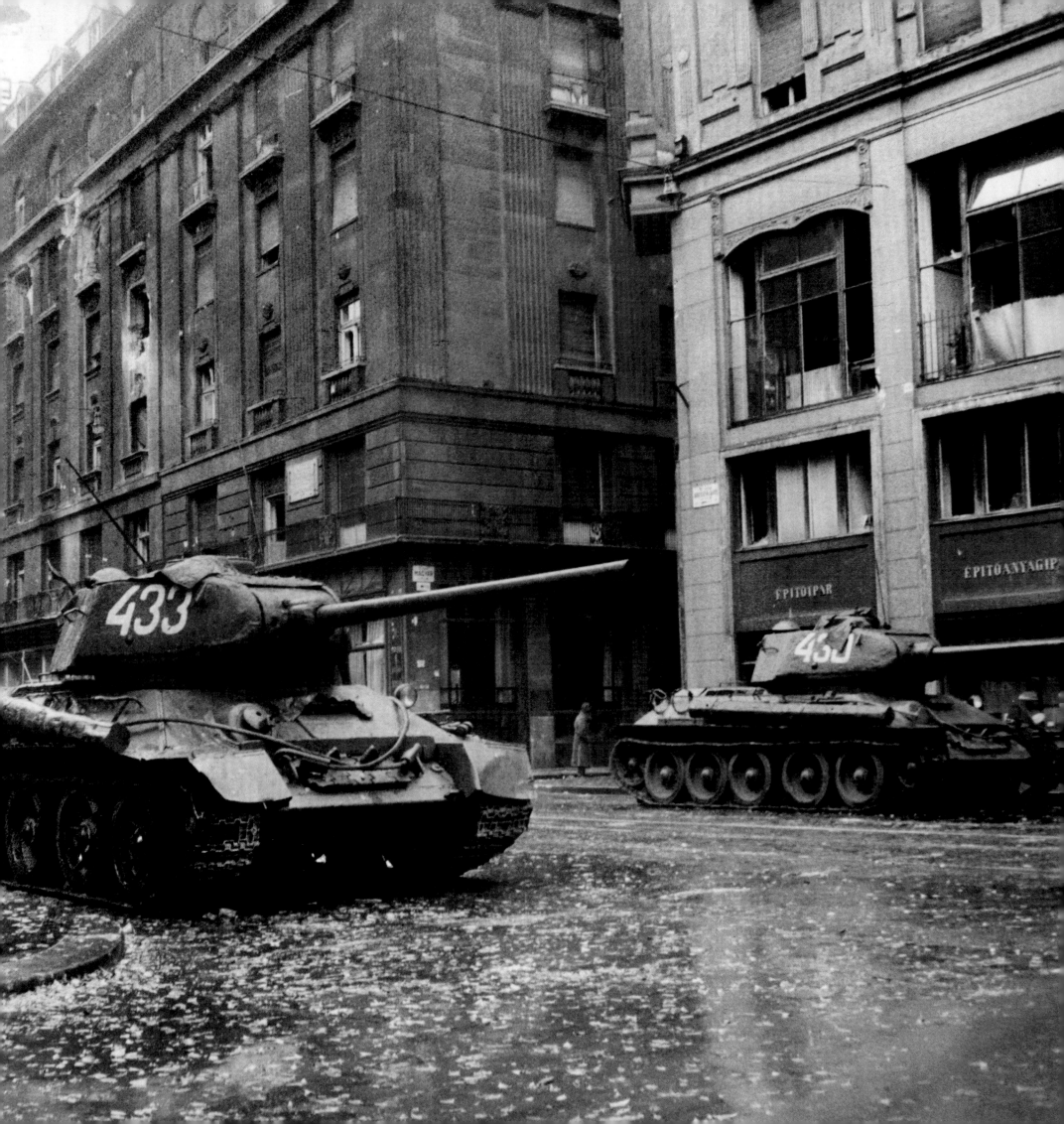

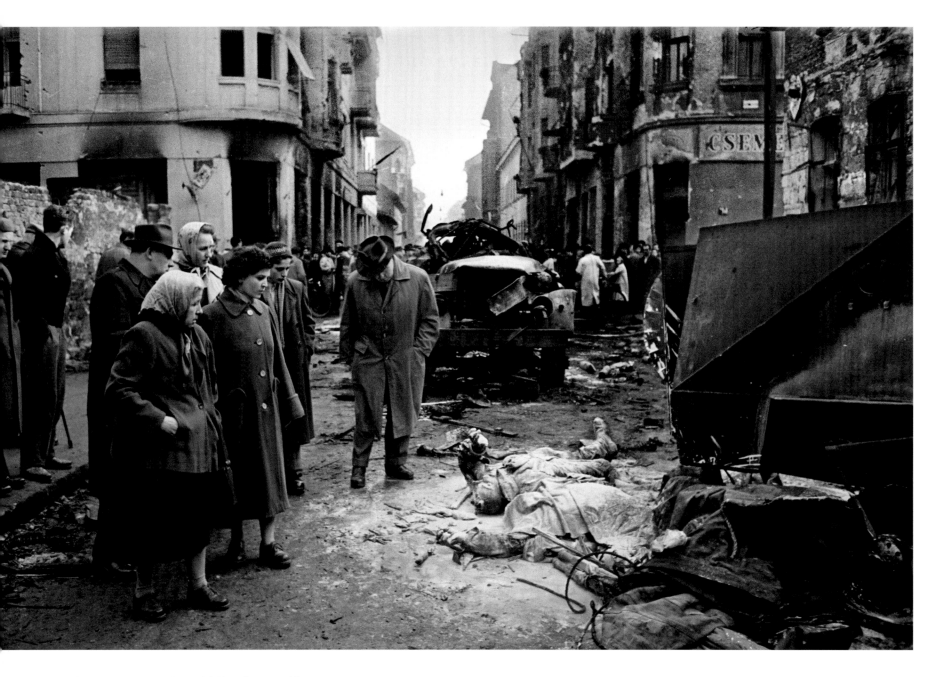

Chalk-covered bodies of fallen Soviet soldiers
on a street in Pest's József district.

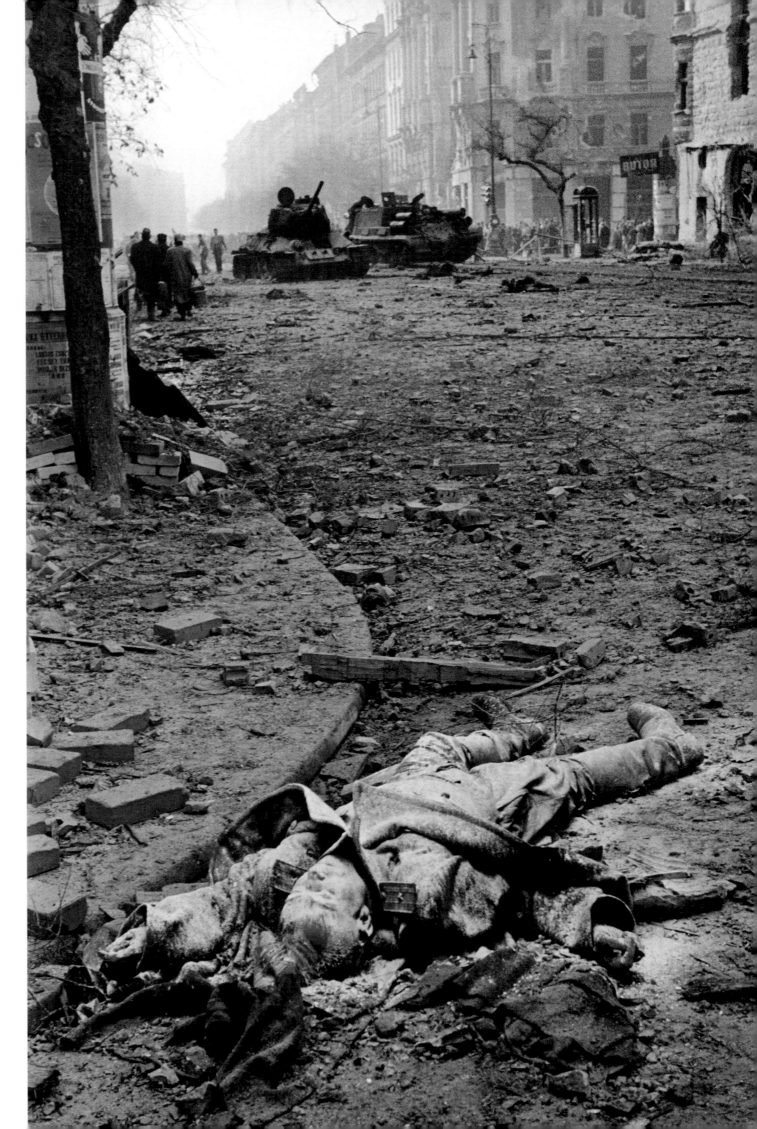

The body of a fallen Soviet soldier
on József Boulevard.

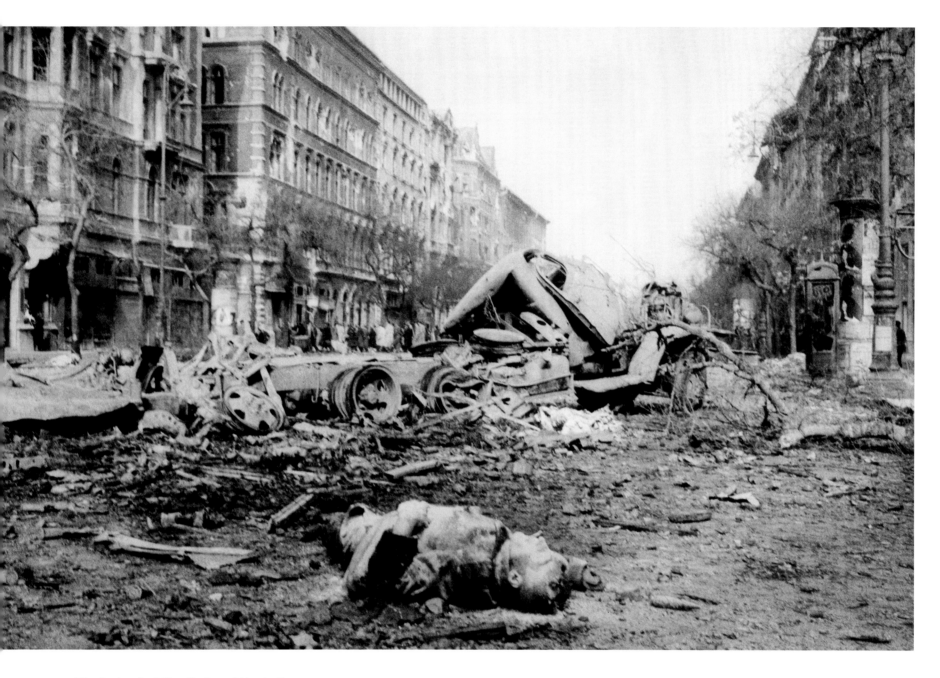

The body of a fallen Soviet soldier in front
of a disabled tank on József Boulevard.

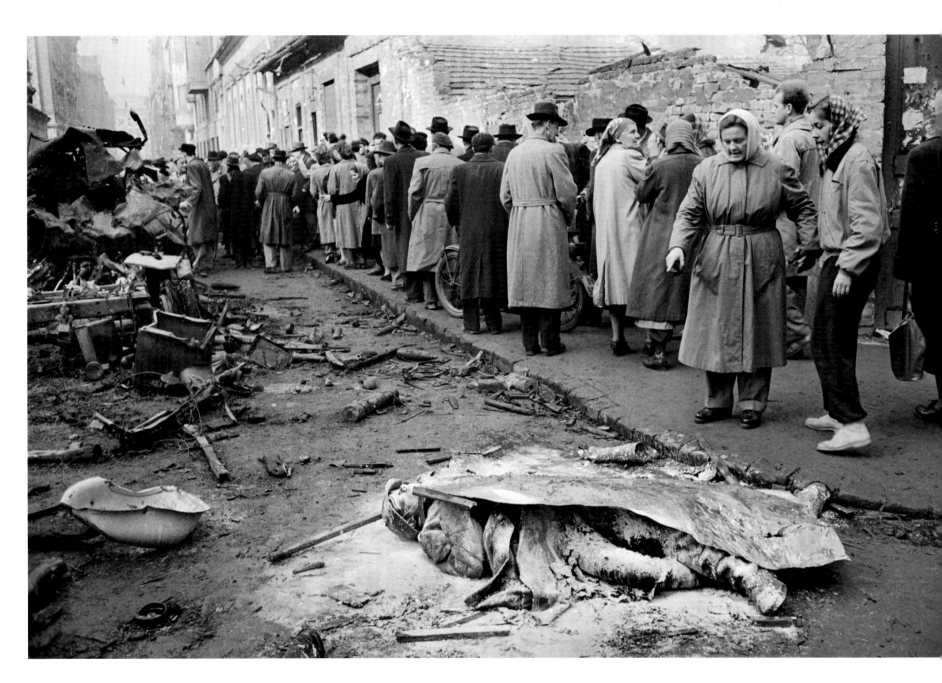

Citizens queuing for food look at destroyed tanks
and dead Soviet soldiers in a Budapest street.

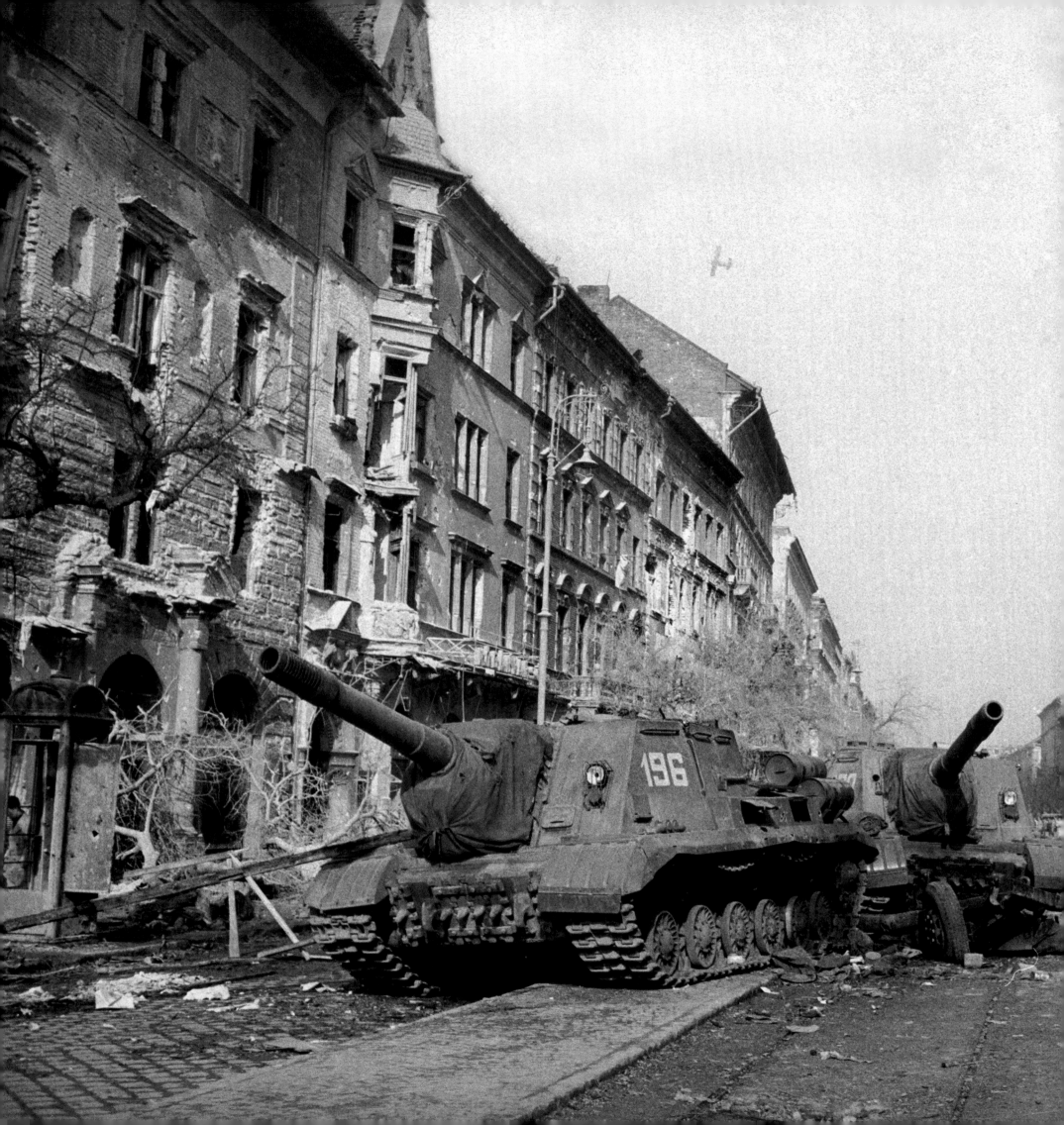

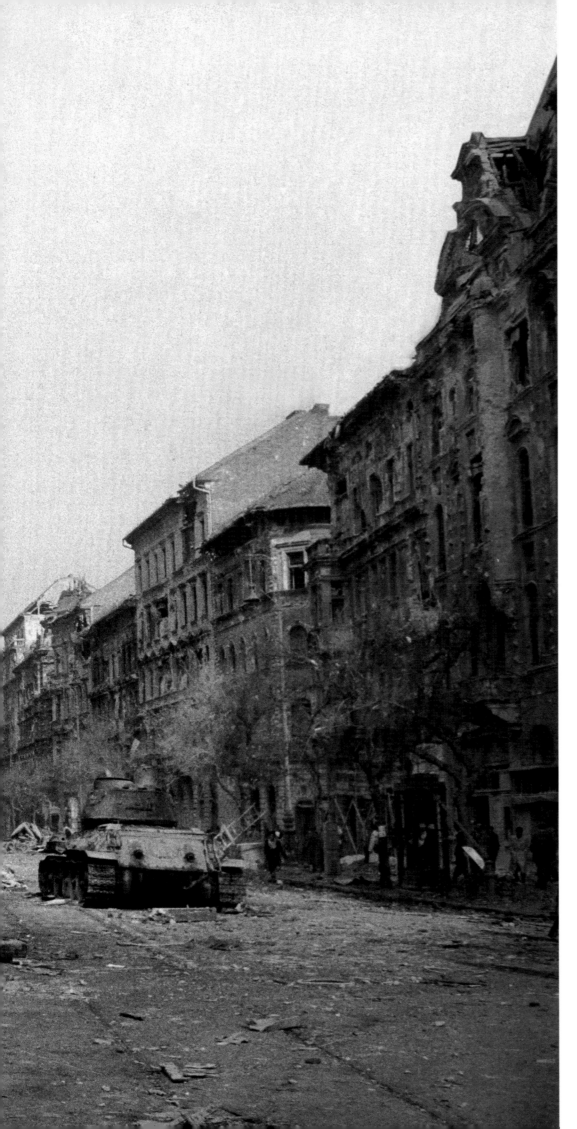

Soviet tanks and artillery on abandoned
József Boulevard as seen from Üllöi Street.

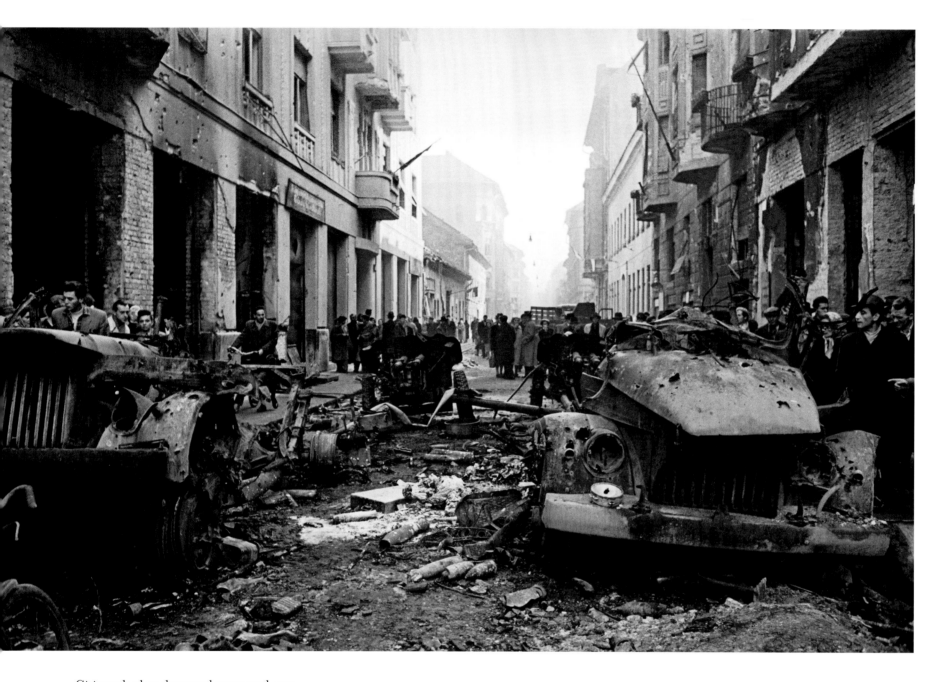

Citizens look at destroyed armoured cars
in Práter Street.

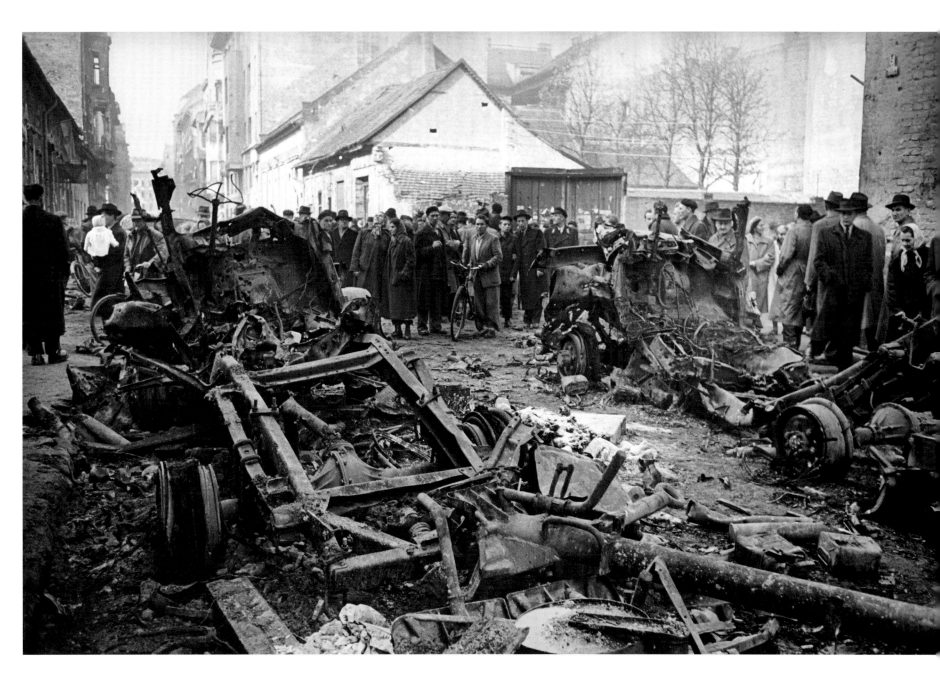

Destroyed armoured cars in Práter Street.

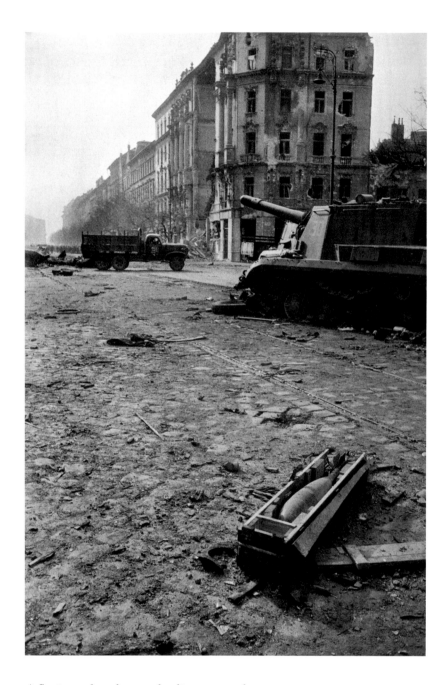

A Soviet tank and unused splinter grenades
in an ammunition crate on the corner of József
Boulevard and Üllöi Street.

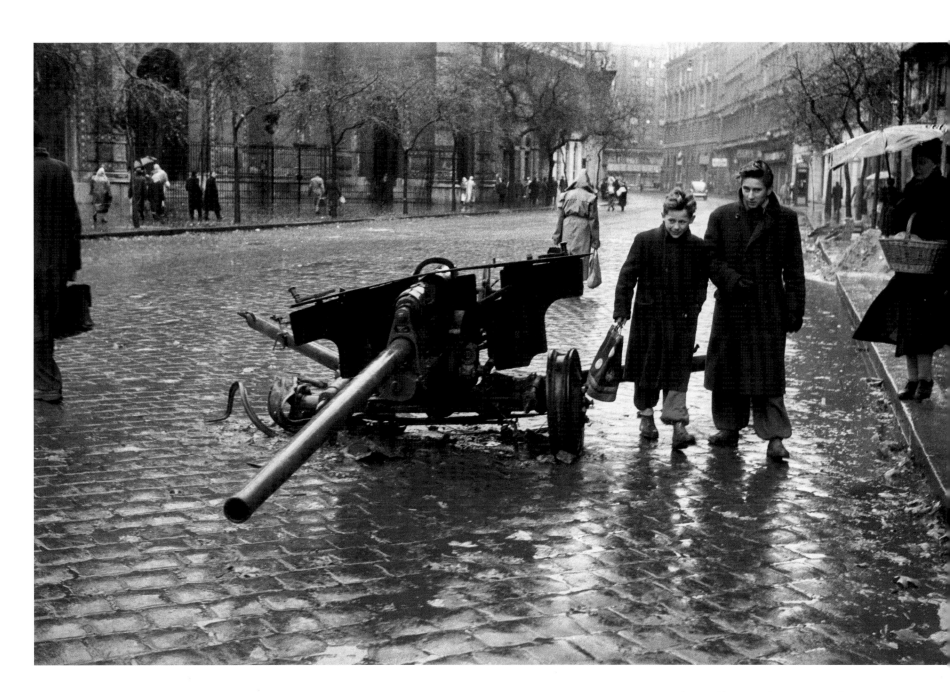

An artillery wreck in Dohány Street.

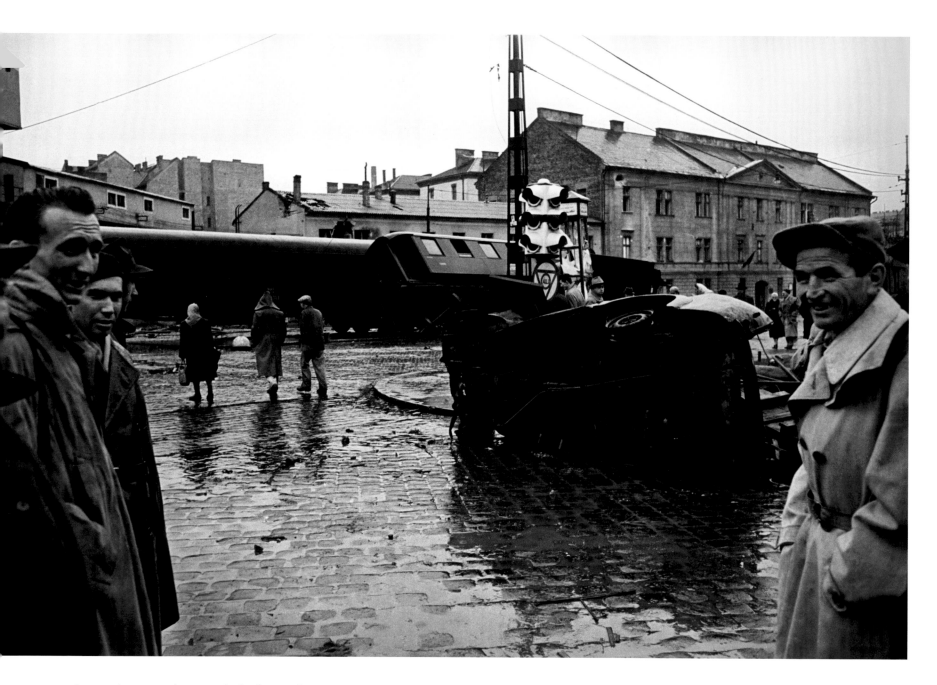

A ruined armoured car; in the background,
railroad cars which had been moved from the
South Railway Station to Buda, where they were
supposed to block roads against the returning
Soviet Army.

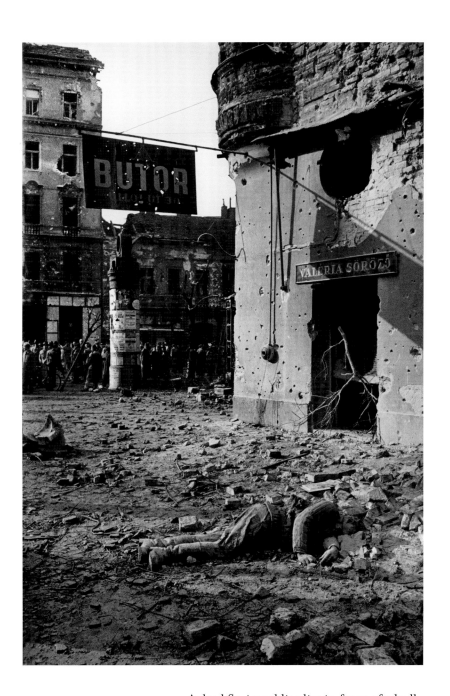

A dead Soviet soldier lies in front of a badly
damaged house on József Boulevard.

Meeting of the Writers' Union
on 28 December 1956, during which
Hungarian writers discussed the situation
following the end of the revolution.
The speaker is Péter Veres, chairman
of the Union.

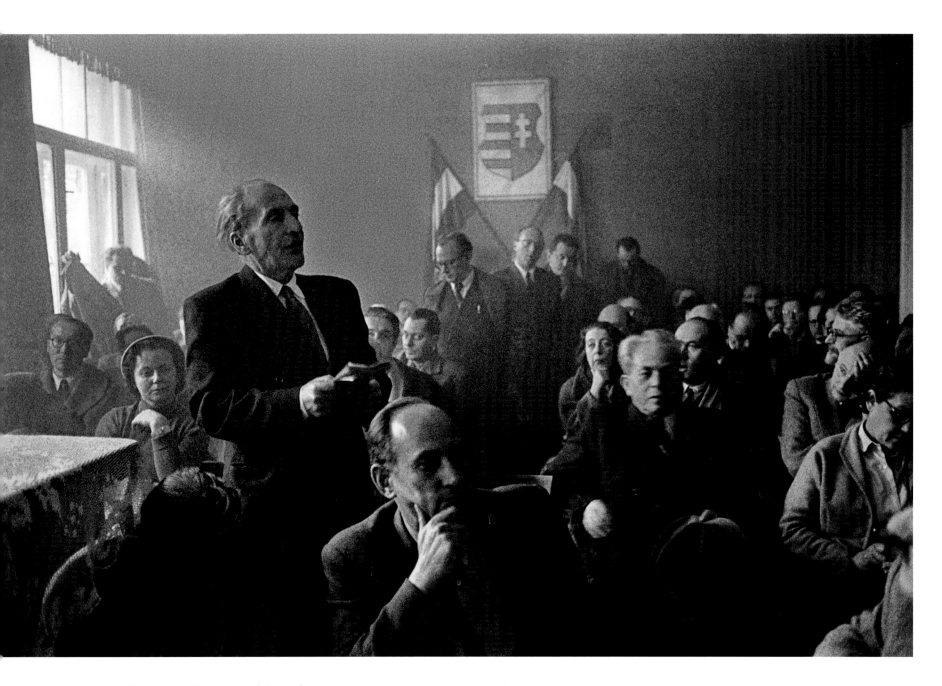

Meeting of the Writers' Union on 28 December
1956. Tibor Déry has the floor. In the foreground
is Gyula Háy (chin in hand). Several weeks after
this meeting, both men, Déry and Háy, were
sentenced to prison.

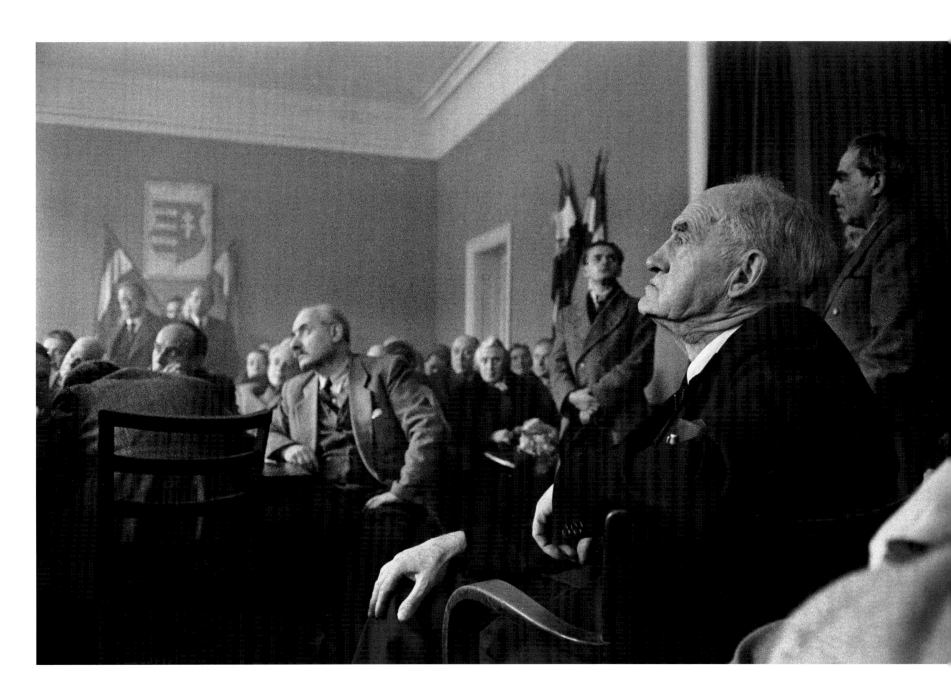

After the defeat of the revolution, the Writers'
Union met once more to discuss revolution and
repression. The Union was dissolved in January
1957; it was reinstated in September 1959.

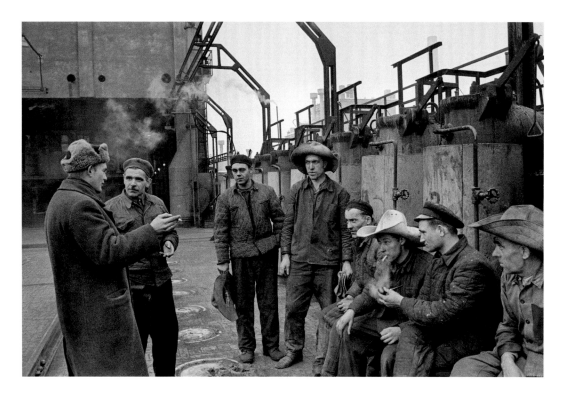

A go-slow at the Sztálinváros steel mill; the cokery is stoked every seventy (instead of twenty) minutes. Workers discuss a reduction of the workforce with members of the works council.

A membership meeting of the agricultural cooperative Karcag after the defeat of the revolution.

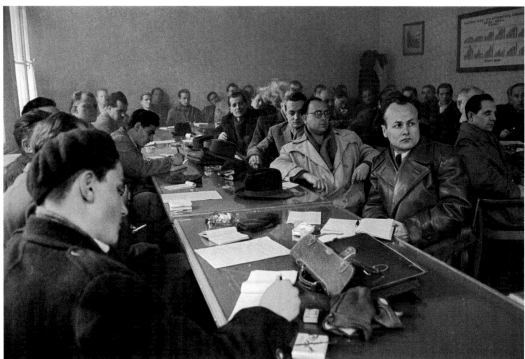

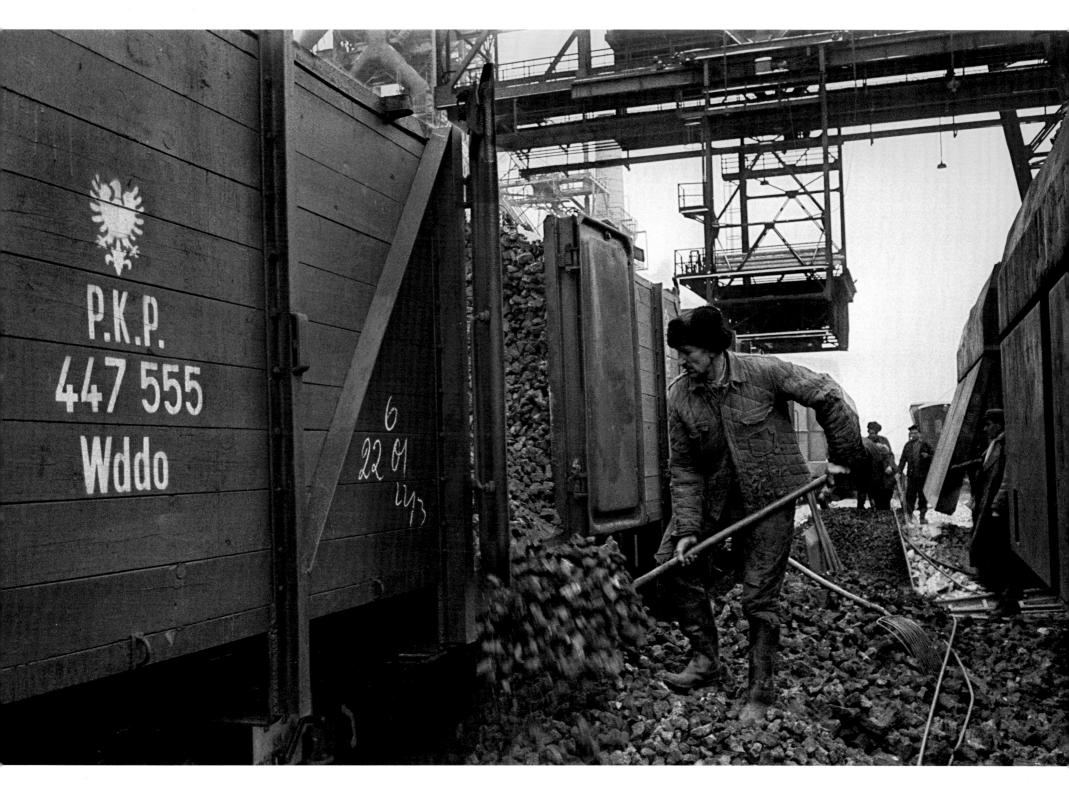

Polish coal – help sent by Polish comrades – is
unloaded in Sztálinváros.

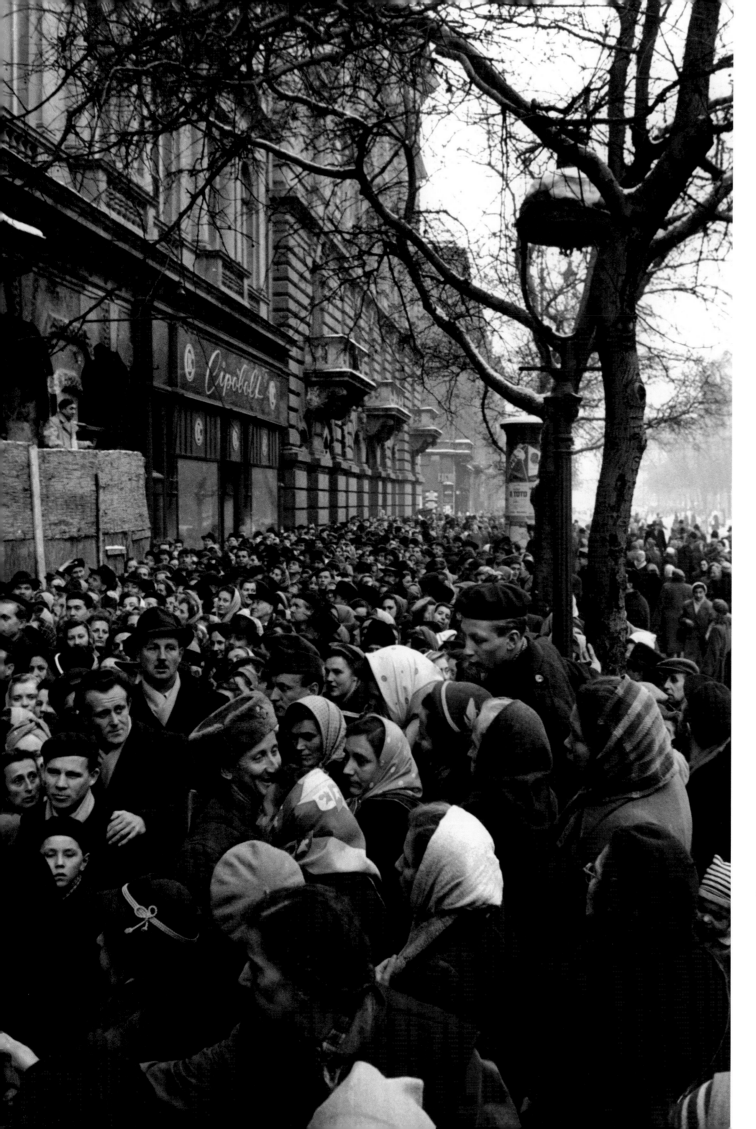

Long lines of shoppers stand in front
of a department store on Rákóczi Street.
The police only allowed small groups
of people to enter the shop at a time.

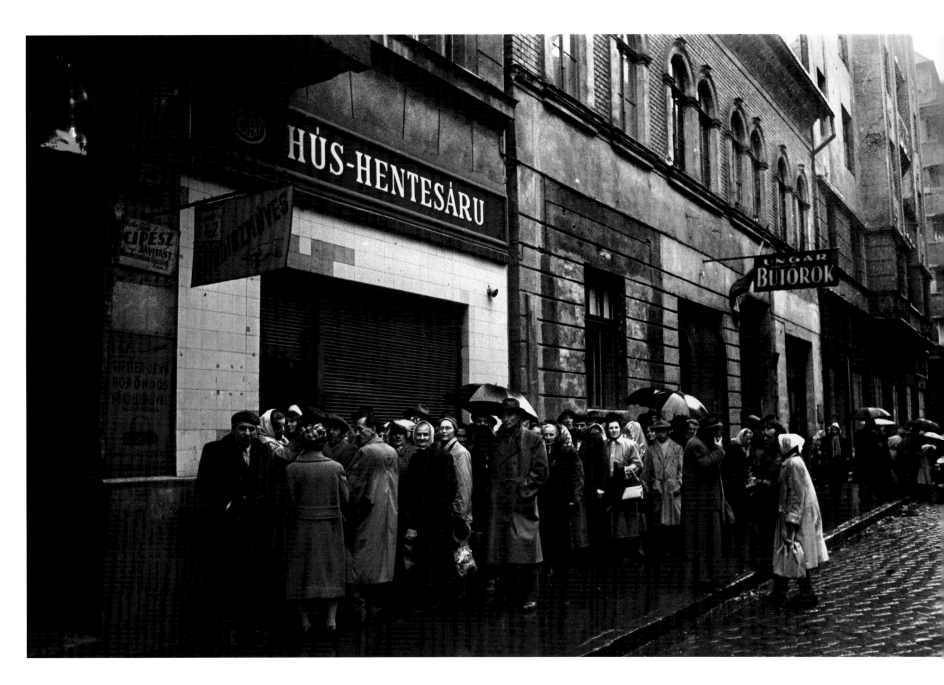

Standing in line in front of a Budapest
butcher's shop.

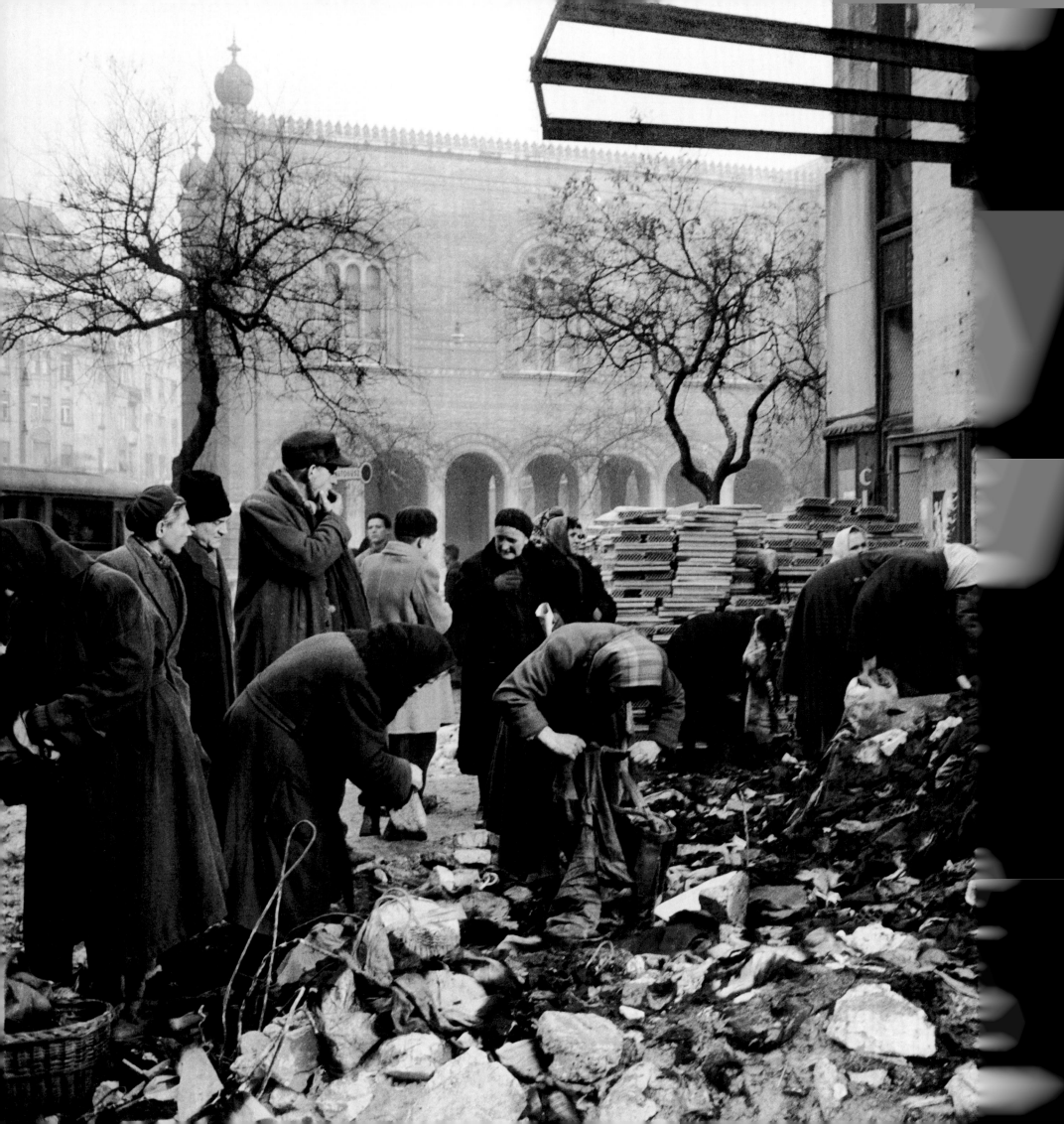

People rummaging around among the
remains of a burned-out department store
on Tanács (today Károly) Boulevard,
at the corner of Dohány Street.

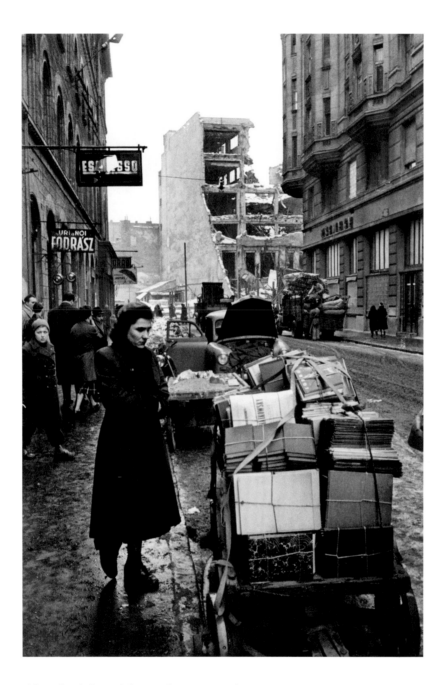

After the defeat of the revolution, people move
heavy loads through the streets of Budapest.
Books rescued from the rubble.

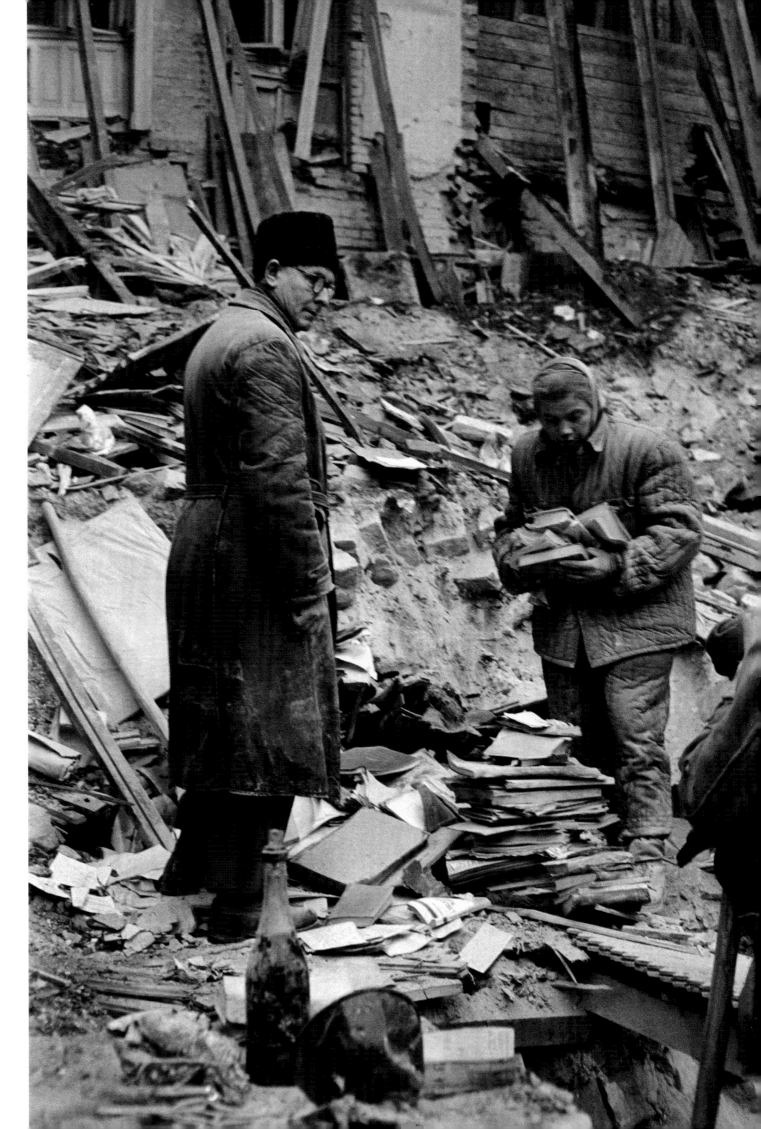

Collecting books from a damaged building.

A lone cannon in the snow on the
outskirts of Budapest.

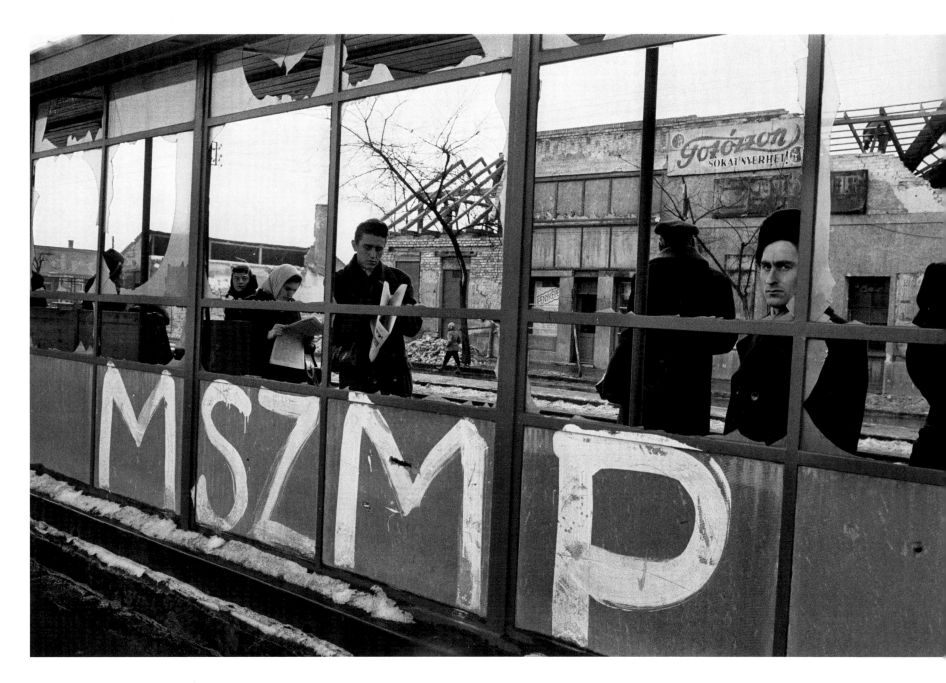

On a suburban streetcar station in Budapest, the letters: 'MSZMP', Hungarian Socialist Workers' Party, stand for an anti-Stalinist party founded on 31 October 1956 under the leadership of Imre Nagy and János Kádár. After 4 November, Kádár adopted the name for the post-revolutionary Communist Party, which existed until 1989.

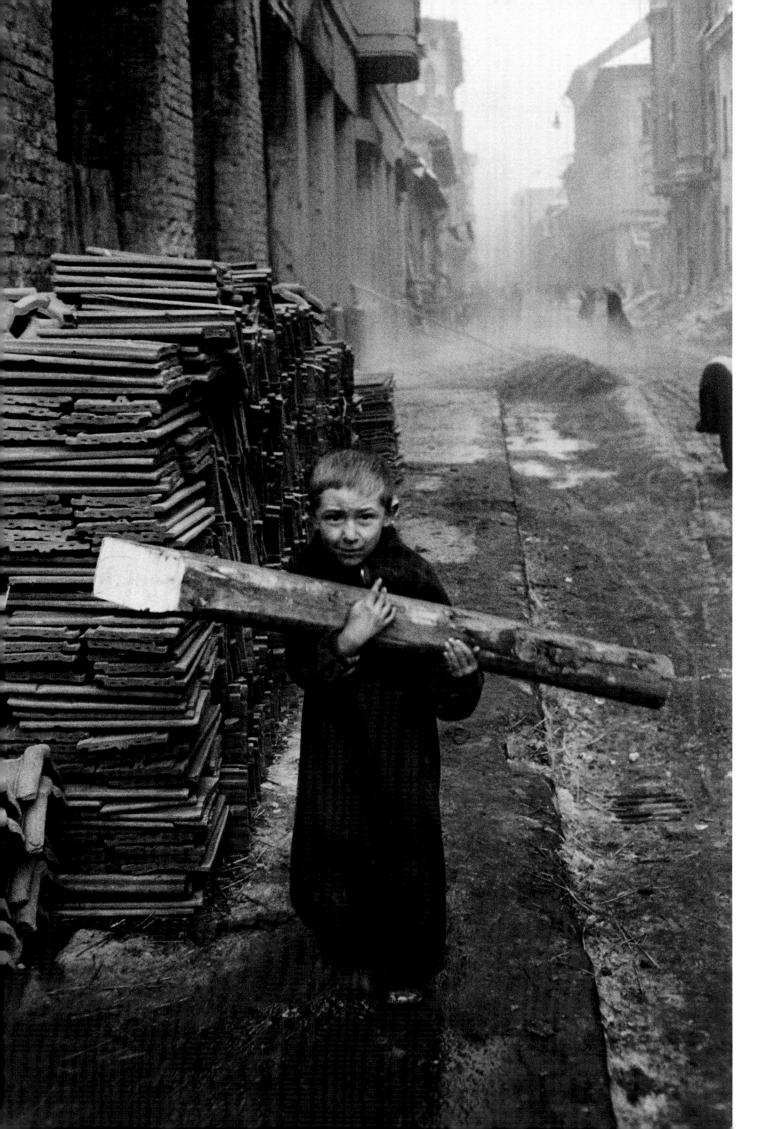

During the very cold winter of 1956–57, a small boy carries a large piece of firewood home.

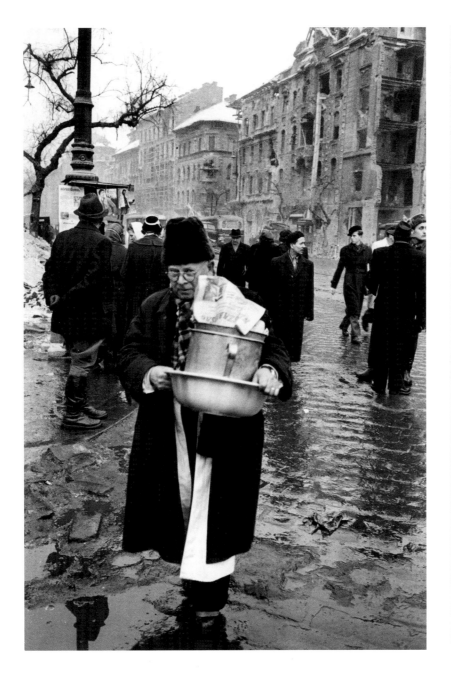

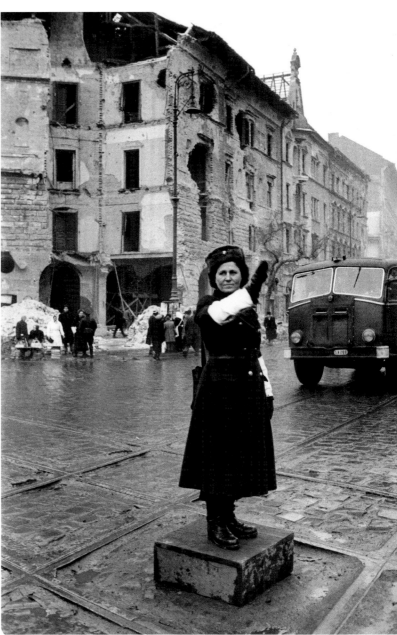

Through the sleet and snow of an extremely
cold winter, the citizens of Budapest carry
remains of possessions or odd goods available
in the few open shops.

A policewoman directs traffic at the intersection
of Üllöi Street and József Boulevard during the
winter of 1956.

A woman pulls three heavy sacks
through the snow.

THE FAILURE

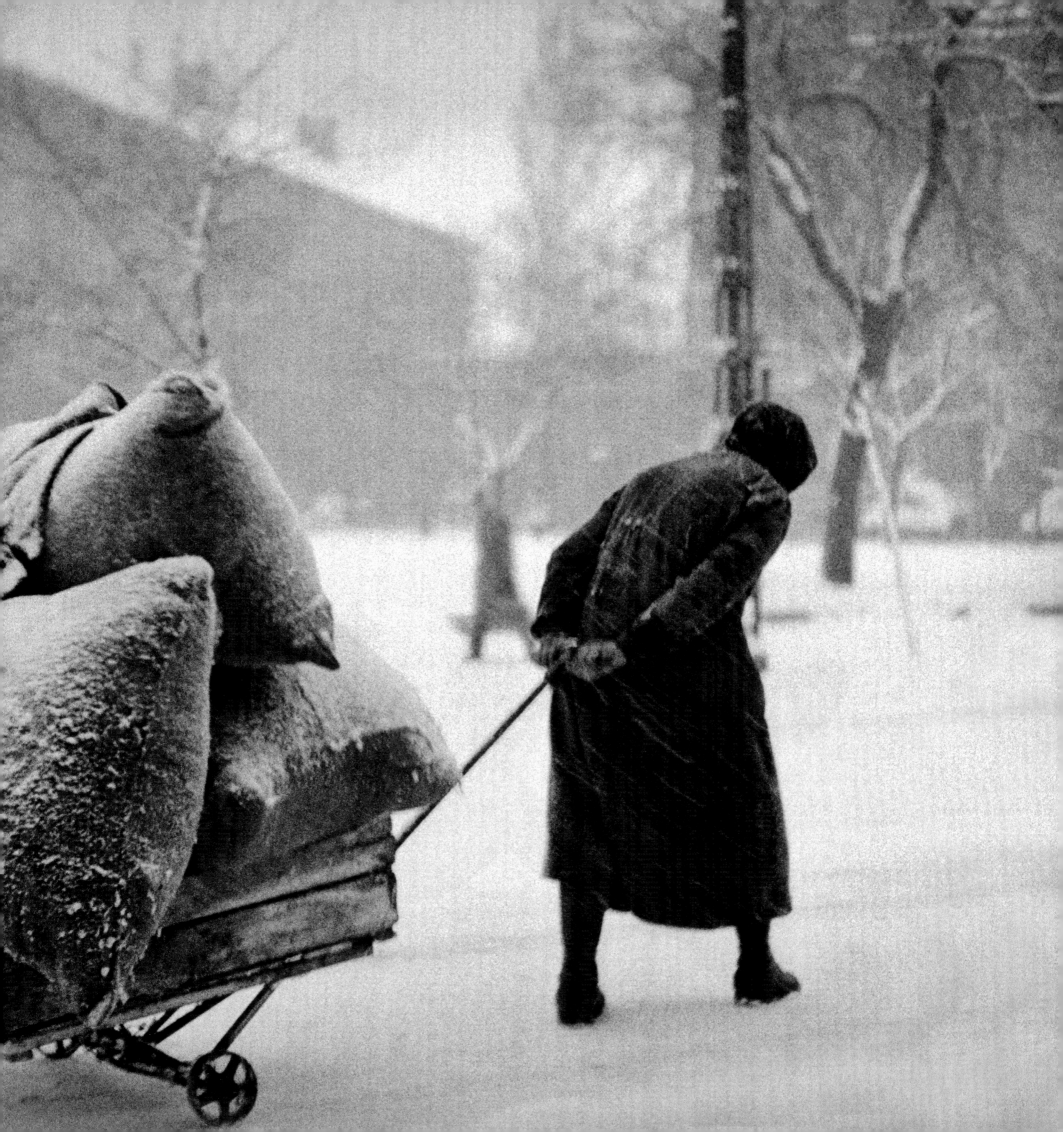

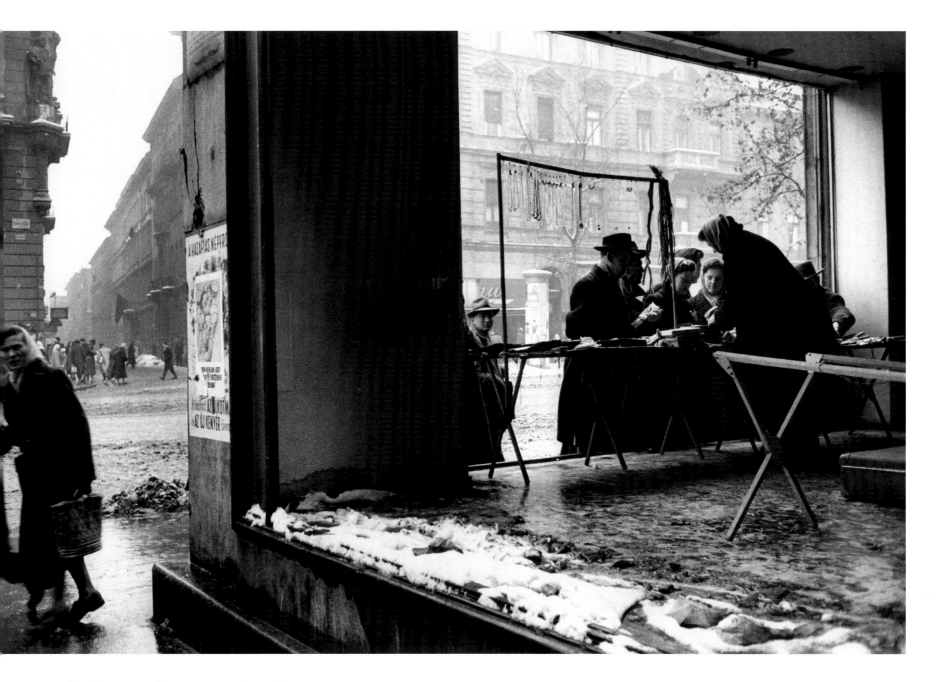

In a burnt-out shop a woman sells necklaces,
rings and other trinkets.

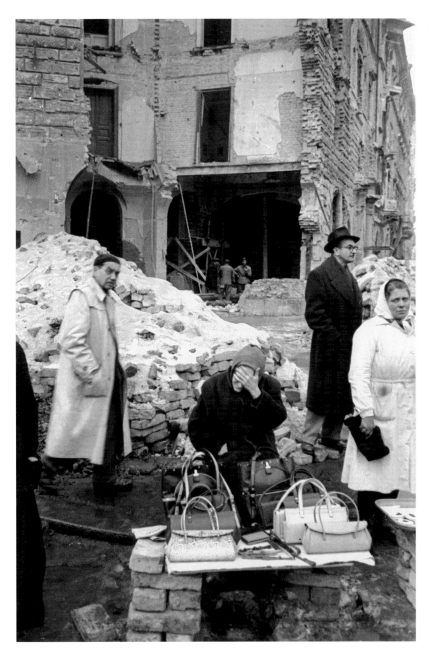

A woman sells bags from an improvised stall.

Food deliveries to Budapest were irregular;
people queue for pretzels sold from a cart
in a Budapest street.

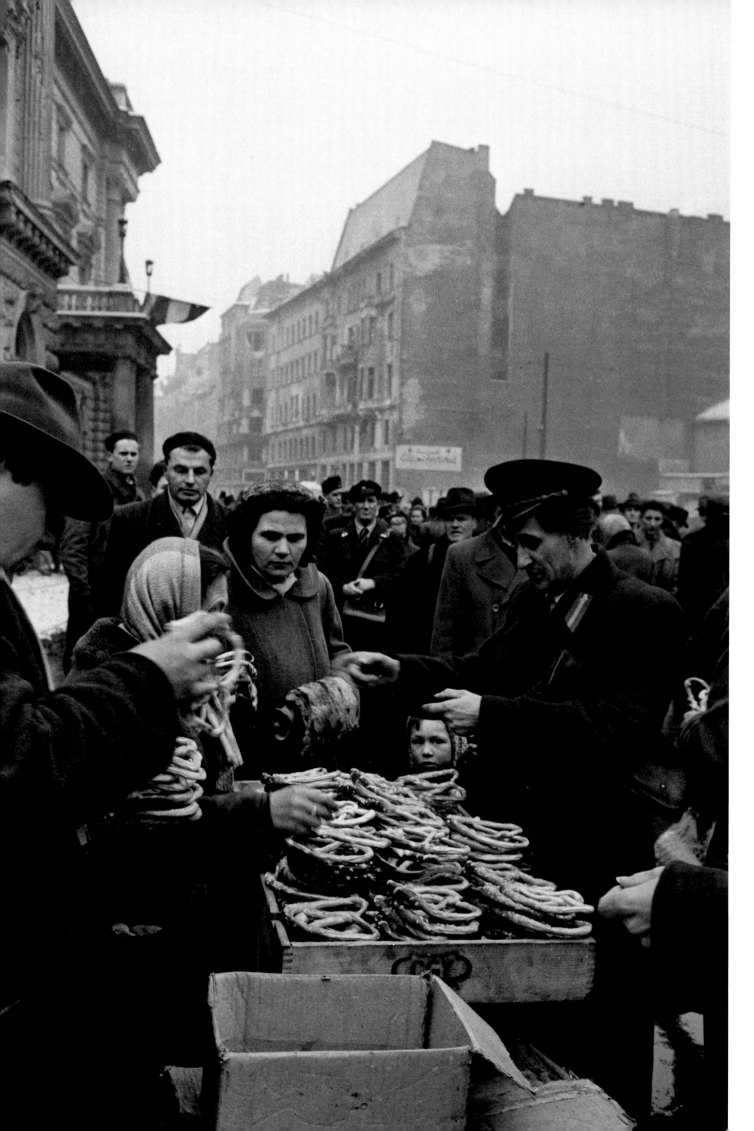

People stand in line for pretzels sold
from a cart in a Budapest street.

Life returns to snowed-under, artillery-
damaged Budapest: a couple leave church
after their wedding; a photographer takes
their picture.

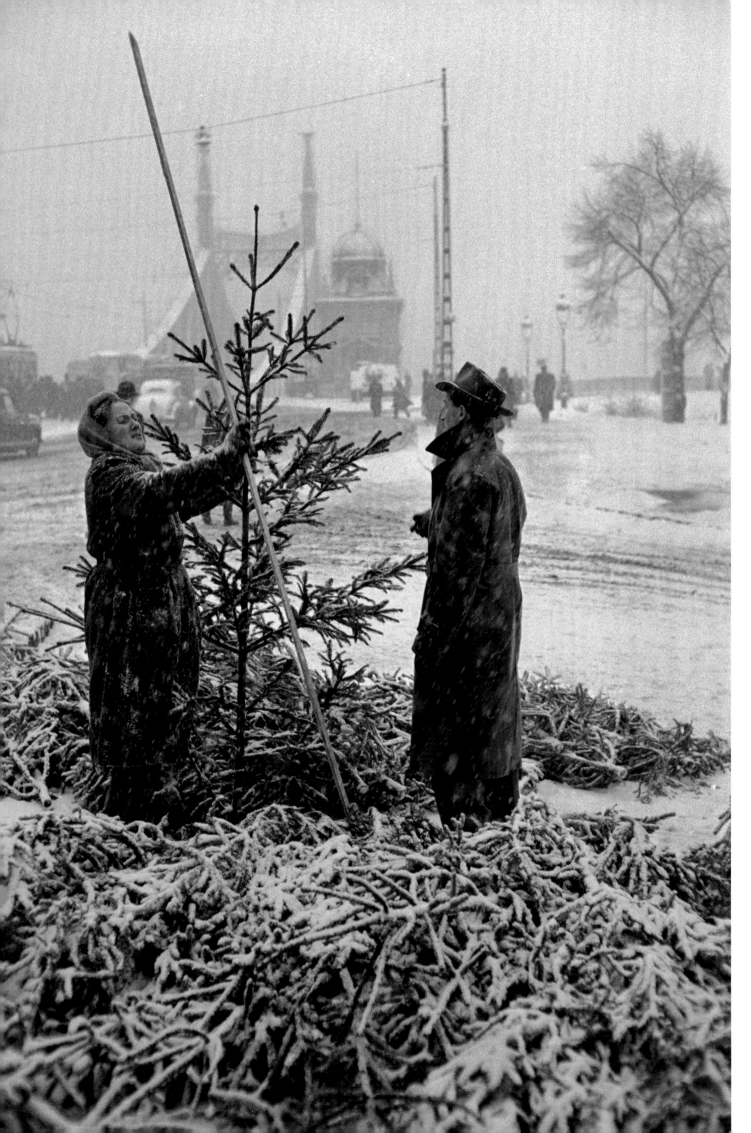

A woman sells Christmas trees
on the Pest side of Szabadság Bridge
(Freedom Bridge).

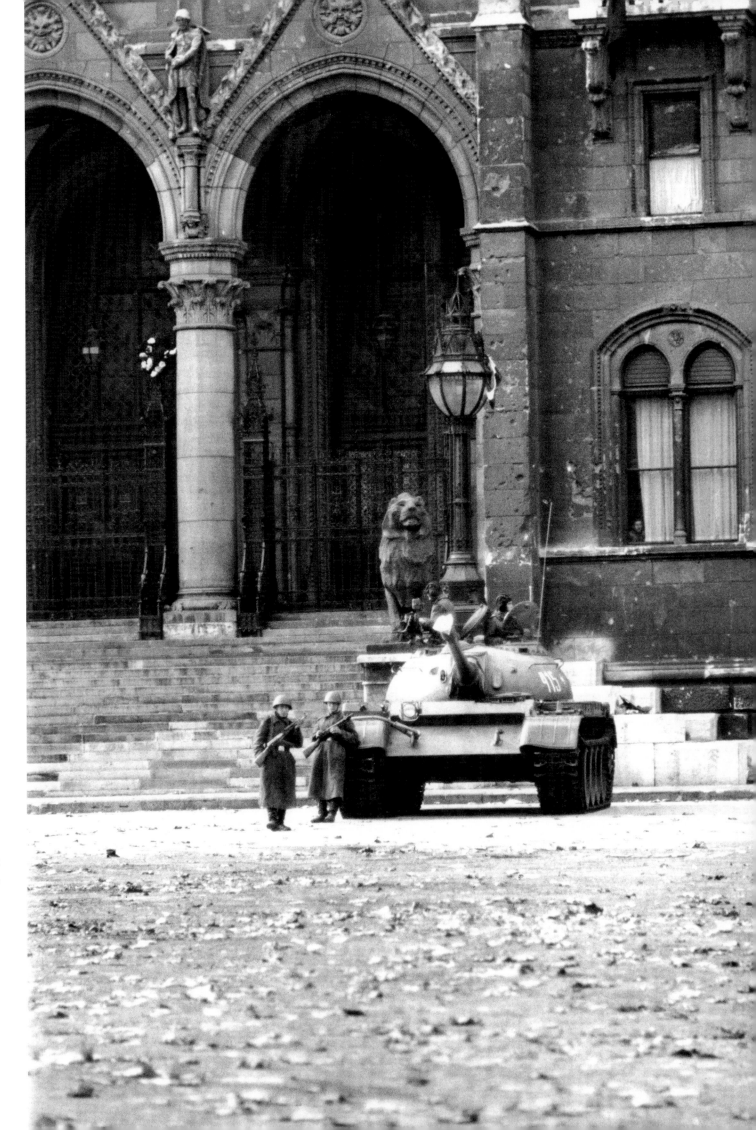

A Soviet tank and sentry in front
of Parliament, after 4 November.

On 31 December 1956, after the defeat of
the revolution, the Chinese ambassador pays a
courtesy call to the Hungarian government.

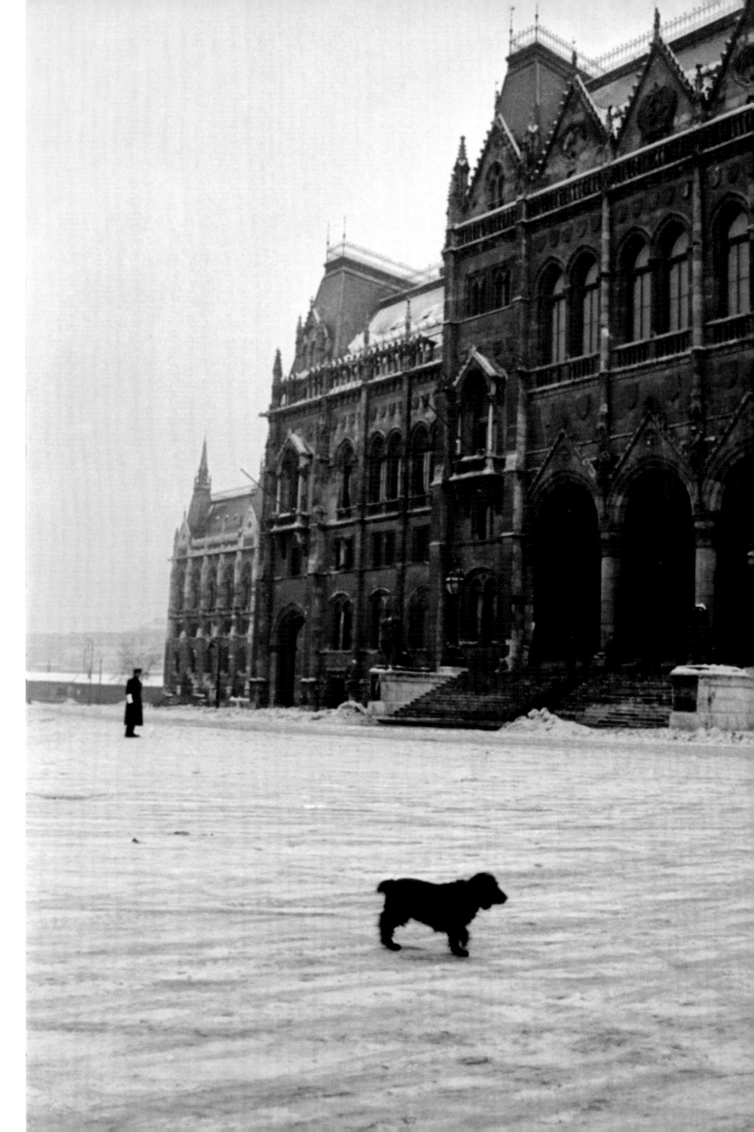

Budapest was very quiet during
the Christmas Holidays of 1956.
A lonely dog on the snowy square
in front of Parliament.

Andau Bridge crosses a small canal which forms the border between Austria and Hungary. More than 155,000 refugees fled to Austria between the end of November and December 1956. Most of them came across this bridge, which was damaged by artillery fire, but people continued to climb over it with suitcases and small children. The bridge was reconstructed after the end of Communism in 1989.

The flight

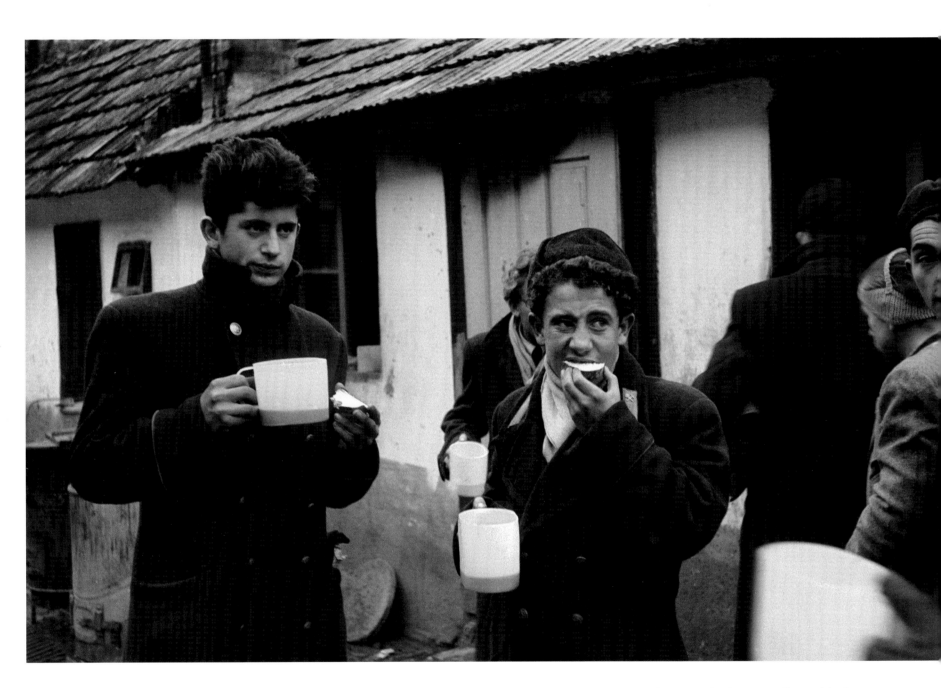

Refugees in the Austrian village of Andau.
They were received with cups of hot tea,
bread and butter.

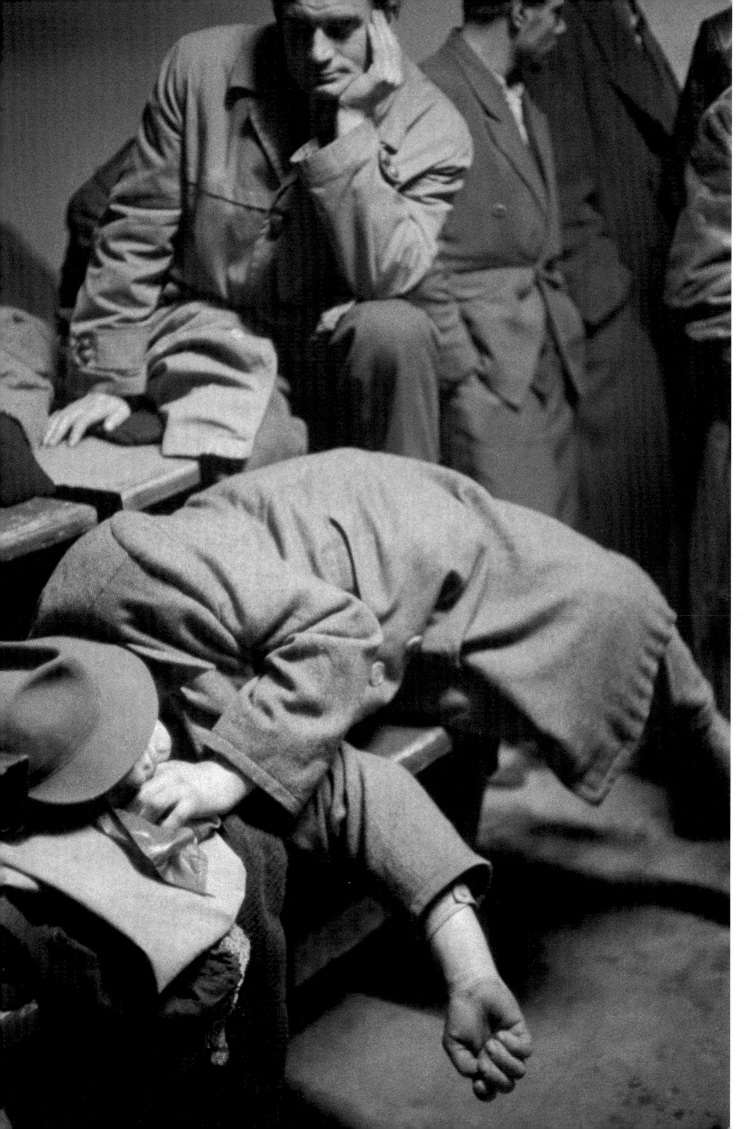

Sleeping refugees in Andau reception camp.

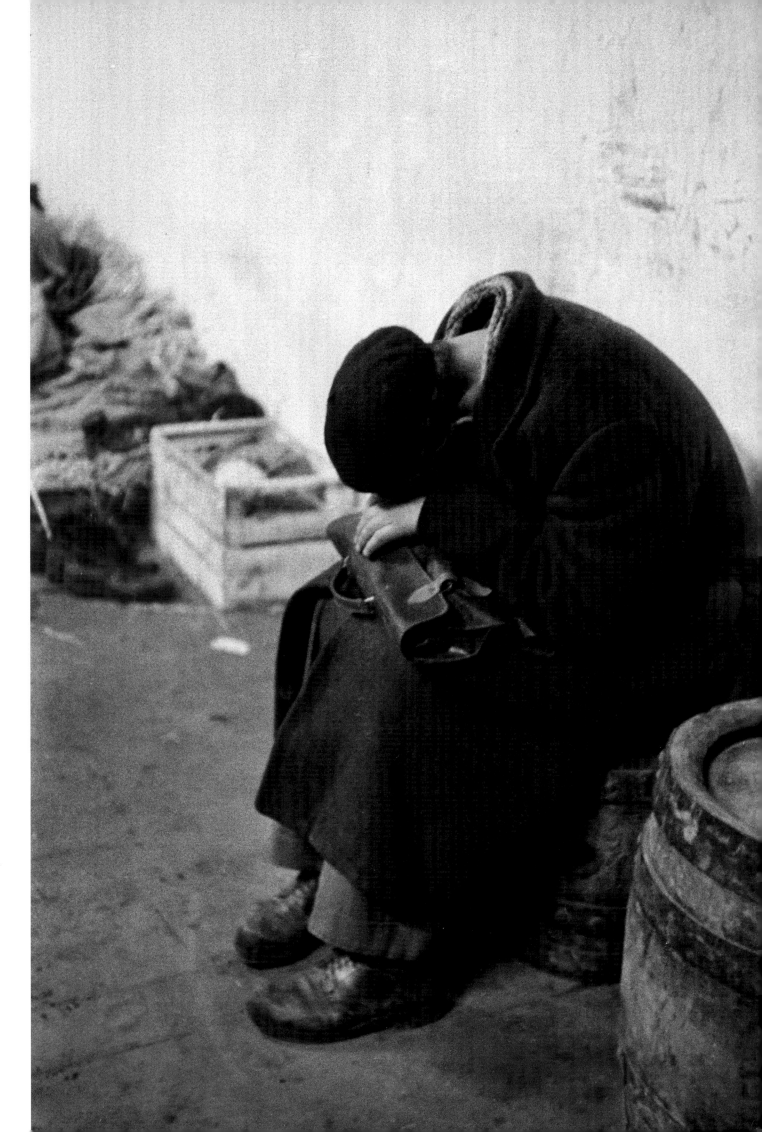

A tired refugee.

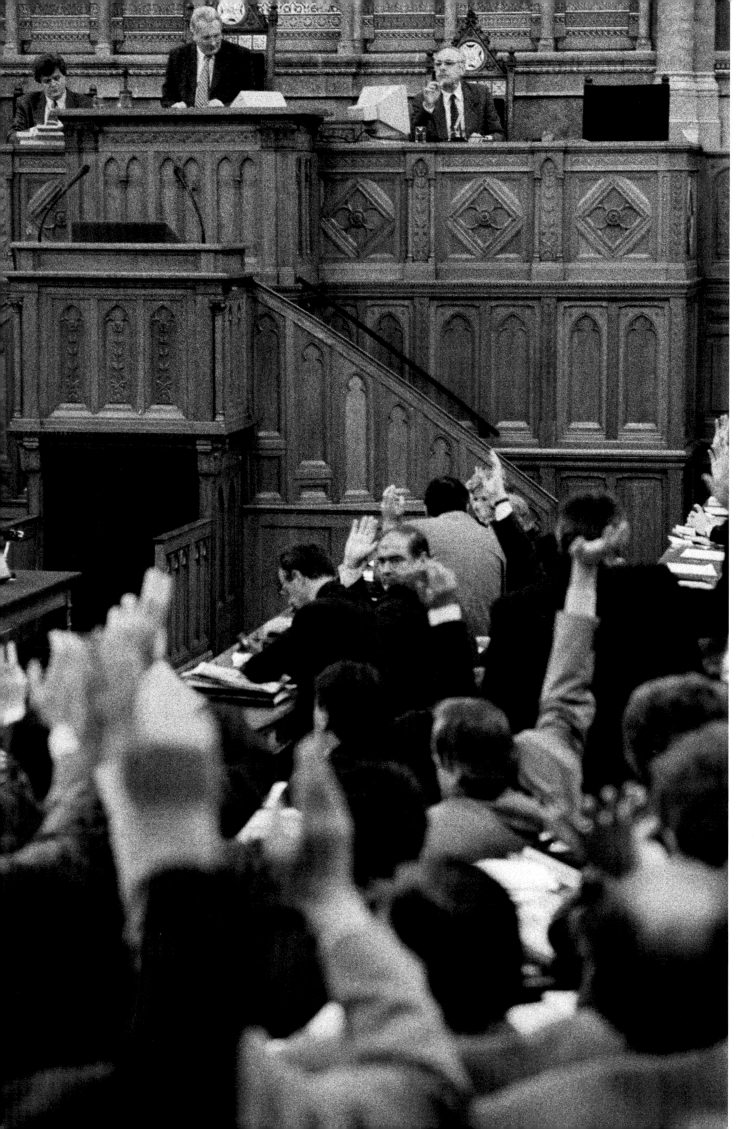

When Imre Nagy announced that Hungary would leave the Warsaw Pact, the Soviets decided the revolution had gone too far. Forty-two years later, on 18 February 1998, the Hungarian Parliament voted to apply for NATO membership.

Beginnings of a new era

The official funeral of Imre Nagy and his companions, executed on 16 June 1958, took place on 16 June 1989. The Hungarian Republic was proclaimed on 23 October 1989, and the first free elections took place the following spring. Hungary joined NATO in 1999 and became a member of the European Union on 1 May 2004.

Nicolas Bauquet

The revolution seen from the West:
shock and helplessness

The crushing defeat of the Hungarian uprising by the Red Army's tanks spelled death not just for those in Budapest: on 7 November 1956, three days after the start of the Soviet intervention, two militant Communists and a trade union representative were killed in Paris, in the aftermath of a demonstration in support of the Hungarian uprising which had degenerated into an assault on the headquarters of the French Communist Party. Although long since forgotten, the event provides some indication of the tension reverberating throughout Western Europe not only as a result of the uprising of 23 October, but also due to the Soviet attack on 4 November.

In Paris, Rome and Amsterdam, tens of thousands of people took to the streets to express their outrage, hoping to lessen their sense of helplessness by taking affirmative action. The Communist parties joined forces against this impressive show of solidarity, taking refuge behind a counter-culture which was insensitive to such 'bourgeois' indignation, drawing on the very strength of the opposition to close ranks in such times of uncertainty and doubt.

The 1956 uprising and its oppression not only represented the crystalization of the political and cultural tensions of the Cold War at the heart of Western European society, but also clearly signalled the end of an era, or at least the 'beginning of the end' of a Communist utopia which had captivated entire generations of European intellectuals.

In Western Europe, as in the United States, the 'thirteen days that shook the Kremlin'[1] had an explosive effect. On the morning of 24 October, Europeans awoke to a world which seemed poised on the edge of a precipice. The unimaginable had happened: a small forgotten nation, bound and gagged by the all-powerful and ostensibly invincible Soviet empire, had dared to stand up and defy its occupier. Thanks to the presence of Western journalists and photographers, several of whom, like Jean-Pierre Pedrazzini, paid with their lives, the unprecedented nature of this uprising was brought to light: a working-class revolt against a power which claimed to belong to the working class; an intellectuals' revolt against a regime which, not long before, they had upheld; a spontaneous revolt of an entire population seized by an uncontrollable thirst for democracy.

Public opinion followed the evolution of the situation in Hungary with fervour. In Catholic circles, the calls to pray for Hungary multiplied, and the Pope addressed several messages of support to the Hungarian people. Even in Communist

In Western Europe, as in the United States, the thirteen days that shook the Kremlin had an explosive effect.

circles, those few days were marked by a sense of uncertainty, of apprehension, faced by what was perceived as an impossible leap into the unknown. Imre Nagy was, after all, a Communist leader, entrusted, until 30 October, with the confidence of the Soviet Praesidium. The world held its breath for a few more days.

On the morning of 4 November, public opinion was gripped by a completely different feeling, that of outrage and helplessness in the face of the cold-blooded atrocities committed by the Red Army: not only the destruction of a city and the massacre of its civilians, but also the murder of hope and the rape of the most fundamental of rights, that of a people to freely choose its destiny. The following evening, in West Berlin — that enclave of freedom

in the midst of the Soviet empire — more than 100,000 people showed their full support by demonstrating for 'Freedom for Hungary'. In the evening, thousands of students left the procession and headed towards the Brandenburg Gate, guarded by the East German army. Social Democrat Willy Brandt, in whose words 'a bloody confrontation would not help Hungary, but could spark off a war', had to intervene quickly in order to avoid the worst.

Demonstrating, praying and writing all seemed somewhat trivial compared to the momentous events unfolding in a place where one could not actually go. Soon, however, the Hungarian ordeal would provide Western Europeans with the opportunity to show their solidarity in a more concrete way. In the following weeks, nearly 200,000 Hungarians fled

across their western border, where the Austrians did their best to give them a decent welcome; other countries including France, Germany and especially Canada and the United States, also prepared to offer them asylum which, in many cases, became permanent. Hungary was in ruins, brought to its knees by the general strike; with winter fast approaching, trainloads of food sent from the West temporarily alleviated its suffering. Even the poets made offerings of their words to 'Our Hungarian Friends', a reference to the title of a poem by Jules Supervielle.[2]

Faced by this tidal wave of indignation, the Communist parties of Western Europe remained steadfast in their unanimous support of the Soviet decision to 'bring help' to the Hungarian people, threatened as they were by a counter-revolution. According to Soviet archives, this bloody outcome was not only desired, but actually requested of them by Palmiro Togliatti, leader of Italy's Communist Party.[3] The Communist press, from *L'Humanité* and *L'Unità* through to *The Daily Worker*, took the opposite stance to the 'bourgeois' press', describing the Budapest uprising as a 'Fascist plot' which threatened the very success of Socialism. Returning from a stay in the Hungarian capital, André Stil,

editor-in-chief of *L'Humanité*, went as far as to say, on 20 November, that 'despite its wounds, Budapest had begun to smile again.'

Looked at from the Western side of the iron curtain, the Red Army's intervention brought the cultural and political tensions of the Cold War to a head. Before then, a rapprochement between Communists and Socialists had been on the cards, in France as well as in Italy. But thereafter, things descended into verbal and even, on occasion, physical confrontation, to the point where an outright ban on the Communist Party featured on the agenda of France's parliament. According to a tried and tested method, the leaders of the Communist parties used this tension to close ranks around what was, both literally and figuratively, their besieged citadel. The funeral of the militant Communists killed in Paris on 7 November became an excuse for a massive show of force, and 13 November was proclaimed a day of anti-Fascist mobilization. The Anglo-French intervention in Egypt on 31 October over the Suez canal was seized upon by the Communists as the perfect means of diverting peoples' attention away from Hungary, denouncing it as proof of the real 'imperialist intervention'. Nevertheless, within the apparent cohesion of these 'counter-societies'

Demonstrating, praying and writing all seemed somewhat trivial compared to the momentous events unfolding in a place where one could not go.

which constituted Western Europe's Communist parties, cracks were starting to appear at all levels, something unheard of until then. Ever since Khrushchev's secret report on Stalin's crimes had been divulged to a small number of people on the fringe of the Twentieth Soviet Communist Party Congress in February 1956, something had been shattered in the 'land of the great lie' and in its Western offshoots. The prospect of a clean break from Stalin's crimes encouraged dreams of reform and of 'a new start', but it also marked the end of blind faith in the USSR and its party.

In spite of renewed calls by Europe's Communist Party leaders, including Maurice Thorez, Palmiro Togliatti and John Gollan, to halt the destalinization process and save their own grip over their parties,

an ever-larger number of voices were demanding greater democracy at the heart of the party, and greater independence from Moscow. It was into this context that the Hungarian conflict erupted, throwing the Communist Party leadership into turmoil. As early as 30 November, deep rifts within the leadership of Italy's Communist Party worried its leader, Togliatti, sufficiently for him to inform his Soviet bosses by telegram. On 3 November, during a special executive committee meeting of the British Communist Party, a number of its prominent members, led by George Matthews, confronted their leader John Gollan. Meanwhile, in France, only Pierre Courtade, a political commentator, dared place responsibility for the uprising on the Hungarian Communist Party's own mistakes; he was quickly silenced by Maurice Thorez.

The effect of these upheavals went far deeper than the ranks of the party leadership, affecting the whole of the Communist world. In Great Britain, in the months following the Soviet intervention, over 7,000 people – twenty per cent of the total membership – left the Communist Party, while France's principle worker's trade union, the Conféderation Générale du Travail (CGT) was deeply divided by the Hungarian issue, some of its branches going as far as to formally condemn the Soviet intervention. In Italy, as early as 26 October, the Communist trade union, the Confederazione Generale Italiana del Lavoro (CGIL), led by Giuseppe di Vittorio, expressed its 'historic and definitive condemnation of the anti-democratic methods of government and political rule which had led to a rupture between the leadership and the popular masses.' In 1957, over 200,000 people left the Italian Communist Party, constituting the largest ever exodus from Italy.

These reversals for Western Europe's Communist parties particularly affected intellectual circles. For many, either party members or sympathisers, already shaken by the 'secret report' on Stalin's crimes unveiled at the party's Twentieth Congress, Budapest was the moment of truth. 'After the exposure of Soviet Communism, everything changed. We were accountable for its crimes and lies to the French people,' wrote Pierre Daix in his memoirs[4]. Intellectuals involved with the British review *The Reasoner*, published an article in their 4 November issue entitled 'Through the Smoke of Budapest', calling for greater democracy within the Communist party. The article opened with the following words: 'Stalinism has sown the wind and now the whirlwind centres on Hungary.' They were suspended from the party a few days later, before leaving it altogether on 14 November. Meanwhile in Italy, on 29 October, 101 Communist intellectuals sent a manifesto to the central committee opposing all Soviet intervention. Many fell back line, but historian Renzo Di Felice and the writers Alberto Moravia and Italo Calvino left the party, along with the poet Franco Fortini, who wrote in a poem entitled *4 November 1956*:

> *Il ramo secco bruciò in un attimo*
> *Ma il ramo verde non vuol morire.*
> *Dunque era vera la verità.*
> *Soldato russo, ragazzo ungherese,*
> *non v'ammazzate dentro di me.*
> *Da quel giorno ho saputo chi siete:*
> *e il nemico chi è.*

In France, the list of those who broke with the Communist Party or distanced themselves from it as a result of the Budapest intervention, was even more impressive, giving some idea of just how powerful the fascination with the USSR and the Communist utopia had been until then. Their numbers included well-known names like Sartre, Picasso, Vercors and Aimé Césaire, and rising intellects such as François Furet, Alain Besançon, Emmanuel Leroy-Ladurie, Annie Kriegel and Max Gallo.

In retrospect, 1956 would appear to have been a watershed in the history of twentieth-century Communism, the beginning of the end of the magnetic power exerted since 1917 by the great light to the east. 'The USSR had become an estranged State,' wrote the French philosopher Edgar Morin,[5] who had taken his exclusion from the party in 1951 badly, yet remained obsessed by the utopia of Communism. 'Not a stranger because it was Russian, and I French; but a stranger because it was now devoid of all universality. The USSR had retreated into Real Politik. It no longer had any eschatological mission. It was a State.' And yet, another thirty years were to pass before, in Annie Kriegel's words,[6] this 'attack on the very essence of Communism' would bring down the system itself,

bringing with it 'the downfall of the counter-revolutionary state throughout the East, under the weight of its lies and contradictions,' as writer Albert Camus had hoped in 1957.

While the intervention of 4 November 1956 weakened Communism as a faith, it undoubtedly strengthened the USSR as a state, and consequently represented something quite other than the 'beginning of the end'. As Pierre Kende put it, it represented the 'formalization of the tacit Yalta pact', the *de facto* recognition of the right of the USSR to dominate its empire, and, also, the consolidation of its status as a superpower. For a long while to come, it would draw its strength from this notion, from the very idea which had given rise to its birth.

In 1956, Hungarians scarcely needed the encouragement of Radio Free Europe's programmes to live in hope of the overthrow of this European order: Soviet troops had withdrawn from Austria the previous year, and were it not for the Warsaw Pact, signed in May of that same year, there would have been no possible justification for any Soviet military presence in Central Europe. The pact, now part of history, was scarcely one year old when Imre Nagy

While the intervention of 4 November 1956 weakened Communism as a faith, it undoubtedly strengthened the USSR as a State.

announced Hungary's decision to withdraw from it on 1 November 1956. Although the United States had embarked upon a discreet revision of its policies towards Central and Eastern Europe, easing up on its economic and political boycotts, President Eisenhower nonetheless came to office, in 1952, on the back of his campaign to 'drive back' Communism and liberate the 'captive nations'. The total absence of international recognition of Soviet domination in Eastern Europe undoubtedly weakened the USSR's position on the world scene. Notes taken by V. N. Malin, a member of the Soviet Praesidium, during emergency meetings, reveal that the regime's hierarchy hesitated for a long while before deciding to intervene a second time. While the outright loss of Hungary was never envisaged, the withdrawal of Soviet troops was a definite possibility, right until to the moment when the decision to intervene was finally and irrevocably taken on 31 October. Until then, the fate of Europe hung in the balance.

The Soviet intervention on 4 November, and the impotence of Western diplomats, entrenched the limitations of the Eastern and Western blocs and, perversely, reinforced the possibility of a peaceful coalition. The West's failure to respond was due not only to the legitimate fear of an outbreak of nuclear war, but also to a determination not to jeopardize the chances of a diplomatic thaw. This had been underway since the death of Stalin in 1953, if not the year before, and which was just starting to bear fruit with the Geneva conference and the Austrian State Treaty of 1955.

The West's failure to respond was due not only to the legitimate fear of an outbreak of nuclear war, but also to a determination not to jeopardize the chances of a diplomatic thaw. This had been underway since the death of Stalin in 1953, if not the year before...

As the Hungarian historian Csaba Békés explained[7], the Hungarian episode may have had all the appearances of a diplomatic crisis, but it never seriously threatened the underlying process leading up to the Helsinki conference in 1975 at which Soviet power in Central Europe was recognised *de facto*, and eventually *de jure*, in return for the growing economic interdependence between East and West. Within this context, the main preoccupation of Western diplomats, regardless of their own personal feelings towards Hungary, was to steer clear of anything which might fly in the face of the Soviet Union, and to use multilateral organizations such as NATO or, especially, the United Nations to express sufficient indignation to calm public opinion. The 'unanimous boycott of Hungary's oppressors' which Albert Camus had called for, was confined to János Kádár, the puppet, rather than extended to his puppet-masters. From 1962, the Hungarian question was no longer even on the UN's agenda. During his visit to Budapest in 1964, where he was warmly welcomed by Kádár, General de Gaulle was delighted by the 'continuous development of our cultural and economic ties'.

For France, as for the United States or Great Britain, the priority at this point was to create individual ties with each of the Eastern bloc countries, to promote national interests and encourage economic interdependence and cultural exchange. A report by the American National Security Council, in May 1958, formalized this major turning point, taking great care to recommend 'maintaining a delicate balance', encouraging contact in order to open up the regime 'without compromising the symbol which Hungary had become'.[8] A few years later, Kádár's Hungary began to be seen as Eastern Europe's star pupil, the one who had managed to negotiate the greatest degree of freedom with Moscow thanks to a bizarre post-revolution relationship with its persecutor.

The 'Hungarian exception' had become a reality. By the end of the 1960s, Hungary was without doubt the most prosperous, the most free and the most open of the popular democracies. So much so that from the 1970s, an abyss separated it, for instance, from Romania, foundering under the paranoia of its *conducator*, and Czechoslovakia, stuck in neo-Stalinism. So was it 'Victory in Defeat', to quote the title of Hungarian historian Miklós Molnár's book which appeared in 1968? On closer inspection, it

would appear that, on the contrary, the trappings of Kádár's Hungary were the bitter price paid for by an entire population's moral capitulation, to such an extent that it appeared to János M. Rainer, Director of Institute 56 in Budapest that 'the mental state of Hungarian society was better under Mátyás Rákosi than during the soft dictatorship of Kádár.'[9]

If, for Hungarians, 23 October was the outward expression of their treasured and refound liberty, then 4 November was the striking demonstration of their subjugation. Neither the scandal of a European nation being overrun by troops from the Caucasus and Central Asia, nor the absurdity of an economic and political system totally at odds with the true needs of the country, did anything to change the reality or the permanence of the situation. One simply had to survive and to come to terms with it.

For a few weeks or months, poignant scenes of passive resistance, such as 'the silent procession of black-clad women in the streets of Russian-occupied Budapest, mourning their dead in public'[10] which converged on Hösök Square (Heroes' Square) from the four corners of the city on 4 December 1956 continued to move the West. What had previously

enabled Hungarians to cope with the arrests, deportations and executions, with the blackmail of the political police and the intimidation, no longer existed. Nobody believed any longer in a sudden reversal of the situation, but rather in the certitude that the present masters were there for a long time to come, if not forever.

The news of the execution of Imre Nagy and his companions on 16 June 1958 signalled the death of the last glimmer of hope for revenge. Just as their bodies were buried under false names, without graves, in lot number 301 of the Rákoskeresztúr cemetery, so the revolution was condemned to eternal damnation (*damnatio memoriae*), the very cornerstone of the Kádárian compromise: 'He who is not against us is with us.' Hungary sank into a political desert for the next two decades.

Once the outcry and indignation had died down, the truth could only be told in the West, by those who had managed to flee or who had not forgotten: François Fejtö, Pierre Kende, Miklós Molnár, Charles Gati, Tibor Méray, Federigo Argentieri, Bill Lomax and many others. Mainsprings of the development of anti-totalitarian thought in the West, they were also, from the late 1970s, the link

with a new generation of dissident Hungarian intellectuals which included Gábor Demszky, Tamás Gáspár Miklós and János Kis. The circulation of ideas between Hungarian publications in Paris and Brussels and the clandestine *samizdats* in Budapest was instrumental in keeping the events of 1956 at the heart of the new revolution which, this time, was to be both peaceful and victorious.

In opposition to a power which was prisoner to its own initial falsitude, these intellectuals offered the strength and simplicity of a demand for truth and justice, beginning with those victims of the revolution buried without graves.

On 16 June 1988, while François Fejtö inaugurated the symbolic tomb of Imre Nagy and his companions in the Père Lachaise cemetery in Paris, thousands of young Hungarians gathered at lot number 301 were being bludgeoned by the police. A year later, 200,000 people congregated in Hösök Square (Heroes' Square).

The same day, 16 June 1989, gathered around the remains of Imre Nagy, Pál Maléter, Géza Losonczy, Miklós Gimes, József Szilágyi and a coffin representing all the other victims of the revolution,

'the nation took possession of itself' (Bálint Magyar) and proceeded symbolically to put the regime to death. On 6 July 1989, the death of János Kádár was announced at the same time as the annulment of the verdict against Nagy and his fellow victims by Hungarian justice. And a few months later, shaken by the breach which had opened up between Hungary and Austria, the iron curtain ceased to exist.

Translated from French by Philippa Richmond

1. Tibor Méray, *Thirteen Days that Shook the Kremlin,* London, Thames and Hudson, 1959.

2. *Hommage des poètes français aux poètes hongrois,* Paris, Seghers, 1957, p. 77.

3. Telegramme of 31 October 1956, published in *Cold War International History Project Bulletin*, No. 5, Spring 1995.

4. Pierre Daix, *Tout mon temps, Révisions de ma mémoire*, Paris, Fayard, 2001.

5. Edgar Morin, *Autocritique,* Paris, Julliard, 1959.

6. Annie Kriegel, 'PC occidentaux: le retour de l'histoire', in Pierre Kende, Krzystof Pomian (eds.), *1956. Varsovie–Budapest,* Paris, Seuil, 1978.

7. Csaba Békés, 'The 1956 Hungarian Revolution and World Politics', in *The Hungarian Quarterly*, Vol. 36, Summer 1995.

8. National Security Council Report 5811, 'Policy Toward the Soviet Dominated Nations in Eastern Europe', 9 May 1958, published in Csaba Békés et al., *The 1956 Hungarian Revolution: a History in Documents*, CEU Press, Budapest/New York, 2002.

9. Interview with János M. Rainer, *Népszabadság*, 22 October 2003.

10. Hannah Arendt, 'Totalitarian Imperialism: Reflections on the Hungarian Revolution', *The Journal of Politics*, February 1958.

IN REMEMBRANCE

Previous page
The statue of Imre Nagy on Vértanuk Square (Martyrs' Square) in Budapest stands opposite the Hungarian Parliament. Nagy was executed on 16 June 1958. The monument, by Imre Varga, was erected in 1996.

The best statues from the Communist era, most of them 'Socialist Realism', were removed from Budapest's public places and found a new home in Szobor Park (Statues' Park), far from the city centre.

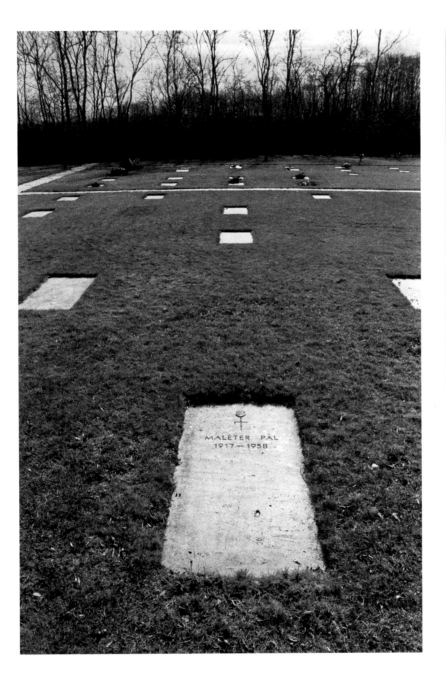

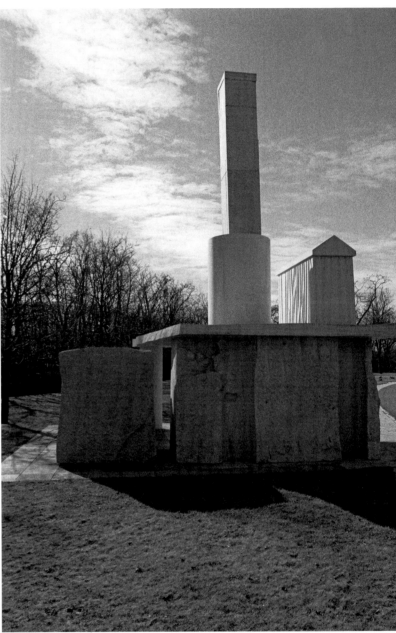

The tombstone of defence minister General Pál Maléter, defender of the Kilian barracks, in Rákoskeresztúr cemetery, the 'Martyrs' cemetery'. Pál Maléter was executed on 16 June 1958.

The central memorial, by György Jovánovics, in Rákoskeresztúr Cemetery, where most of the executed insurgents were buried in unmarked graves. Between December 1956 and June 1961, some 230 Hungarians were executed because of their involvement in the revolution.

Lot 301 in Rákoskeresztúr cemetery, the tombstone of Ilona Tóth. A physician in a Budapest hospital, member of a group of freedom fighters, she was executed at the age of twenty-four.

Epilogue

After that, I didn't visit Hungary until 1986 when the French Cultural Institute organized a symposium to shed light on the effect of the Hungarian revolution throughout Europe. France, more than any other European country, was deeply affected by the Hungarian revolution, which eventually resulted in a rift within the French Communist Party.

Then, in 1998, I suggested to András B. Hegedüs that we try to find the surviving members of the Petöfi Circle and invite them to a reunion. In 1956, the Petöfi Circle met in a hall of the Army Club. In the meantime, it had turned into the maiall of the Bavarian Landeshypotheken Bank, a room decorated in white marble with crystal chandeliers, bearing not the slightest resemblance to the shabby place where the Hungarian revolution began. We invited between forty and fifty people who were once part of the club to meet there for coffee. The reunion turned out to be totally depressing because those who turned up had become either old or sick and tired, many could not walk without canes and most had not seen each other since the revolution. They spoke cautiously, not certain if or how the other one had evolved: 'Yes, szervusz (hello), how are things going? Oh, your wife passed away? Things aren't so great with me either, everything hurts. Yes, and this one died in prison, and that one, so on and so forth.'

It was a gathering of old folks who wanted to talk about everything except the revolution or the year 1956. After a couple of hours the whole sad, tired group split up. Not one word was lost on the revolution, the future, or the past.

Erich Lessing
Translated from German by Jeanette Demesteere

Are the events of 1956 really to be a closed book after fifty years? For those who were involved, and those who were eyewitnesses at the time, perhaps yes. The revolution reached its conclusion only on 4 November 1956, when the Soviet troops once again marched into Budapest and crushed the heroic resistance of the Hungarian rebels. It came to an actual end in January, 1957 when the workers' strike was called off, life returned to its usual routines, and all hope seemed to disappear. And finally, over the decades, Kádárism created a clean break, as no one any longer spoke of the revolution and it seemed as if no one any longer remembered it.

In 1989, people suddenly began to think of the fall days of 1956 once again. Only then did the story of 1956 come to its true ending with the crumbling of the Soviet-style Eastern European states; only then, when the revolution was truly victorious, and a large part of its goals realized.

Those among the participants of the revolution of 1956 who lived to see this victory certainly felt themselves, at least for a moment, among the truly happy. There are surely many reasons why, years after 1989, they can no longer remember, or no longer wish to remember, as clearly as they did back then.

Just as in 1957, life in the 1990s went on. In Hungary too, the new democracy had to contend with many problems and difficulties. The seemingly closed story of the revolution nonetheless remains alive. It remains alive because the story of 1956 will come to be seen as perhaps the most important historical event of contemporary Hungarian democracy. In order to truly allow this to happen, we must remember it from time to time, to preserve the story of the revolution from being forgotten and recount how we see it decades later. As we have done in this book, and with these photos.

János M. Rainer
Translated from Hungarian by Michael Blumenthal

Duotone reproduction, printing and binding
by Grasl Druck & Neue Medien, Bad Vöslau, Austria.